The Catalogue for
THE RAVEN MASON COLLECTION
at Keele University

The Catalogue for
THE RAVEN MASON COLLECTION
at Keele University

Edited by
GAYE BLAKE ROBERTS FMA, FRSA
and
JOHN TWITCHETT FRSA

KEELEUNIVERSITY**PRESS**

© University of Keele, 1997

Keele University Press
22 George Square, Edinburgh

Typeset in Bembo
by Pioneer Associates Ltd, Perthshire, and
printed and bound in Great Britain
by the University Press, Cambridge

A CIP record for this book is available from
the British Library

ISBN 1 85331 225 8

CONTENTS

FOREWORD

It gives me great pleasure to see this catalogue in print, representing as it does, the culmination of several years' dedicated activity to bring the Raven Mason Collection to Keele University. I am glad to have this particular opportunity to record the University's sincere appreciation of the generosity of the Raven family and the support of the Raven Trust throughout this time.

Through the benefaction of John Mason Raven and Ronald William Raven, the Raven Mason Collection of ceramics was established at Keele in 1993 in the custodianship of the Raven Trust. The University has undertaken the care and curatorship of this important corpus of Mason's ware, which is representative of the period of intense development and creativity in the English ceramic industry during the late eighteenth and nineteenth centuries. It is our aim to promote the Collection as an educational resource for students and scholars and as a heritage asset to the many visitors attracted to Keele, who come from the local and regional community and from abroad.

It is important to see this Collection in context. It forms a distinctive and integral part of Keele's Department of Visual Arts, the first new department, offering new undergraduate courses, to be founded at Keele for over thirty years, and for this reason alone it is a significant landmark in the University's academic and educational development. It was our privilege to name the John Raven Chair in Visual Arts in commemoration of the endowment which brought it into being.

One of the department's prime objectives is to develop programmes of teaching and research associated with ceramic history. A specialist unit has been set up to co-ordinate these activities which will range from contributions to undergraduate and postgraduate courses, through to continuing and professional education programmes and summer schools which will draw enthusiastic and knowledgeable audiences at regional, national and international levels.

My personal thanks are extended to the inspirational involvement of Dame Kathleen Raven whose dynamic goodwill has characterised this project, and indeed to the Raven Trustees, experts in the field of ceramics, and several of whom contributed to this volume.

Staffordshire is recognised as home to the world's premier pottery industry, and we are delighted that Keele University can play a part through this Collection. Visitors to Keele will be very welcome in the Raven Mason Suite.

PROFESSOR JANET FINCH
Vice-Chancellor

ACKNOWLEDGEMENTS

The Trustees of the Raven Mason Collection:

 Mr John Marshall (Chairman)
 Mr Andrew Cheney
 Professor Francis Frascina
 Dame Kathleen Raven, DBE, D.Litt
 Miss Gaye Blake Roberts
 Mrs Deborah Skinner
 Mr John Twitchett
 Mrs Velma Young

Professor Janet Finch, Vice-Chancellor, Keele University

Professor David Vincent, Professor of Social History, Keele University

Professor Brian Fender, former Vice-Chancellor, Keele University

Miss Ann Linscott, Director of Corporate Communication, Royal Doulton plc (Rtd.)

Mrs Eileen and Mr Rodney Hampson

The late Mr Ray Young

Mrs Katey Banks, Curator the Raven Mason Collection

Mrs Sue Bridgett, Head of Corporate Communications, Keele University

Mr Terry Bolam, Technical Co-ordinator, Department of Visual Arts, Keele University

Mrs Nicola Pike, Managing Editor, Keele University Press

CHAPTER 1

RONALD WILLIAM RAVEN AND JOHN MASON RAVEN

Dame Kathleen Raven DBE

The Raven family, of which Ronald and John – always known as Jack – were distinguished members, came from Coniston in the Lake District. There were four children altogether, including another boy, Fred Smith, and a girl, Kathleen Annie. Fred had a successful career in business whilst Kathleen chose nursing and rose to become the Chief Nursing Officer in the Department of Health. They were born into a happy, loving Christian home, where beauty, truth and service were greatly valued.

Their mother's father was Jeremiah Mason, a direct descendant of Miles Mason, the potter, who had started production in 1796. This Mason connection was an important element in the family consciousness and the children appreciated and, from early years, were encouraged to collect beautiful things.

Their father's mother, Kate (Smith) Raven, was a personal assistant to and lifelong friend of John Ruskin, the historian and art critic who lived at Brantwood, across the lake from Coniston. Ruskin was a frequent visitor to their grandparents' home, and his books, his gifts and his interest in the family formed a strong influence on the following generations. One of his eccentricities when staying the night away from home was to turn to the wall any pictures in his bedroom of which he did not approve!

Ronald's and Jack's parents were Fredric William Raven and Annie Williams Mason. Fredric, who had interests in the local green slate quarries and a large tailoring business, was a talented wood carver. Annie was very artistic, drawing and designing patterns, and was a clever needlewoman. She was still designing and stitching beautiful tapestries until over ninety years of age. Both were very alive to the need to have beautiful things around them and, while fully enjoying all the natural beauty of the countryside around Coniston, filled their home with collections of pottery and pictures, notably Mason porcelain and watercolours by local artists of some stature, such as Alfred Heaton Cooper, who was a family friend. In this way they gave their children an appreciation of lovely things as an accepted part of life.

The children grew up in the happiest of homes. Their parents were devout Christians and strict as regards behaviour and courtesies. Family prayers were said each Sunday after breakfast and meetings of the Plymouth Brethren were

attended every week. Their parents were also extremely sociable and loved entertaining. Very often the house was filled with friends from various spheres and from different parts of the Lake District, and further afield, enjoying the meals cooked by their mother who, by any standards, was an excellent cook. At these parties the children entertained the guests; Ronald was a talented pianist and Jack and Kathleen both played the violin. Although made to work hard at anything undertaken, the children had great fun; both their grandfather and mother were clever mimics, and often gave not unkind impersonations of several 'characters' in the area, causing much laughter in the home. Their parents sometimes would tell them of their ancestors, of the Masons and their wares, and grandmother would talk at length about Ruskin and of his friends, Gladstone and Disraeli, whom she had met at his home. She liked to talk of her many travels with him, particularly in Italy. They must have spent some happy times, for when grandmother's second daughter was born, Ruskin asked Kate and John Raven to call her 'Venice'. To this they agreed and Aunt Venice along with Aunt Ethel Mason, who lived with the family, helped and amused the children for many years. Grandfather was very witty and a unique violinist who could play anything by ear; he constantly entertained his grandchildren. He was also a collector of pictures and had an eye for beautiful furniture. Neither Ronald nor Jack ever knew their mother's parents, both of whom had died young before they were born, but their maternal grand-mother was a very good singer, whilst grandfather, a farmer and descended from the Mason family, was very generous, giving everything away!

All the conversations heard by the children, with evangelists, artists and the many friends from different walks of life, had a profound effect on their minds and attitudes. The writer can remember it all vividly. They were shown beautiful pictures, sometimes acquired by their parents, and used to visit the Norwegian Log Studio of the artist Alfred Heaton Cooper and his parents, which then stood opposite the village church. On growing up and being taken to London, in addition to the usual visit to Madame Tussauds they were taken to museums and art galleries; when visiting towns close to home, the antique shops were sought out and sometimes items were purchased.

Out of doors was just as happy. A tennis court was laid out in the garden where tennis parties were arranged, and in front of the house was a large field where the family played cricket and the children practised running in spiked shoes for the school Sports Day. This obviously paid dividends, for both Ronald and Kathleen won medals, Kathleen aspiring to a Gold Medal for sports, whilst Jack excelled at tennis, and Ronald at cricket; each brother retained a keen interest in these sports throughout their lives.

The family roamed the countryside, climbed the mountains with their dogs and looked down at the glorious scenery, taken for granted by the children until later in life when it was more fully appreciated. They rowed across the lake for picnics, fished in the streams, went 'nutting', blackberrying and

mushrooming; their father being something of a naturalist, the children learnt much on these excursions about birds and the habits of hares and rabbits, squirrels and wild deer. They explored for 'peacock' copper up at the old copper mines, to manage which their maternal great-grandfather had come from the tin mines in Cornwall. (The copper mines were a flourishing trade in Coniston in the late nineteenth century.) All the children were taught to skate by their father, and moonlight expeditions were made to skate on Tarn Hows, a famous beauty spot. Father died at the age of seventy-one in 1952 but their mother lived another twenty-one years to the age of nearly ninety-three.

All the children, in turn, went to Ulverston Victoria Grammar School, where many of the teachers made learning enjoyable, but at the same time exacted hard work out of the pupils. It was a long demanding day, having to travel by train, leaving home at 7.00 a.m. and returning at 6.30 p.m., with homework still to do.

Ronald, a talented pianist, was preparing himself at the age of seventeen for a career in music, having several pupils in the area at the time; but his heart's desire was to be a doctor, and at eighteen years of age he went to London, soon followed by Jack, into a different profession, and later by the entire family. Ronald trained at St Bartholomew's Hospital. In a distinguished undergraduate career he won almost every prize available, including the coveted Brackenbury Prize. He worked for and with some of the most eminent doctors of the age, loving his work, qualifying as a doctor in 1928 and becoming a fellow of the Royal College of Surgeons of England three years later at the age of twenty-seven. It is significant that, sixty years later, the 'Raven Department of Education' at the Royal College of Surgeons of England has been named in his honour for his service to the College and to mankind. The establishment of this Department has fulfilled Ronald's vision of the future, for he always looked ahead, when doctors would require constant training and teaching to equip them for all the medical and surgical technology developing at an unprecedented rate.

During those sixty years, Ronald's work for the cure and care of patients with cancer was legendary. He became one of the leading cancer surgeons in the world. He had an indefinable aura of healing, always giving hope. Being appointed Registrar in Statistics to the National Radium Commission in 1931 gave him, at an early age, a deep and lifelong interest in the disease of cancer and all that it implies. Before the Second World War he was appointed Assistant Surgeon to the Royal Cancer (now the Royal Marsden) Hospital and the Gordon (now the Westminster) Hospital and, as a fluent French speaker, to the French Hospital in London.

In 1939 the Second World War was to interrupt his career: he volunteered and saw active service in the North African and Italian Campaigns, becoming Commanding Officer in charge of 5th and later 57th General Hospitals.

Towards the end of the War he was drafted to Malta where he established the Malta Memorial District Nursing Association which still flourishes. He made many friends in Malta and, after the War, built a villa there where he and his family returned each year for many years. Ronald was mentioned in despatches, awarded the OBE (Mil.) and ended the War as a Colonel with the Territorial Decoration.

He was quickly appointed Surgeon to the Royal Marsden and the West-minster Hospitals and with diligence, intellect and meticulous care, followed his chosen path in the international field of cancer. Rehabilitation of the patient after surgery became an increasing concern to him, and the Rehabilitation Ward at the Royal Marsden Hospital is named after him. He was not just a doctor; he was one of the world's leading cancer surgeons and a renowned teacher. His vision and skills extended the frontiers of the surgeon's art. Using his many gifts as surgeon, teacher, orator and writer, he operated, consulted and taught in many of the countries of the world, and was awarded honours in countries as diverse as Colombia, India, Italy, Saudi Arabia, Egypt and Jamaica. In Greece, which he visited only a few months before his death, he was awarded the Papanicolaou Medal; he was the only surgeon outside Greece to have been so honoured.

In this country, at the Royal College of Surgeons of England, he was Erasmus Wilson, Aris and Gale Lecturer, Bradshaw Lecturer and Hunterian Professor. Ronald was a most generous and kind, gentle man with a quiet but quick sense of humour greatly appreciated by his students whom he taught at the University of London. During his professional life, no less than 400 Fellows of the Royal College of Surgeons passed through his hands. Those Fellows are now spread across the world. He also worked continuously to write on every aspect of cancer care and treatment, drawing on his wide contacts in the United Kingdom and abroad. Several of his books were trans-lated into foreign languages, including Japanese, Dutch and Russian. After considerable research, he started a private campaign against smoking many years before it was adopted as official policy. A series of books, some of them definitive standard works, testify to his dedication to his profession. The last of them which he himself saw in print, was *The Theory and Practice of Oncology*, which embodies his lifetime's work. The Professorial Chair in Clinical Oncology bearing Ronald's name was established at the Royal Free Hospital in London during his lifetime, made possible through the generosity of some of his grateful patients.

His parents' influence and his inherent love of elegant things meant that he continued to collect beautiful articles, and he recommended his students to do likewise as a therapeutic diversion. One way in which he himself relaxed was by playing the piano every day; he also loved his cars, from his Morgan at seventeen years of age, to his fast Aston Martin which he insisted on cleaning himself at the weekend when he came down to the farm at

Wingrave. There he liked to take the Collie sheep dogs, to which he was devoted, for long walks across the fields.

Ronald lived in Harley Street from 1946 until his death in 1991 and over the years he filled his five-storey house there with a rich collection of pictures, porcelain, antique furniture and other beautiful items. There, he loved to entertain friends in different spheres of work from all parts of the world. His pottery and porcelain was naturally concentrated on Mason's Ironstone and also on Derby Porcelain. His Mason collection, with that of his brother Jack, is now housed in Keele Hall. Both brothers wanted this 'family' collection to be kept together and not dispersed, and enjoyed by all interested people. The dedicated rooms at Keele University were opened by the Chancellor in October 1993 – Keele being chosen due to its proximity to Stoke, where the Masons' Factory still produces beautiful china of many designs.

Ronald's collection of Derby China is superb, and is now on view in a specially dedicated room in the Royal Crown Derby Museum, opened during his lifetime by (as she then was) HRH The Princess of Wales. Ronald bought nothing that was not perfect and, advised by John Twitchett – an authority on Derby Porcelain – his collections were thus of the highest quality.

Through his long life ran a unifying thread: brought up as a devout Christian, he retained a highly personal faith and spent many hours writing devotional works on the scriptures. He was a man of many parts; highly professional, artistic, religious, tirelessly active in charitable work, a founder of the Marie Curie Memorial Foundation which he chaired for thirty years, later becoming President; a member of Council and a Patron of the Royal College of Surgeons of England; a Master of the Worshipful Company of Barbers, later Barber Emeritus; Chairman of the Royal Medical Foundation of Epsom College for thirty-four years, later being elected President; and much more besides. He was a dedicated doctor, an accomplished musician, a lover of beautiful things, a humble Christian. The rooms at Keele are a memorial to a part, but only a part, of a very full life.

Jack shared the family's artistic talents. He loved music and played the violin and the piano. He was gifted in drawing and design, and he too inherited from his parents the desire to collect beautiful things. His ready wit and quick repartee, inherited from his father, made him great fun and a fascinating companion. He was a leader with a talent for getting people to do what he wanted and to enjoy doing it. All the children were taught to drive at the earliest possible age and later it was always Jack who drove all over Europe taking the family and friends on holiday, furthering their interest in and knowledge of the arts in their widest sense.

When Jack left Ulverston Grammar School, he nearly decided to be a teacher, having won a College bursary. Although he did not do so, he retained throughout his life a deep and abiding interest in, and concern for,

education. In fact, he went into banking, moved to London and within twenty years rose to a position of considerable importance. The war years were spent in London – amongst other things, fire-watching on the roof of the bank. Banking, however, had never been his passion as a career, and in 1948 he changed. He had the courage to become a farmer, when he acquired Manor Farm in Wingrave in Buckinghamshire, where his parents joined him.

From this point on Jack played an influential and respected role in the public life of the county and locality. For many years he served on both the Aylesbury Vale District Council and the Buckinghamshire County Council, always standing as an Independent and refusing offers to stand as a party candidate. He was Chairman of Wing Rural District Council, and served with distinction as Chairman of the Buckinghamshire County Planning Committee and as Chairman of the Aylesbury District Executive, which had the main responsibility for education in the area. For many years he chaired the governing bodies of schools in Wing and Wingrave and of Cedars School in Leighton Buzzard. He was a Foundation Governor of Aylesbury Grammar School. The Headmaster told the writer that if ever he wanted anything done, he asked Jack – and it was done. For several years he sat on the Bench as a Justice of the Peace. He was very pleased on some occasions to serve under Sir Norman Birkett (Lord Birkett) who had been at school with his father in Barrow-in-Furness. His financial training made him a popular choice as treasurer of several charities in the area. He took all this somewhat exacting work in his stride, chairing innumerable meetings, and nobody realised he was doing it, so little fuss did he make. He had an extremely busy life, but he frequently walked the fields on the farm with his dogs; the farm animals would run towards him, such was his affinity with his country friends. He was an excellent cook, even made butter and kept bees. He became President of the Buckinghamshire Bee Keepers' Association. Jack was a good horseman, riding 'Beauty' across the Buckinghamshire fields. He found time to attend sales in large houses in the area and bought many treasures. Like his brother Ronald, he was a great collector of antique furniture, of pictures and of Mason's Ironstone ware. His mother shared his home and, with their combined artistic abilities, Manor Farm and, later, Manor Lodge were joyous and beautiful homes in which to live and entertain their multitude of friends. Often Jack took his mother and other close friends on his trips abroad, driving them through France, Switzerland, Italy and Spain. He and Ronald and their mother went to Egypt every year for several years where they had many friends, and then to the villa in Malta twice a year until his mother was over ninety years of age; even then, she retained her zest for life, was always serene and still read widely. Jack was a splendid companion.

Keele University now has not only Jack's porcelain and pottery, but also a permanent memorial to his lifelong interest in education in the 'John Mason Raven' Chair in Visual Arts, made possible by a generous grant from his estate.

He was a man of integrity, a gentle and kindly man, with a sharp intellect, a keen sense of humour, a high moral sense and a great devotion to the service of his fellow men.

Proceedings for the establishment of this Department were well advanced during Ronald's and Jack's lifetime. Both took a lively interest in its planning and both were keen that I should complete the task. This has been achieved with the unstinting help of many friends; to name but a few, the former Vice-Chancellor (Professor Brian Fender), John Marshall, John Twitchett and Velma Young.

One can only express pleasure and satisfaction on Ronald's and Jack's behalf as to what has been done, and imagine the joy they would have experienced at seeing their magnificent pieces of Mason's porcelain and pottery flood-lit in such elegant and beautiful surroundings – given by them for posterity to enjoy.

RONALD WILLIAM RAVEN

Born 28 July 1904 in Coniston, in the Lake District.

Educated at Ulverston Victoria Grammar School and, later, at St Bartholomew's Hospital in London, where he won the Brackenbury and other prizes.

Qualified as a doctor in 1928.

Demonstrator in Pathology, St Bartholomew's Hospital, 1929–31.

Fellow, Royal College of Surgeons of England, 1931. (Hunterian Professor, 1948; member of Council, 1968–76; member of Court of Patrons, 1976–91.)

Registrar of Statistics, National Radium Commission, 1931–4.

Junior Hospital Appointments, 1931–5.

Assistant Surgeon, Gordon (later the Westminster) Hospital, 1935–9.

Assistant Surgeon, Royal Cancer (later the Royal Marsden) Hospital, 1939–46.

Surgeon, French Hospital, London, 1936–9.

Royal Army Medical Corps, 1941–6, serving in North Africa, Italy and Malta (where he later established the Malta Memorial District Nursing Association). He was mentioned in despatches, and returned to civilian life with the rank of Colonel.

Served 1946–52 in the Territorial Army, commanding 57 (Middlesex) General Hospital.

Appointed Officer of the Order of the British Empire (Mil.) and Officer of the Most Venerable Order of the Hospital of St John of Jerusalem, both in 1946.

Consulting Surgeon, Royal Star and Garter Home for Disabled Soldiers, Sailors and Airmen, 1948–69.

Surgeon, Royal Cancer (Marsden) Hospital, 1946–62.

Surgeon, Gordon (Westminster) Hospital, 1947–69.

Joint Lecturer in Surgery, Westminster Medical School, 1951–69.

Appointed Chevalier de la Légion d'Honneur, 1952.

Awarded Territorial Decoration, 1953.

Senior Surgeon, Royal Marsden Hospital and Institute of Cancer Research, 1962–69.

Lecturer, Royal Institute of Public Health and Hygiene, 1965–85.
Consulting Surgeon, Westminster and Royal Marsden Hospitals, 1969–91.
Elected Honorary Fellow of the Royal Society of Medicine, 1987.
Died in London, 24 October 1991.

These are the facts of Ronald Raven's medical career. Around them he wove a rich,
varied and deeply fulfilling life.

The Surgeon

He specialised in oncology and became one of the leading international cancer
surgeons. He was a pioneer in operations for cancer of the pharynx and the oesoph-
agus. His concern embraced not only the eradication of the disease but also the
rehabilitation of the patient. He was a founder member and President of the Society
of Head and Neck Oncologists (1968–71); and of the British Association of Surgical
Oncology (1973–77). He was a founder member of the Oncology Section of the
Royal Society of Medicine. He was instrumental in founding, and for over thirty
years served as Chairman and President of, the Marie Curie Memorial Foundation.
His final achievement was the establishment of a London University Chair in, and
the Department of, Clinical Oncology at the Royal Free Hospital in London. The
Department is specifically concerned with both research and patient care.

The Traveller

He travelled widely, to teach and to consult his fellow surgeons abroad. The many
countries he visited included: Colombia in 1949 (where he was Honorary Professor
at the National University); Saudi Arabia in 1961 (the first British surgeon to be
invited before diplomatic relations were established) and again in 1962, 1975 and
1976; Egypt in 1961 (where he was Visiting Professor of Surgery at the University of
Ein-Shams and to the Maadi Hospital in Cairo); the United Arab Emirates in 1975
and 1985; South Africa; Southern Rhodesia (as Zimbabwe was then called); India
(Visiting Professor at the Cancer Institute of Madras, and in hospitals in Bombay and
Delhi); Czechoslovakia; Jamaica; Greece; Italy; and Malta. The awards given to him by
overseas medical organisations are too numerous to mention.

The Writer

Ronald Raven continuously drew on his professional experience to write books for
the benefit of his fellow surgeons. During the Second World War he prepared mate-
rial on 'Shock and War Wounds' and on 'Injuries in the Field', later published in offi-
cial army manuals. Throughout his life he wrote and edited a steady stream of works
on various aspects of cancer and its treatment, the last he saw published being *The
Theory and Practice of Oncology*. *An Atlas of Oncology* was published posthumously.
These books embodied his lifetime's work. He also wrote and published a number of
books of a devotional character.

The Collector

From an early age he collected pictures, furniture and porcelain. His house in Harley Street was as much a gallery as a home and place of work. He became a Fellow of the Royal Society of Arts in 1987 and an Honorary Life Member of the Derby Porcelain International Society in 1988. His collection of Crown Derby is now on public view in a room dedicated solely to his gifts in the Museum of the Royal Crown Derby Porcelain Company. His collection of Mason's Patent Ironstone is now in Keele University. Earlier in his life he was a philatelist and was an international medallist in 1950.

Other Concerns

His work with the Marie Curie Memorial Foundation and his establishment of the Department of Oncology at the Royal Free Hospital have been mentioned above. He was also for over thirty years Chairman of the Royal Medical Foundation of Epsom College. A member of the Barber Surgeons Livery Company, he was Master in 1980–1 and later elected Barber-Emeritus. He was for many years Vice-President of John Groom's Association for the Disabled. He was throughout his life an accomplished pianist.

JOHN MASON RAVEN

Born 4 August 1906, in Coniston in the Lake District, John (always known as 'Jack') Raven was also educated at Ulverston Grammar School. His life was lived on a different canvas from that of his brother, but it was similar in several respects: his devotion to public service, his love of travel and his passion as a collector.

His first intention had been to become a teacher, and he was awarded a Bursarship to enable him to study for the teaching profession; but he was in fact deflected from this into banking, where, for over twenty years, he pursued a solid career until, at the age of forty, he was Deputy Head of the Trustee Department of the District Bank. Then, in his early forties, he made a complete change of direction. He acquired Manor Farm in Wingrave in Buckinghamshire, and in 1949 became a farmer. It was in Wingrave that he devoted much of his energies to local public service, as a Councillor on both the Buckinghamshire County Council and the Aylesbury Vale District Council. He declined to enter party politics and always stood and served as an Independent. He became Chairman of the Wing Rural District Council, and he also chaired its Housing, Planning and Finance Committees. He sat on the Bench as a Justice of Peace.

Here too his early interest in education found an outlet, as Chairman of the Aylesbury District Executive, which had the main responsibility for education in Aylesbury and district. He also served for many years as Chairman of the Governors of Wingrave School, of Cedars School in Leighton Buzzard, and of Wing Secondary Modern School. He was also a Foundation Governor of Aylesbury Grammar School. In all of these posts he worked assiduously for the schools and their welfare.

In addition to these responsibilities he also served for many years as Honorary Treasurer of the local Pratt's Charity; was the Honorary Treasurer of the Council for

Britain of the Malta Memorial District Nursing Association; and was President of the Buckinghamshire Beekeepers' Association. Throughout these years he acted as unofficial finance manager to the Raven family, particularly to his brother Ronald, taking on himself the burden of administering the family's financial affairs. Jack travelled widely, driving his car with family and friends all over Europe, visiting Malta and Egypt each year for many years and Canada and America several times. He had close friends in many countries. He often accompanied his sister to Saudi Arabia and the United Arab Emirates. He played the piano and violin but still found time to play tennis and golf, was a keen gardener and a good horseman.

Like his brother, he acquired from his parents a deep appreciation of fine porcelain, and his home in Wingrave was a treasure-house of collectors' pieces, most notably of Mason's Patent Ironstone. Some of his pieces were unique, and they, with the rest of his collection, have now found a permanent home in Keele University, along with all the Mason ware from his brother's house.

A large part of John Mason Raven's estate was devoted to helping to fund the Professorial Chair of Visual Arts named after him in Keele University.

He died on 18 December 1990.

THE MASONS AND THEIR TIMES

Professor David Vincent

As with the other great figures of the early industrial revolution, the Masons both produced and were produced by the processes of historical change. Their energy, skill and commercial acumen drove forward the processes of manufacture and marketing in a key area of the economy, yet at every point their success was conditioned by wider forces of commercial, social and political progress. The key to understanding their achievements lies in their capacity to understand the direction in which the world was travelling. They were not themselves great originators. Almost every one of the innovations of which they boasted can be attributed on closer examination to some rival or predecessor. Although they produced over the lifetime of their factories an immense volume of distinctive and attractive ware, their real talent was for taking hold of history and making sure they were first to profit from it.

The foundation of the family's success was laid by the time-honoured combination of good fortune and good marriage. Most of the leading entrepreneurs of the era did not make themselves. The capital that was invested in the early industrial processes had usually been accumulated by earlier generations who had done well in the expanding agricultural and commercial economy of the seventeenth and eighteenth centuries. The Masons came from the prosperous Yorkshire market town of Dent, where the local merchants had for long exploited the growing demand from the south for the wool from the sheep grazing in the moorlands. There was a long-standing flow of money and people between the remote corner of the West Riding and London, and there was nothing unusual in Miles being sent down to the capital to work as a clerk to his uncle who had already established himself as a stationer. The premises next door were occupied by a well-to-do glass merchant and chinaman, and gradually the bright young Yorkshireman transferred his interest to the business and the family which owned it. On the death of the head of the firm, he married the daughter, who had inherited a sum equivalent in today's values to several million pounds. As with so many others of his own and later times, his wealth was founded on wealth.

In the final quarter of the eighteenth century, large quantities of porcelain were being imported from China and other parts of the Far East. Miles Mason's new business was at the heart of the burgeoning international trade

in which Britain was an increasingly dominant force. The profits from the rapidly expanding world market flowed into the pockets of the merchants and of the lawyers and shipowners and officials who worked with them, and in turn the prosperous middle ranks of society were able to indulge a taste for fine table ware and other domestic luxuries. Britain's control of the shipping lanes was a consequence of her military and diplomatic strength. One way and another, all the wars that had been fought since the Restoration had been linked to the defence or furtherance of commercial advantage. However, military adventure was always a double-edged sword for those whose business was founded on imports. Whereas the uninterrupted flow of goods from China and Japan was a tribute to the strength of Britain's wooden walls, the increasing volume of excise duty imposed by the need to pay for the armed forces threatened the profits of all those involved in this and related luxury trades. Hard times turned to desperate times with the outbreak in 1793 of what was to be two decades of war with the French. Import duties on china were raised to prohibitive levels in 1799, and the effects of taxation were compounded by the widespread interruption of trade as the competing powers sought to destroy each other's economies. Many merchants went bankrupt or quietly retired to the country. Miles Mason did otherwise. As British armies marched away to the continent, he set off for Liverpool and the Potteries.

What is now known as vertical integration was a standard device of the period. One of the reasons why it is difficult to draw firm lines of demarcation through the eighteenth-century economy is that those seeking to make money saw no reason to confine their activities to a single sector. In the Potteries, the smaller producers often combined their manufacture with seasonal farming. The larger firms tried to control the flow of their goods from the kiln to wholesale and retail distribution, and moved back into the supply of their raw materials, especially coal. In this sense, Miles Mason's response to the difficulties caused to him by the worsening political situation was surprising only in its vigour. He turned away from the Orient and towards the two main centres of pottery production at the time, Liverpool and Stoke. The firm had always had a side interest in selling home-produced ware, and in his time of need, Miles had well-established contacts to build on. He selected partners in both places, and began to transact business as a maker as well as a distributor. By the turn of the century he had gained sufficient experience and self-confidence to go it alone.

At the same time that Miles took over his own destiny as a manufacturer, Napoleon was gaining control of France and then of most of continental Europe. Whilst the victory at Trafalgar in 1805 kept the shipping lanes open, trade with Britain's main markets across the Channel virtually ceased. Until Napoleon was finally driven back inside the borders of France, Britain was forced to become a self-sufficient economy, creating a wide opening for those capable of supplying home-produced goods which mimicked the quality and

design of those which once had come from abroad. It is likely that as it grew, the pottery industry would eventually have found a way of copying and then improving the secrets of Chinese porcelain, but the war accelerated the search for a home-made version capable of matching the quality of the ware which was now so difficult to import. Although both soft-paste and hard-paste porcelain had been produced from around the middle of the eighteenth century, their manufacture had not proved commercially successful. It was not until 1796, just as Miles Mason was setting up his business in the Potteries, that the peculiarly English version of porcelain known as bone china, which combined stability with translucence, was perfected and standardised by Josiah Spode II. Amongst the group of manufacturers in the industry trying to exploit the new developments was George Wolfe at Lane Delph (now Fenton), whom Miles selected as his initial partner when he moved into the industry. Through Wolfe, he gradually learned the new techniques, and by the turn of the century, with a decade and a half of a war economy still ahead of him, he was able to set up on his own and begin producing an imitation of the kind of ware that his wholesale firm in London used to bring in from the Far East.

The most obvious explanation for the ornate, highly patterned ware which became the hallmark of the firm was the influence of the imported china which had been the core of the London operation in its heyday. The significance of the Imari patterns of Japan was particularly apparent as the range of production grew under Miles and then his three sons, who joined the business between 1806 and 1813. However, the firm was not merely retracing its footsteps; neither was it engaged in selling some kind of heritage product. From the outset, it was operating at the leading edge of popular taste, pushing forward the boundaries of what the public wanted, and reaping the benefits of broader currents of cultural change. At the heart of the developments was a particular relationship between elite and middle-class consumption patterns. There is a temptation to see the dynamic and for a while immensely successful company as the direct successor of Wedgwood as the dominant force in the industry. Josiah Wedgwood I had died the year before Miles arrived in the Potteries, and whilst his firm continued, it was no longer the principal location of innovation in the industry. In reality, no single enterprise could replicate the range of achievements of the founding father of the modern industry, and Mason's were by no means the only company vigorously pursuing new methods of production and marketing in the decades after Josiah's death. There are, nonetheless, striking parallels between the techniques pioneered in Etruria and those followed by Miles and his sons, nowhere more obviously than in the creative response to market demand.

Wedgwoods had built their reputation by producing high-quality goods for sectors of society which once had aspired to much fewer or much cheaper objects to place on their tables or decorate their houses. As part of this strategy, Josiah had gone to great lengths to gain the patronage of royalty, both at home

and abroad. The immense dining sets made for kings and tsars were in part a means of exploiting what had always been a rich but narrow market, but more importantly they were a device for establishing what would now be termed brand identity. For an affordable sum, newly arrived merchants and lawyers could, through their purchases at the London showrooms, convince themselves and their relatives and neighbours that they had completed the journey from the ranks of the common people to the culture of the landed orders. They might not yet have achieved titles and estates, but at least they could display the taste and discrimination which marked the natural gentleman. Of all consumer products, ceramics were the most direct form of domestic display. Beds, carriages, furniture and clothes all had vital functions in conveying messages to those whom the owner wished to impress, but the plates, cups and bowls were at the very heart of formal social intercourse. Every time company was entertained, the demonstration of taste and wealth was inescapable. The order of the dining table replicated week in and week out the displays in the showrooms and the illustrations of the great royal services, which seemed to differ more in volume than in design or intrinsic quality. Wedgwood sold meanings, as well as the means to consume food and drink, and to a greater or lesser extent, so did all those who sought to build upon his achievements.

In the case of the Mason products, the initial interest in oriental patterns was well suited to an exploitation of the developing passion of the king's eldest son for Chinese and Japanese artefacts. The period of the Regency, 1810 to 1820, coincided with the completion of the work of the firm's founder, who relinquished the reigns in 1813, and the beginning of the career of the youngest and most dynamic of his sons, Charles James Mason. With the construction and furnishing of the Brighton Pavilion, the company found itself marching in step with the arbiter of elite taste. It was perfectly placed to repeat Josiah Wedgwood's achievement of moving into a mass market whilst retaining its image of a purveyor of goods to the 'nobility and gentry', the targets of Miles Mason's first sales campaigns when he had moved from wholesale to production. The trick was to combine the fact of volume with the image of rarity. As the middle classes continued to grow in numbers and wealth, the real profits were to be made in responding to their purchasing power. An auction advertisement placed by Charles James in 1828 captures something of the range and scale of the operation:

Many hundred table services of modern earthware, breakfast and tea ware, toilet and chamber sets, many hundred dozen of baking dishes, flat dishes, broth basins, soup tureens, sets of jugs, and numerous other articles. The china is of the most elegant description, and embraces a great variety of splendid dinner services, numerous dessert Services, tea, coffee, and breakfast sets, of neat and elegant patterns, ornaments of every description that

can be manufactured in china from the minutest article calculated to adorn pier table and cabinet, to the most noble, splendid, and magnificent jars some of which are near five feet high.

For their part, the middle-class purchasers needed to combine fancy with practicality. In their imaginations, they were dining with royalty, in their household accounts they were laying out money which they could ill afford to spend twice. It was important that the dinner services and breakfast sets not only looked splendid but also were as resistant as possible to chipping and breaking. The second great achievement of Mason's was to respond to the frugality as well as the self-indulgence of their customers. As elsewhere, the key advance had more to do with marketing than technology. There is much doubt whether the famous patent for ironstone china which the twenty-one-year-old Charles James Mason took out in 1813 was wholly the result of his own experiments. There were other, earlier versions of much the same formula, some still protected by patent. Furthermore it seems in reality to have contained little or no iron, and certainly was not china. But he found a name for stone earthenware which brilliantly met the need for reassurance about the durability of the product, and managed to sell it in a way that complemented rather than contradicted the message conveyed by its ornate decoration. In the early nineteenth century, iron was at the heart of techno-logical progress, and the Pennine stones were the foundations of the new factories. The term 'ironstone' integrated all that was of value in the past and the future. What was now offered was a product which might have the longevity of the old earthenware pots with the style of the fragile goods imported from the East. And whether or not they were as technically innov-ative as Josiah Wedgwood and some of their competitors, the Masons were by now more than competent potters. The new body was genuinely tough, and would take and preserve the brilliant decoration that was applied to it.

The first phase of the growth of the pottery industry had been founded on water. Canals had been critical in opening up a market to the centres of population and the seaports. The second phase was equally dependent on the expansion of transport systems. The improvement in road surfaces dramatically increased the destinations which were within a day's reach of any town or city, and in the late 1830s, the trunk railway lines began to be built. People and goods were year by year conveyed more rapidly, more cheaply and more safely, and at the same time information flowed more easily across the country. It became possible to treat the entire domestic market as one great theatre, with dramatic messages published in the columns of every provincial news-paper, and goods shipped to local venues for giant sales. There had been advertisements aplenty in the eighteenth century, and also many ingenious alternatives to selling goods across a shop counter. The opportunity which now awaited the imaginative entrepreneur was to bring together the new

techniques of mass production with the proliferating mechanisms for mass communication. The third great achievement of the Mason firm, especially under the dynamic leadership of Charles James, was to push to its very limits the possibilities of large-scale sales techniques.

Whereas the firm's founder had moved sequentially from wholesale to production, his youngest son pioneered their total integration. In town after town, enormous auctions were announced. It was implied that some unique event in the production process had made it necessary suddenly to sell large amounts of first-class ware at unrepeatably low prices. What gave apparent substance to the grandiloquent claims in the advertisements was the firm's ability to direct to a single location so great a volume of differentiated high-quality products that it really did appear as if an entire year's production was being sold off to one privileged group of customers. So well-organised was the factory, so unscrupulous was the marketing and so energetic was the distribution, that it proved possible to repeat the unrepeatable in town after town, month after month. Until questions began to be asked by *The Times*, the firm could get away with the fact that communications from a central point to peripheral locations were generally better than those between the locations. It was not easy for one participant in a one-off auction to compare notes with another. The volume of sales was staggering, with single auctions in the major cities realising sums, in today's prices, running into seven figures.

The early industrial economy was a place of endless conflict. The major achievements of the Mason firm were played out in the context of fierce competition amongst the manufacturers and between the masters and their men. During its heyday, the firm won more admirers than friends. The sales techniques, unregulated by trading standards authorities, offended both tradition and self-interest. The mass auctions threatened to bankrupt both rival consumers and the conventional wholesale trade from which the firm had sprung. In its time, the firm's leaders exposed the key contradictions of industrial progress. Their success depended on their impatience with tradition. They pursued every new idea of making and selling, and had little time for accepted wisdom about the treatment of those they employed. Two of the brothers, George Miles and Charles James, took a leading role in the campaign for the first Reform Act of 1832, and tried, unsuccessfully, to exploit the wider franchise which was called into being. At the same time they inherited money and made more. If their radical sentiments alienated their more cautious fellow manufacturers, their willingness to take on the newly formed unions in the 1830s in defence of their right to manage their factories as they wished also distanced them from the people of the Potteries. When riots broke out in 1842, Charles James's prior advocacy of better housing for the workers did not prevent his house from being a natural target of the protestors. And as enterprising but inherently unstable sales devices

began to lose their effectiveness, all the past profits could not prevent their rivals from gradually taking over their markets and their designs. In 1848, the Masons parted company from their times. Just as the political challenge of Chartism came to an end and the economy settled down to a long period of stable growth, the firm became bankrupt.

CHAPTER 3

MASON'S – A HISTORY

Gaye Blake Roberts

Miles Mason was born, according to tradition, on 4 December 1752 at West House, near Dent in north-west Yorkshire. His christening is noted in the Dent Parish Register: 'Miles, son of William Jan.ny 3rd 1753'. His father was descended from a prosperous yeoman family though it is thought that Miles might be the product of a second marriage. Little is known about his early life or education but it is possible that he attended the local grammar school before being sent to London to work as a clerk for his uncle, John Bailey, a bookbinder and Freeman of the Stationers' Company and the brother of his father's first wife, Anne Bailey of Sedburgh. In 1769 John Bailey purchased Frog Hall, Chigwell Row, Essex, which was located close by a large property, known as the Great House. This belonged to Richard Farrer, a well-established and prosperous glass merchant and china man whose business premises were at 131 Fenchurch Street. On 13 August 1782 Miles married Ruth Farrer, a sixteen-year-old heiress, and by doing so took over the management of the fortune left to her in trust by her father on his death in 1775. On 8 September 1783 Miles Mason became a Freeman of the Glass Sellers Company.

From 1784 until 1802 the name 'Miles Mason' or 'Miles Mason & Co.' appears regularly in the London directories under a variety of addresses. Miles was obviously a good businessman and was both successful and prosperous. He was also an active member of the China Club, an organisation of 'china men' who regulated and organised the business practices for their trade. The China Club was founded at the Globe Tavern and Coffee House, Fleet Street, on 19 May 1785, with Miles becoming the first Chairman, an office he held until January 1788 when he declined to serve a further term, although he continued to support the Club for many years.

During the eighteenth century the importation of large quantities of oriental porcelain into Europe, through such organisations as the East India Companies, was one of the main controlling factors in the development of the native English industry. By the end of the 1780s the trade in oriental porcelain in London was in decline, partly due to the availability of good English ceramics, from both the porcelain and pottery manufactories, and partly due to the increased import duty on the oriental ceramics. Evidence

exists that the English East India Company's direct interest in Far Eastern ceramics ceased in 1792; however, due to the large quantities already on the high seas it was not until the early months of 1795 that there was a noticeable decline in the availability of these goods. Miles Mason experienced some difficulties as a dealer, when the English East India Company decided to cease the importation of huge quantities of oriental ceramics, but he had in a small way been partially responsible for their actions. As an officer of the Glass Sellers Company, in collaboration with other dealers he had been operating, for several years, a ring in order to restrict the competition and attempt to keep the prices deliberately low.

Miles Mason, as a china and glass seller, is recorded as having at least two apprentices. In the 'Binding and Orphans Duty Register' of the Glass Sellers Company, now held at the Guildhall Library, London, it records that on 27 March 1787 'Richard Lloyd Son of John Lloyd late of Radnor in South Wales Farmer dec d. bound Apprentice to Miles Mason'. Two years later another apprentice is noted: 'George Yates Son of William Yates late of Edmonton in the County of Middlesex Esq r. dec d. was bound to Miles Mason Cit and Glass Seller for 7 years'.

When the supply of oriental porcelain began to decline in 1796 Miles Mason entered into a partnership with Thomas Wolfe and John Luckock (or Lucock) of the Islington china works, Liverpool, for the manufacture of porcelain, apparently in an attempt to ensure the continued supply of suitable wares for his London retail premises. In the same year Miles also contracted into a partnership with the wholesale pottery dealing company of James Green & Limpus, whose premises in Upper Thames Street, London, were located close to his own shop. Eventually Miles was able to successfully establish himself both as a manufacturer of pottery and porcelain and as a retailer. This proved to be an ideal arrangement because the retail premises provided him with an outlet for his own wares, from Liverpool and Staffordshire. The arrangement lasted until the death of James Green in 1802, at which time Miles gave up the wholesale company and closed his own shop in Fenchurch Street. He was able to rely on the extensive trade he had established with other retailers and by 1804 he could confidently state that his wares were sold, 'at the principal shops only'.

The information that Miles Mason manufactured porcelain in Liverpool from 1796 is gleaned from a newspaper advertisement announcing the termination of the partnership. It appeared in Williamson's *Liverpool Advertiser* and the *London Gazette* simultaneously, dated June 1800. The advert gives the names of the partners as Thomas Wolfe, a potter who would have had the practical knowledge; John Lucock, who was described as a talented modeller or trained engraver; and Mason, who undoubtedly provided the financial backing and commercial expertise. In Liverpool the company produced

porcelain of a hard-paste type decorated predominantly in underglaze blue cobalt, the majority of pieces being transfer-printed with oriental-style designs very much in keeping with their contemporaries. The reasons Miles chose Liverpool for his porcelain manufactory is unclear but he is known to have had some connections, through his marriage, with the city.

In October 1789 Thomas Wolfe had taken the lease on the Islington China Manufactory, Folly Lane, Liverpool from the widow of John Pennington, a porcelain manufacturer. This new company traded as Thomas Wolfe & Co. Their products seem to have been unmarked and it is therefore through the existence of excavated fragments from the manufacturing site at Folly Lane, Upper Islington, Liverpool that the wares have been positively identified. Wolfe also appears to have sold Staffordshire pottery at a 'Staffordshire Warehouse' initially located from 1787 in Duke Place and then from 1790 at the south-east corner of the Old Dock. It is possible that Miles Mason retained some financial interest in the retailing activity because after his formal retirement from ceramic manufacture in 1813 he moved to Liverpool, only returning to live in Stoke on Trent in 1818 on the death of Thomas Wolfe. Additional evidence of Mason's enterprise in the manufacture of porcelain in Liverpool occurs in the papers for the dissolution of the partnership, which stated in 1800 that, 'Notice is hereby given that the partnership heretofore subsisting between Thomas Wolfe, Miles Mason and John Lucock and established at Islington, Liverpool, in the County-Palatine of Lancaster, in the China Manu-factory, under the firm of Thomas Wolfe & Co. is this day dissolved by mutual consent'.

Miles Mason set up a manufactory at the Victoria Works, Lane Delph, on the southern outskirts of Stoke on Trent in 1796, where his stated aims clearly indicate that his products were to be extremely durable and strong. At Lane Delph he concentrated on porcelain production in the area he knew best, though almost certainly some earthenware and a prototype ironstone china were made experimentally. His idea was to make relatively inexpensive use-ful wares that could be brightly decorated with cheerful patterns or merely decorated in underglaze blue cobalt. It is not clear exactly how quickly Miles Mason was able to establish the porcelain manufactory in Staffordshire, after the closure of the Liverpool concern, especially as he was simultaneously in the process of closing his London retailing premises. The first documentary indication of this new enterprise occurs in a newspaper advertisement in the Morning Herald dated 15 October 1804, which is headed 'Masons' China'. It reads in part:

> Miles Mason, late of Fenchurch Street, London having been the principal purchaser of Indian porcelain, till the prohibition of that article by heavy duties, has established a manufactory at Lane Delph, near Newcastle-under-Lyme, upon the principle of the Indian and Sève china. The former

is now sold only in the principle shops in the City of London and in the Country as British Nankin. His article is warranted from the manufactory to possess superior qualities to Indian Nankin china, being more beautiful as well as more durable NB The articles are stamped on the bottom of the larger pieces to prevent imposition'.

In 1796 Miles Mason entered into a third partnership with George Wolfe (Thomas Wolfe's brother), for the manufacture of pottery. The company, known as 'Wolfe & Mason', was short-lived, terminating in the summer of 1800. The notice dissolving the partnership appeared in the *Staffordshire Advertiser* on 19 July 1800, where Miles Mason is described as a 'China Merchant' of Fenchurch Street in the City of London and George Wolfe as being of, 'Fenton Culvert (otherwise Lane Delph), Manufacturer of Earthenware'. In an invoice which now appears to have been lost, quoted by Llewellynn Jewitt in 'Ceramic Art of Great Britain', he refers to Mason's providing in 1797, 'blue dessert ware sets'; these may well have been the products of the alliance with George Wolfe.

Miles continued to operate the factory on the site at the Victoria Works certainly until 1802, and probably until 1805, when an advertisement for the leasing of the site occurs in the *Staffordshire Advertiser* for 9 November 1805:

CAPITAL POTWORKS

TO BE LET

and entered upon at Martin-mas next

All these compleat set of Potworks situate at Lane Delph in the
Staffordshire Potteries, now and for several years past occupied by
Mr Miles Mason, as a china manufactory, together with an excellent
modern sashed house and necessary out buildings, adjoining thereto . . .'.

It would appear that the factory failed to attract a tenant, as in April 1807 the works were offered by auction but still listed as, 'in the tenure and holding of Mr Miles Mason'.

After leaving the Victoria Works, Mason moved to a larger factory which became known as the Minerva Works, Fenton; it had previously been occupied by his former partner John Lucock. The relocation of his factory seems to have coincided with his increased success and rapidly expanding business. In 1806, at the same time as the move, Miles took into partnership his eldest son, William, on his coming of age. Very little is known about William's career; he was born on 27 January 1785, but no information concerning his early life seems to have survived. On the closure of the Minerva Works in Lane Delph, William became the occupant of a pottery belonging to Sampson Bagnall. This move would appear to indicate that William became an independent potter but it is unlikely that he was ever working truly on his own

as, curiously, Bagnall's works are listed as 'Miles Mason & Son' from 1812–16. It would seem likely that Miles Mason provided considerable financial support to his son during this period but after his retirement the control of the Sampson Bagnall works appears to have fallen to William's increasingly successful younger brothers.

In 1815 William Mason followed his father's original profession and entered into the china retailing business as well as maintaining his manufacturing interests in Staffordshire. His shop was located at 1 Smithy Door, Manchester. The venture does not seem to have been either particularly successful or profitable, as is shown by the surviving correspondence, from January 1815, between William Mason and the firm of Wedgwood and Byerley; they had supplied creamware to him, but he was unable to settle a relatively small debt which was ultimately paid by his father.

After Miles Mason's death in 1822 Bagnall's works was passed to the executors of Miles' estate and was ultimately taken over by Charles James and George Miles Mason from 1825, apparently without any consultation with their elder brother. Evidence of the failure of William Mason as both a retailer and manufacturer occurs in the notices which appeared in the *Pottery Mercury* for 15 and 22 November 1828, for a 'Meeting of Creditors of William Mason of Lane Delph at the Wheatsheaf Inn, Stoke'. William Mason appears to have left Staffordshire soon afterwards, becoming an auctioneer in London.

Although Miles Mason's name is usually associated with the wares of the company in the second decade of the nineteenth century, in reality it was probable that his sons George Miles Mason and Charles James Mason were managing the factories and developing the business. Miles Mason formally retired in June 1813, leaving the works to his two younger sons, who traded as 'G & C Mason'. On the death of Miles Mason in 1822, aged 70 years, a fulsome obituary appeared in the *Gentleman's Magazine* indicating his standing within the community and both the manufacturing and retail worlds. It is possible that the celebrated auction by Phillip's of London in June 1822 was occasioned by the death of Miles; the catalogue describes it as the 'Stock of China of the late Mr Mason Patentee and Manufacturer of the Ironstone China'. The factory premises inherited by George Miles and Charles James Mason were obviously on a large scale and it would appear that they were well equipped and contained a considerable quantity of stock and raw materials.

George Miles Mason was the second son, born on 9 May 1789. He was an Oxford graduate and a man of refined taste. He was to become a noted figure in Staffordshire for the introduction of an improved mail coach service which linked Staffordshire with the remainder of Britain, and he agitated for the development of railways from Birmingham and Liverpool. He also campaigned for many reforms within the ceramic industry. Almost certainly,

The Raven Mason Collection

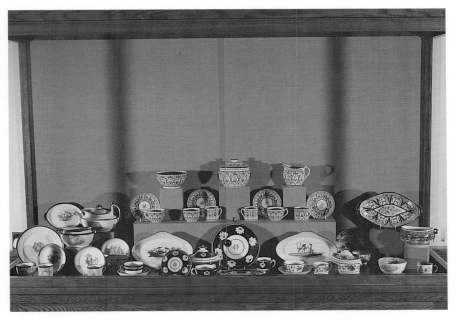

Miles Mason case PLATE A

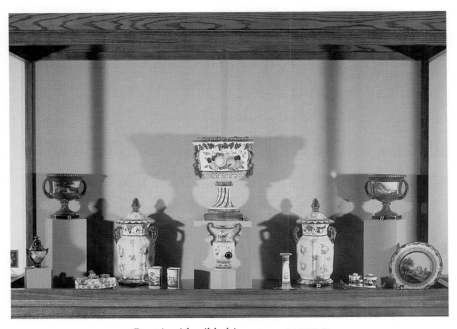

Case 1 with gilded ironstone PLATE B

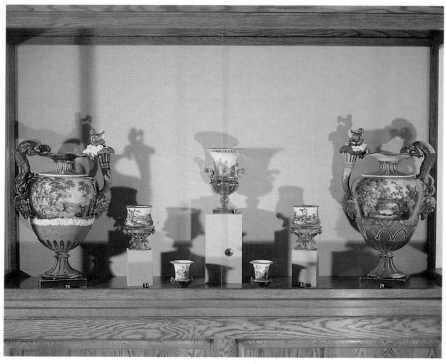

Case 2 with gilded ironstone PLATE C

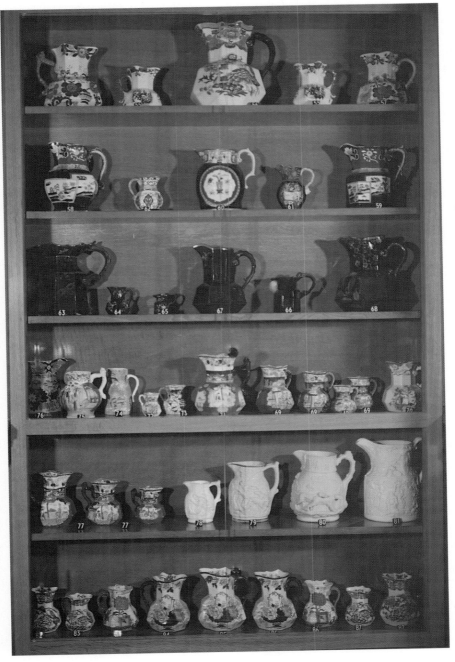

Jug case PLATE D

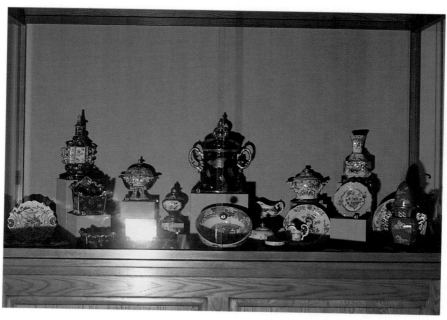

Case 3 with ironstone including mazarine blue PLATE E

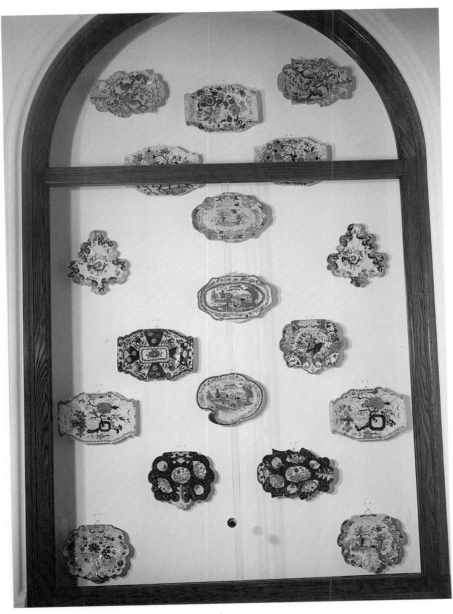

Dessert dish case PLATE F

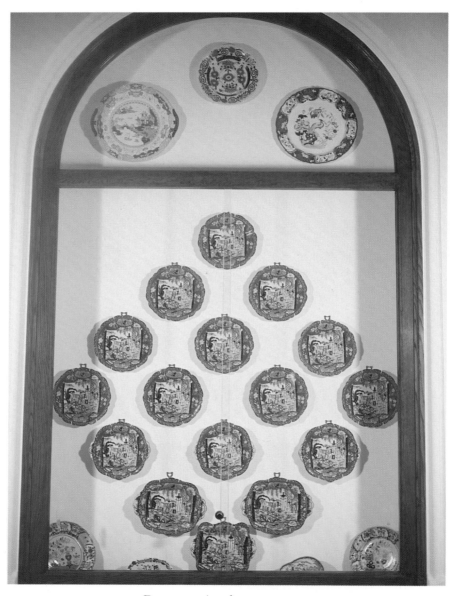

Dessert service alcove PLATE G

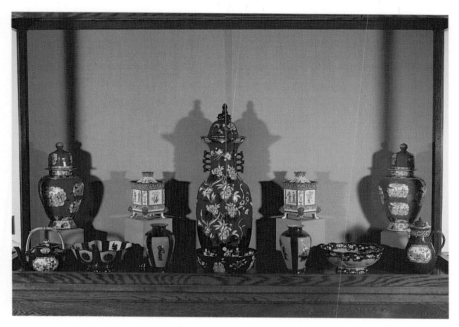

Ashworth case PLATE H

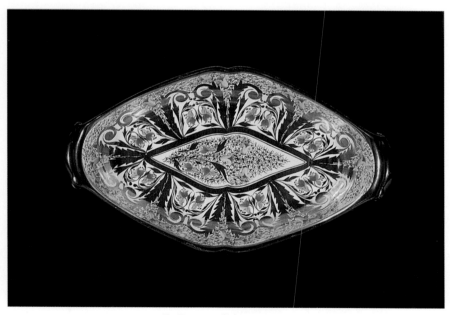

7 Dessert dish PLATE I

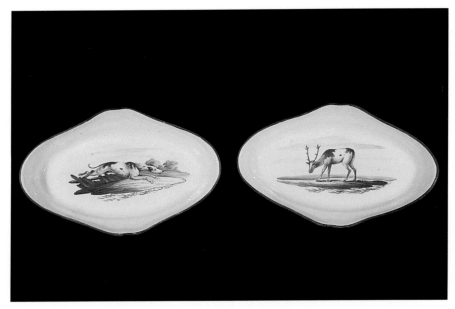

9 + 9A Dessert dishes PLATE J

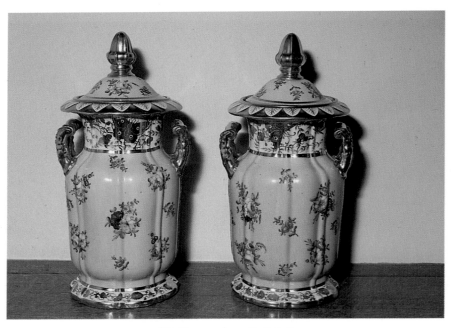

20 Essence jars PLATE K

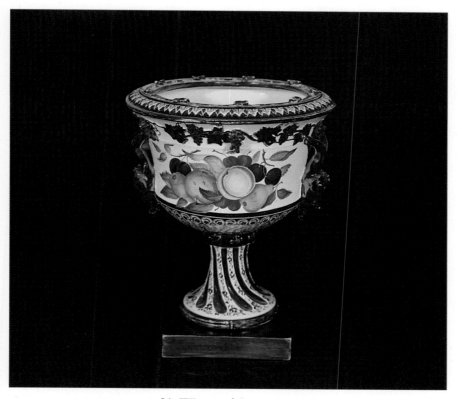

21 Wine cooler PLATE L

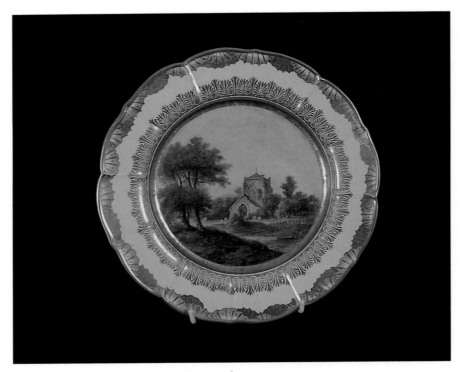

24 Dessert plate PLATE M

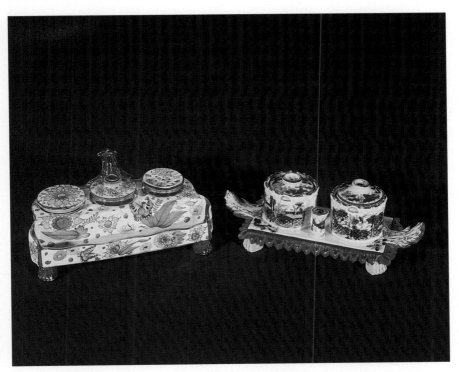

27 + 28 Inkstands PLATE N

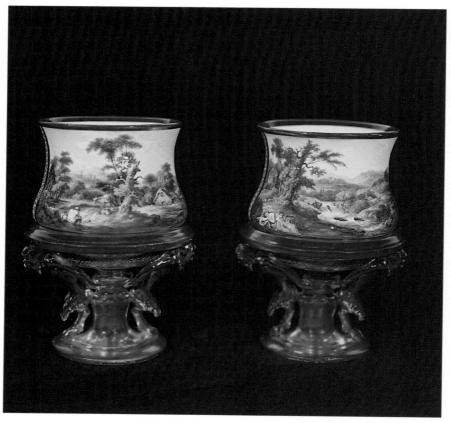

31 Pair of vases PLATE O

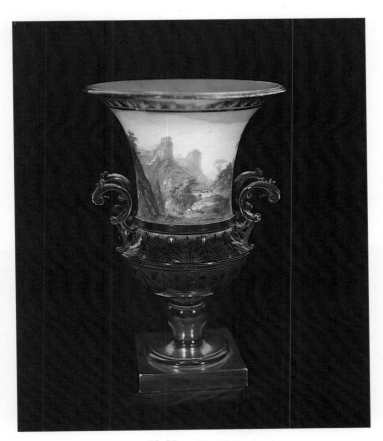

32 Vase PLATE P

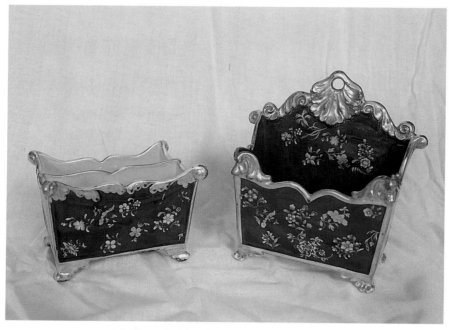

36 Paper holder **35** Letter rack PLATE Q

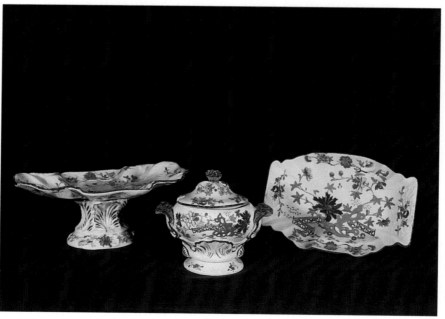

48 3 items from dessert service PLATE R

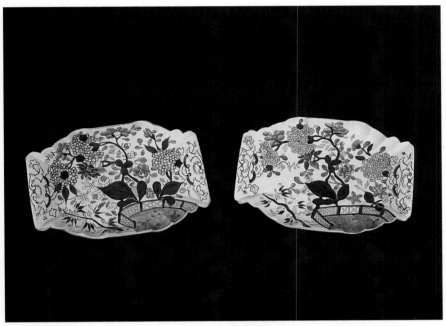

102 + 102A Dessert dishes PLATE S

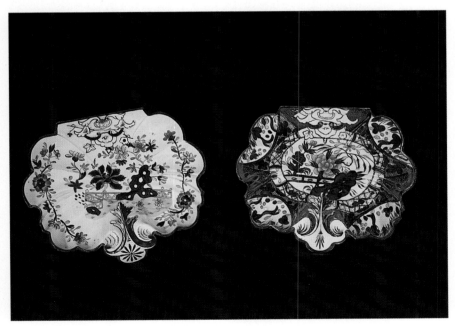

111 + 108 Dessert dishes PLATE T

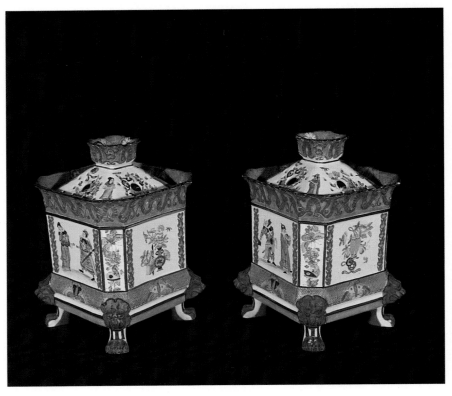

173 Pot-pourri vases PLATE U

George Miles looked after the administration of the business, often taking a prominent role in the public affairs of the ceramic industry. He married Miss Heming of Mappleton, in Derbyshire, in February 1814. The couple had four children.

Charles James Mason was the youngest child, born in London on 14 July 1791. Not much seems to have been recorded about his early life, though he certainly assisted his father in the pottery business. He married Sarah Spode, the granddaughter of Josiah Spode I, the founder of the Spode manufactory, and the daughter of Samuel Spode, a salt-glazed stoneware potter. They had two children.

Although Miles Mason was probably the driving force behind the experiments and the development of ironstone china between 1805 and 1813, it was Charles James Mason who was the signatory on the famous patent, number 3724, taken out in July 1813. The patent states that it was:

'A process for the improvement of the manufacture of English porcelain, this consisting of using the scoria or slag of ironstone pounded and ground in water with certain proportions, with flint, Cornish stone and clay, and blue oxide of Cobalt.'

The ingredients (given in the official document) on their own would not have produced a viable ceramic body and it has been suggested by various authorities that the patent was deliberately misleading so as to protect the brothers' particular variant of a heavy earthenware body which they intended to market under the title of 'Patent Ironstone China'. The patent was granted for a period of fourteen years. The new product rapidly became very popular, probably due to its cheapness rather than its strength or durability. Miles Mason was manufacturing wares for the rising middle-class market, with patterns and designs ranging from the most lavish and expensive gilded sets to simple and relatively inexpensive pieces. On 14 June 1813, the three Mason brothers entered into an agreement to purchase the premises known as the Fenton Stone Works, Lane Delph, but they were forced to wait until the expiry of the lease in 1815 before they could take possession. The factory was considerably larger than the Minerva works and the surviving illustrations on bill heads and the adopted company mark show that it was an imposing four-storey building. It was described in 1829 as having, 'the most beautiful façade of any in the district'.

When George Miles Mason retired in 1826 the firm carried on trading as 'C. J. Mason & Co.'. It is possible that the 'Co.' was added to indicate the involvement of Samuel Bayliss Faraday, who had joined the firm in the 1820s as their European representative. The period of the 1820s and 1830s was one of considerable prosperity for the Mason's Company; it was also at this time that the first indications of change within the industry began to be felt.

C. J. Mason initially seems to have understood the needs and requirements of his workpeople and to have championed improvements in working conditions and wages and pioneered some new technology.

By March 1836 Charles James had become an active member of the Potteries' Chamber of Commerce whose stated aim was to 'protect the general interests of the trade' but whose real intention was to prevent the growth and power of the Potters' Union. This change of attitude by C. J. Mason came as a surprise to his workforce and it is possible that this was one of the contributory factors when, eight years later, his home, Heron House, was attacked during the Chartist Riots in Staffordshire, causing some damage to the contents. The discontented workers called a public meeting for 12 November 1844 and printed handbills decrying the new machinery introduced by Charles James; 'for the making of all kinds of Flat Ware, which may be worked either by steam or hand power'. Charles James withdrew George Wall's patented flatware machine in December, thus calming the employees, but it could be suggested that his apparent capitulation owed more to the faulty ware produced by the machine than to a change in his desire to see various advancements within the industry. Charles James Mason did not enjoy good working relationships with his employees and he was publicly charged with the gross depression of wages. Similarly, his auction policy for selling his wares forced the prices down and consequently meant a reduction in the wages of the pottery workers.

The Fenton Stone Works were retained by Mason until 1848, although Charles James had planned to retire in August 1846. By October Messrs Daniel's had taken over Mason's Fenton manufactory, but their occupation was for a very short time because Mason was declared bankrupt in March 1847.

Between 1813 and 1848 Mason's had produced enormous quantities of their Patent Ironstone wares with the inevitable results that the market became totally saturated; similarly, the constantly re-used oriental designs had lost favour and were considered outmoded by the public. Charles James Mason was formally declared bankrupt on 17 February 1848. The immediate cause of his insolvency seems to have been the calling in of his debt, which was over £2,000. The factories and his personal possessions were offered for sale by auction and were advertised in the *Staffordshire Advertiser* in March 1848. Charles James survived the bankruptcy, possibly as a result of his brother, George Miles, coming to his financial rescue. In the Rate Books for 1849 his address is given as Mill Street, Longton.

In the official catalogue of the Great Exhibition of 1851, Charles James Mason is listed under 'Longton, Staffordshire, Designer, Manufacturer, and Patentee'. He exhibited a wide range of examples of his Ironstone China including garden seats, fish-pond bowls, large jars, and other less spectacular

domestic items. It seems probable that by the time of the Great Exhibition, Charles James had re-established himself at the Daisy Bank Works, Lane End, Longton, one of the main manufacturing areas in the Potteries. The lease for the land and Daisy Bank Works survives; made between J. E. Heathcoate Esq. and C. J.Mason, it was for the term of seven or fourteen years, from 11 November 1850. It was signed and dated 29 March 1851 but Mason's occupancy ended in 1853. It was agreed that on 2 February 1851, C. J. Mason should pay twenty pounds rent for the first quarter on this extensive factory and thereafter 140 pounds in four equal parts on the quarter days. At that time Charles James Mason employed seventy-five people of whom thirty-five were children, and it is almost certain that they were producing earthenwares, frequently heavily decorated with designs, such as 'Bandana' ware.

After little more than two years, C. J. Mason failed for a second time, partially because his wares did not bear comparison with other contemporary manufactures, and possibly due to the nature of the heavy decoration. Many of the pieces appear to have been costly to produce and it is feasible that he did not make enough everyday, 'bread and butter' pieces which could be sold in quantity, thus making full use of the capacity of the works. Charles James Mason was fifty-nine years of age when he commenced production at the Daisy Bank Works in what would appear to have been an ill-judged venture. At the sales of the goods and effects of C. J. Mason, the majority of the moulds, engravings and equipment were purchased by Francis Morley, an experienced potter of High Street, Shelton. In 1852 Charles James was married for a second time to Miss Astbury of Longton by whom he had a daughter, Annie, born in 1853. He died on 5 February 1856, having witnessed the decline and final failure of his pottery business to which he had devoted his entire life. He was buried beside his father and his first wife in 'Mr Mason's Vault' at Barlaston churchyard.

THE LATER HISTORY OF MASON'S IRONSTONE

Francis Morley initially manufactured earthenware between 1836 and 1842 in partnership with William Ridgway and William Wear, under the name Ridgway, Morley, Wear & Co., before becoming Ridgway & Morley in 1842. By 1845 Francis Morley had begun to trade under his own name, but added '& Co.' to incorporate his partnership with Samuel Astbury. This arrangement lasted until 1858 when a new partnership was formed between Morley and his son-in-law, Taylor Ashworth. With the purchase of the patterns and moulds from the Mason's factory, Morley transferred them to his pottery at Broad Street, Hanley, the current location of the Mason's manufactory. In the Paris Exhibition of 1855 Morley showed a selection of the traditional Mason's patterns for which he was awarded a first prize. By 1862 Francis Morley had

retired, passing on the Mason's printing plates and other equipment to Taylor Ashworth and his father, George Leech Ashworth.

The company traded under the name of Geo. L. Ashworth & Bros. (Ltd.) from about 1861, and although George died in 1873, it continued using the title until 1968. It is interesting to note that in the census held in April 1861 Taylor Ashworth, then only twenty-one years of age, employed 250 men and 100 women as well as fifty boys and fifty girls. Although there is no way of confirming these statistics it does provide some indication of the size of Ashworth's pottery manufactory. The *Art Journal* of 1867 included a report detailing the production, which reads: 'Messrs. Ashworth Brothers continue, to the fullest extent, the manufacture of the "Patent Ironstone China" . . . and produce all Mason's best patterns in services, etc. from the original moulds . . . These they produce in immense quantities, both for the home and foreign markets . . . '

In January 1884 Ashworth's ceased trading, not because of their ceramic manufacturing activities, but due to the failure of the company's textile mills in Rochdale, Lancashire. In December 1883 John Shaw Goddard (1857–1939), the son of a china exporter, purchased the company from George L. Ashworth and with the help of the former manager, Charles Brock, took over the running of the Broad Street Works, Hanley. In 1919 John Vivian Goddard succeeded his father. In the *Pottery Gazette* of July 1914, the firm is described as, 'a highly accredited firm of earthenware manufacturers whose productions are particularly sought after by the public of the present age'.

CHAPTER 4

MILES MASON – THE WARES

Velma Young

After the termination of the partnership with Thomas Wolfe in Liverpool, Miles Mason commenced potting on his own in Staffordshire at Lane Delph. He produced predominantly tea wares, in a grey, hybrid hard paste, not unlike that being made at the New Hall pottery.

This hybrid, hard-paste body was of excellent quality, with an equally fine glaze. It was in production until around 1805, when a type of bone china was gradually introduced. This first period, c.1800–5, saw not only a fine body being made but also imaginative and well designed shapes. It was probably not until 1802 that production at the pottery was at capacity; consequently, the first type of body is not so easily found today. However, the early patterns did carry on through the life of the factory and can be found on all the various bodies that evolved; an early pattern number on a piece does not necessarily point to an early date of production! Pieces from this first period are eagerly sought after today. The grey porcelain has a lovely smooth feel to it, the glaze sits on it so well, giving a lovely sheen; and there is a clean crispness about the piece, whether it is a simple cup or coffee can, or one of the major shapes in a service.

The introduction of a different body to the hard paste was an attempt to create a whiter body, something that all the manufacturers at that time were trying to produce. It appears to have been around 1805 that Miles Mason started experimenting with this new body, but of course we cannot be absolutely accurate as to the date. There was no longer such a grey look, but it still was not 'white'; it was not so fine either and had a tendency to dis-colour. Sometimes pieces from this middle period, when found today, are very brown indeed. Obviously it was far from perfect, and many improvements would have been made over a period. However, it was the beginning of the change to a fine bone china body, which appears to have been perfected by about 1810. The patterns in the higher numbers which are being found combine very decorative designs and excellent gilding, all on a fine, very translucent body. The problems seem to have been solved very satisfactorily in just a few years. This was important, for all other major potters were attempting to do the same. All were looking for a body which would com-pare well with the much whiter porcelain being produced on the Continent as well as that which had for so long been produced by the Chinese.

27

The first period is represented splendidly in the collection by the handsome part tea service of pattern 84 (cat. nos 4 to 4W). The grey-coloured body is shown to perfection and the sucrier and creamer shapes illustrate how well designed these early wares were; the decoration too shows what excellent decorators and gilders were employed from the very beginning to execute the fine patterns which were being created. The creamer and the sucrier are marked M. Mason, impressed, and also carry the pattern number N:84 in gilt.

Not all of the tea ware was of such fine quality. As with every manufacturer at that time 'bread and butter' services were produced; usually simple border patterns with limited use of enamel colours, often just blue and gold, or simply gold. Although cheaper to produce, with a good design and good gilding, these border patterns were still attractive, and very popular judging by the amount that can still be found today. Patterns 354 and 473 in the collection (cat. nos 5 and 6) are good examples of these. The earliest of the patterns reflect very much the style in vogue at the turn of the nineteenth century. Several 'sprig' designs were produced with pattern numbers up to the early thirties, but these were not very original and were simply taken from patterns in use at other manufactories. They were cheap to produce but were probably not produced in any great quantity. The patterns which come after are quite different, far more individualistic, and before pattern 100 is reached some very grand designs and some splendid landscape paintings appear. This mixture of simple borders, heavily gilt and exotic designs and splendid landscape painting, made up a very attractive pattern book for clients to choose from.

That type of decoration was, of course, all overglaze, but another type of decoration was being produced at the same time: printed patterns. These could be printed under the glaze which made them economic to produce and had the added advantage that colours or gilding could always be added, overglaze, to the original printed design if required. Once the copper plate was engraved it could be used over and over again for many years; in fact, many new patterns were created by simply adding a gilt border or another gilt line.

'Bat' printing was used to great effect by Miles Mason, usually in a soft grey but occasionally in a very attractive rust colour. There was quite a variety of themes used for these bat prints. Landscapes and mythical subjects were probably the most common, but some were biblical (Moses in the Bullrushes), some animals, and some taken from popular book illustrations of the day; most notably Sir Walter Scott's 'Lady of the Lake'. These bat prints are well represented in the Raven collection (cat. nos 1 to 1AS, and 2 and 2A). Because these prints are used over and over again the pattern number comes from the amount of gilding used. The least gilding to be found would be a simple gilt edge to the piece; if the gilt band was deepened, another number would be required in the pattern book; even a gilt band around the base of the item

would be considered a different pattern. Miles Mason's bat printing was of a very high standard, as fine as any being produced in the potteries at that time. It was very popular then, and is still very popular today with collectors, some of whom only collect bat printed wares. The rust colour of pattern 351 (cat. no. 1 to 1AS), which looks so stunning with added gilding, is probably the most sought after. However, occasionally the added decoration to the bat print was taken one step further; prints can be found with the design carefully over-painted in enamel colours. These are always very finely done, and often have an added coloured border to complement the pattern. Very hard to find today, these are highly treasured when they do appear; to an untrained eye these services could be mistaken for free-hand painting.

The other kind of printed ware is of the underglaze blue, 'Willow' pattern type. I suppose this must be considered the cheapest of all ware produced as it was not even necessary to add a simple gilt line, but usually this at least was done. It was very popular, and continued to be made throughout the life of the factory in all the various bodies as they were introduced. Miles Mason produced two underglaze blue and white patterns, both with an oriental design; one was his version of the popular 'Willow' pattern (called the 'Broseley Willow') and another was of Chinese pagodas and verandahs, with two Chinamen talking on a verandah and another standing in a doorway looking out (called, not surprisingly, 'Two Chinamen on a Verandah'). The earliest version of this pattern has the number 99; the highest is 789, with several versions in between. They are all created from the one printed design but have either an overglaze gilt border or gilt lines of varying degrees of thickness or position over the pattern. The Broseley Willow has a run of four patterns (nos 47–50), all with a different, elaborate border design, and later on in the pattern book, nos 241, 265 and 270 give three more. An example of pattern 241 is in the collection (cat. nos 10 to 10f). These blue and white patterns were excellently printed in a soft and attractive blue. As with the bat printing, it is the added gilding which denotes the pattern number. These gilt borders were placed rather incongruously over the blue and white pattern, but an attempt was made to use the gilding as a frame for the central design so that it was only the printed border which was obscured. Tea services in the 'Broseley Willow' pattern are known without an elaborate gilt border, just a simple gilt edge and gilt line between the printed border and central panel; although found in large quantities, no piece has yet been found with a pattern number . . . perhaps it was too simple to ever have had one!

One other printed pattern which must be mentioned is the 'Boy at the Door'. This is not printed underglaze as are the other two, but is all overglaze. The design is not an original Mason design but is taken directly from the Chinese, even to the colouring. Although it is not unique to the Mason factory, being used by many other potters (many of them unknown), it is by far the finest version to be found and the closest to the original. The design

shows a Chinese family around a table on a verandah; the boy who gives the pattern its name is peeping around the pagoda door, and is dressed in blue, as he is in the Chinese version. (In many of the non-Mason versions of this pattern the boy is in green!) The transferred outline is printed in black and then coloured in with bright enamels. It is found in very great numbers, almost always with a tea bowl and coffee cup as opposed to the more usual teacup and coffee can. Much of what is found today is in the early hard paste, but it can be found in the later bone china bodies. Perhaps the most unusual thing about this pattern is that although it is found in such large numbers we have never found a piece with a pattern number. This led the late Reginald Haggar, in his research of the factory, to suggest this was no. 1 in the Miles Mason pattern book, for the latter is something else, which has never been found. A tea bowl and saucer in this pattern is in the collection (cat. nos 8 to 8A).

The first period was the one that contained the most interesting shapes. The early teapots in the hard, grey paste were very elegant. Many different shapes were produced, all on an oval base, the most commonly found today being the 'oval drum'. This simple, basic design can be found with several variations: plain, with curved or straight spout and three different handles, all interchangeable. The body itself can be faceted, or have double and single flutes, with all the various handle combinations. This design shows off to perfection any pattern which is placed upon it. However, the most elegant were the taller and narrower teapots, with curved spouts and well balanced handles; again they can be found plain, or faceted. The third shape, not so tall but still a narrow oval with a flat collar, has an unusual square handle and an elegantly curved spout. This teapot can be plain of body or faceted but the handle and spout are always the same. The sucrier and creamer shapes echo and complement the teapots; they too are narrow and have oval bases. The sucrier and creamer of pattern 84 (cat. nos 4 to 4W) in the collection show this early, elegant style perfectly. Changes took place with the introduction of the new body; somewhere around 1805 a low, more boat-shaped teapot was being made and with it corresponding sucriers and creamers. Still with an oval base, but no longer elegant and more like those being produced by other manufacturers, it marks the end of the very unique shapes created by Miles Mason at the outset. This boat shape continued to influence all those that came after. Teapots became a little taller, but were still boat-shaped; some had a taller prow to the collar and very slight differences to the handle. Eventually a tall, broad boat shape took over, of the kind which was being made by all the major potters in the Potteries. The sucriers and creamers followed the same pattern: sucriers could have different handles, either shaped like a shepherd's crook or curling inwards as a ram's horn; creamers varied in size and occasionally had a narrower pouring spout, but the basic shapes remained. The bat

printed teapot in the collection shows the lower shape (cat. no. 1) and the sucrier (cat. no. 3) shows the shape which went with the final, large boat shape.

Tea wares were by far the main part of production during the time that Miles Mason was in control of the business, but a small amount of dessert services were also made. They seem to have been in production throughout the period but never in any great quantity. Odd items from a service turn up every now and again, but seldom a complete or part service. The shapes that have been identified are very similar to those being made by other potters, notably by the Coalport factory. The dessert dish in the collection (cat. no. 7) is typical of others which have been identified as being of Mason origin. It is decorated with the very rich and sumptuous pattern 100. The gilding is excellent and the small flowers in enamel colours create a very handsome pattern; happily it has the impressed M. MASON as well as 100 in gold; thus confirming not only that it *is* Mason but giving us the pattern number too. There would have been other dishes in the service, of varying shapes, e.g. square- and shell-shaped, as well as oval-footed centre pieces and small sauce tureens and stands complete with recumbent lions as finials to the covers. Two more dessert dishes are in the collection, perhaps not so excitingly decorated but even rarer. Both are impressed M. MASON and are again lobed and oval in shape. They are decorated with animal subjects in brown enamel, one with a greyhound, the other with a hind; the complete service would have contained the standard variety of dishes and each piece would almost certainly have been painted with a different animal subject.

Ornamental ware was certainly made, most likely in the second half of the period from about 1805 onwards. This appears to have consisted entirely of vases, from simple spills to large, and exotically decorated garnitures of three and possibly five. Around twelve different shapes, or variations of a basic shape, are known. It has taken many years of careful research to discover these, as so few are marked; only one of a garniture would carry the impressed M. MASON, and when that particular vase is lost there is only the shape and possibly the decoration to help identify it. The smaller and simpler vases are not always highly gilded and painted, but the larger, more imposing ones are. The painting on these vases is extremely fine; unfortunately, the artists never signed their work, and no record of them is in existence. All subjects were captured on these vases; landscapes, of course, and flowers and fruit, but some were decorated in bright Imari colouring, with heavily gilded handles, pedestals and rims. These could be equally as handsome and decorative as the painted pieces.

The method of marking has not made the identity of Mason ware from this period very easy. There were two distinctly different methods. The underglaze

blue and white printed patterns were treated quite differently from the over-glaze, decorated ware. The blue and white ware was marked with an under-glaze pseudo-Chinese seal in blue. Very small and square, it can sometimes, but not always, be found on all pieces in a service; the impressed M. MASON can sometimes accompany it on the major items, i.e. teapot sucrier etc., but not always. The pattern number, if there is one, will only be found on the major items, never on cups, cans or saucers. However, towards the end of the period, services in blue and white still carry the seal mark, but have the added MILES above and MASON below. The reason for this may be because several other potters began to use very similar seal marks and Mason's were anxious to not to be confused with inferior products. A seal mark may not necessarily indicate a Mason piece; shape and pattern must be taken into consideration.

The marking of the overglaze decorated ware is simple; if there is going to be a mark at all it will be on one of the major pieces, M. MASON impressed. Where it is placed is an important factor; frequently, it will be found actually on the footrim. As you can imagine, this makes it very easy to miss, especially if it is not very well impressed. Pattern numbers will be found too, on the major pieces and usually in gold. The cups, cans and saucers of these services are *never* marked, not even with a pattern number. Unfortunately, many services were not marked at all; again, the shape and design must be taken into account when trying to identify an unmarked item. An attempt to re-create the Miles Mason pattern book has been made; it took twenty years of careful research and collecting but, eventually, enough patterns were identified and could be given a pattern number, which enabled a book to be published. *Miles Mason Porcelain: A Guide to Patterns and Shapes*, by Deborah S. Skinner and Velma Young, was published by the City of Stoke-on-Trent Museum and Art Gallery in 1992. This book not only shows the tremendous variety of pat-terns, it gives all the shapes throughout the Miles period. There are many other patterns identified, but they still do not have a pattern number. If only Mason's had been more methodical with their markings in this period (1800–13), it would all have been a lot easier! However, by the enormous amount that has been identified over the years, it proves that Miles Mason was extremely successful in a short period of time.

G. M. & C. J. MASON AND BEYOND –
THE WARES

Velma Young

In July 1813 Charles James Mason, Miles Mason's youngest son, took out his patent for making Ironstone China. Mason's were not the first to make a stone china however; John and William Turner took out a patent for 'Making Porcelain and Earthenware' in 1800, which was in fact a type of stone ware. Pieces made in this medium by them bear the painted mark, 'TURNER'S PATENT' or the impressed 'TURNER'. This ware may not have been very successful, for John and William Turner went bankrupt in 1806; what happened to their patent is not clear today. It is quite possible that it was acquired by Miles Mason, but all records of patent transfer at the Patent Office pre-1911 have been destroyed.

Miles Mason did make a very small amount of stoneware. Items of dinner ware in this body have been found, decorated with an underglaze blue printed Broseley Willow design and marked with the underglaze seal mark with MILES above and MASON below, or the impressed M. MASON; it is extremely rare and hard to find today. When found it is always in a good, strong body and well potted.

Six months before the Turner patent expired in 1814, Charles James took out his own patent for making 'English Porcelain' in July 1813. This would of course protected a valuable asset if Miles Mason had indeed acquired the Turner Patent which now seems probable. Although the patent was in the name of Charles James, Miles Mason is the most likely person to have improved the original formula for stone china and brought it to perfection as the Ironstone China we know today.

With the granting of the patent, Miles Mason retired and the business was continued in the name of his two younger sons, George Miles and Charles James. The type of ware produced changed too; previously the emphasis had been on tea ware, now it concentrated on large dinner and dessert services and all the varied range of useful and ornamental ware to which the ironstone body was so eminently suitable.

It appears to have been an instant success. The name given to this new body must have caught the imagination of the buying public immediately and could have had much to do with its success.

PATENT; suggesting something very new and different.

IRONSTONE: giving the impression of strength and durability.

CHINA: to suggest the delicate decoration and richness of the porcelain services which had been made previously.

The patterns and shapes changed too. The delicate design of the 1800–13 period, which had been produced for tea ware, would not have been suitable for the stronger and heavier ironstone dinner ware. The new patterns were mainly oriental in design, although some with a more European feel to them were produced. The patterns were exotic, exuberant and full of energy; when accompanied by gilding they look extremely rich.

It was the early first period of ironstone production which produced the finest services and ornamental ware, between 1813–30. Finely painted ware, painted by very fine artists, can be found, table as well as ornamental. The shapes which made up these services were equally as interesting and unique as the patterns which decorated them. Very many different shapes of dishes, tureens comports etc., were offered. The large wall display of dessert dishes show these exotic shapes and patterns to perfection. The illustration (cat. no. 39) shows one form of sauce tureen with a divided foot; this feature was carried through to the large comports or centre pieces too, and the pineapple knop on the cover is frequently found on both useful and ornamental ware.

The output of ironstone was enormous from the very beginning. Even so, some bone china continued to be made; unfortunately this was not marked, so it is only fairly recently that much of it has been recognised. Fortunately some of the shapes were made in both bone china and ironstone; the ironstone services were marked and this has enabled us to identify an important group of ware which for a long time had been unidentified. This is the group known as the 'Cabbage Leaf' moulded dessert ware (cat. nos 43, 44, and 45). These dessert services were made in a very wide range of qualities; some were very simply and cheaply decorated but others are truly sumptuous. The bone china group of wares includes the finest of these services. These were frequently decorated with painted floral sprays and various degrees of gilding; more important examples can be found with botanical specimens taken from *Curtis's Botanical Magazine*, . . . birds taken from E. H. Donovan's *Birds of Britain* . . . and animals from Bewick's *History of Quadrupeds*, all named on the reverse. These were some of the most important dessert services made at this time. This moulding is unique to Mason's and once more demonstrates their imaginative eye for design. Strangely, the ironstone services were marked differently from the mainstream of table ware, with a little-used impressed coat of arms, which happily for us had the word 'PATENT' across it; no pattern numbers appeared on the ironstone china items, but they did on the bone china.

Moulding played a big part in Mason design. The 'Tête-à-Tête' set (cat. no. 49) has very fine, 'Osier' moulding and shows rare shapes of tea ware in

ironstone. Almost all the various types of table services have the exuberant shapes and crisp moulding as well; handles of platters, dishes, tureens etc. are never plain, but always crisply decorative, giving that extra energy to any item.

Jugs and mugs are what most people associate with Mason's. The 'Hydra' and 'Fenton' shapes of jug (cat, nos 64 and 65), have been made throughout the life of the factory and are as popular today as they were in 1813. These two particular shapes have been made in all sizes, from very miniature through to very large indeed. They can be very inexpensively decorated in Imari designs, through to highly decorated and richly gilded; the latter are more ornamental than useful. The large wall display of jugs shows quite clearly the vast range produced and which are from all periods. One particular shape (cat. no. 60) is from the slightly later period c.1840–5, but is a particularly pleasing shape and very decorative.

The display of jugs shows to perfection another facet of Mason production. The 'Mazarine Blue' ware (cat. no. 63). This deep blue glaze, when decorated with added gilding and/or enamel painting, usually small floral sprays or insects, is very rich indeed. Some other potters did similar ware but not to the extent of Mason's. Mason's produced this type of ware in enormous quantities and of excellent quality; it was obviously extremely popular, judging by the very large amount which can still be found today. It was occasionally used for table ware, but the decorative and ornamental market was its main target. This is shown by the large and impressive Mitre Jar and Cover (cat. no. 53). It shows all aspects of Mason production: the deep blue glaze, rich gilding, elaborate moulding, extravagant handles and knop to the cover, altogether an impressive piece. Almost all items of a decorative or semi-useful nature are to be found in this blue ware; card racks and inkstands, for instance, were probably more for ornamental than practical use.

In this first period the truly magnificent items of ornamental ware were made. The two large and impressive 'Neapolitan Ewers' are quite a *tour de force* of potting, elaborate in every sense of the word. These particular ewer shapes are almost certainly unique to Mason's, and the two in the collection are thought to have been painted by Samuel Bourne. The gilding from this period is always exceptionally good and often used in abundance, adding greatly to the magnificence of these pieces. Other vases, although smaller, are equally impressive (cat. no. 22); again the painter could be Samuel Bourne. The display cases which hold these ornamental vases with the uniquely Mason shapes, show the superb quality of the landscape and floral painting, the fine gilding and moulding of Mason's ironstone at its finest. Samuel Bourne is the artist whose name is usually associated with the very best of this early period's products; in fact, he is the only artist we can name out of the many who must have worked at the Mason factory. Nothing was ever signed by the artists who painted either ornamental ware or the finest of the table services. However, one particularly well-painted dessert service, decorated with named views on

the reverse and impressed with the Mason mark, was sold originally in 1822 by Phillip's, the London auctioneers, during the sale of stock of the 'Late Mr. Mason'. The catalogue of the sale states quite clearly that the service was painted by Samuel Bourne. Luckily, the family which purchased the service originally at auction kept the receipt; thus, when part of this service was sold some years ago, the artist was authenticated. A plate from this service is now in the Raven collection (cat. no. 24).

The period from 1813–30 certainly produced the very best ware in every respect. It included the finest vases, services and ornamental ware; excellent gilding enhanced the patterns; and the shapes were always imaginative. However, towards the end of the 1820s the elder of the two partners, George Miles Mason, retired. This seems to have been rather a watershed in the fortunes of the factory: the emphasis moves far more towards the mass market; the important and costly vases and services painted by very fine artists are replaced by far more modest wares; the shapes are no longer so interesting, and in fact differ little from those being made by many other potters of the time. Certain patterns did continue in use, particularly the chinoiserie designs which had always been so popular: 'Table and Flower Pot' (cat. no. 39); 'Mandarin' (cat. no. 47); 'Mogul' (cat. no. 106). New patterns were introduced and obviously became very popular, notably the 'Double Landscape' (cat. nos 58 and 59). This pattern lent itself to different 'finishes': it can be found with a yellow ochre replacing the gilding on some items, both table ware and ornamental; this would of course considerably alter the cost of production. Some incomplete pattern books survive from this period and from these we can tell that the use of these different finishes was common practice, thus making many patterns from one! A popular finish appears to have been a soft apricot lustre to edge the plates in a service, in place of gilding or yellow ochre.

The most important new type of ware to be introduced in the late 1830s–early 1840s was 'Bandana' ware. Bandana refers to the type of decoration and was used exclusively on ornamental ware and jugs of all shapes and sizes, in earthenware. The bandana patterns are elaborate and very rich in colour, with mythical beasts writhing and curling around the piece interspersed with other wheel and flower motifs. The most expensive of the items would have the enamel colours laid on a gold background; if the vase or pot-pourri had a cover the finial would usually be fully gilded to complement the gold background of the pattern. In this instance the shapes are exciting and once more seem to be unique to Mason's. Large garnitures of vases in Bandana ware are not uncommon, but the range of quality was large too, and the jugs and mugs decorated in this type of ware very often have all the colour but none of the gilding, to enhance the piece. A typical shape and pattern can be seen in the wall display of jugs (cat. no. 74).

Throughout these periods bone china tea ware continued to be made. The

shapes and patterns followed very much what other potters were producing at that time. Some of the designs for tea ware are very pretty indeed, and rather un-Mason like. They are very seldom marked and it has been a hard struggle to identify much of what must have been a large part of the factory output. A small amount of earthenware, which was called 'Cambrian Argil' using Welsh clay, was being produced around the mid-1820s, but seems to have been discontinued by 1830. The patterns and shapes for this ware followed closely those used for the ironstone body. A few pieces of ware in bone china with the name 'Felt Spar' are known and this appears to have been in response to the successful FELDSPAR body marketed by Spode and Coalport; but very little of it was made, with only a few items having emerged over the years. 'Fenton Stone Ware', another earthenware body in spite of its name, also started in the 1820s and seems to have been used for the lower end of the market.

The ironstone body was such a strong and durable medium it was used for the most amazing pieces; you could have your fireplaces made in it, large hall vases, four-foot-high garden seats, even your bed posts! It was one of the great success stories of the early nineteenth century. Sadly, by 1848, fashions had changed and perhaps Mason's had not changed with them; the retirement of George Miles towards the end of the 1820s may have had a bearing on it for this allowed Charles James to take the course of tailoring his output towards the mass market, leaving the finer, superbly painted ware behind. Certainly the quality of the second period was not that of before, and by 1848 Charles James Mason was declared bankrupt.

THE DAISY BANK WORKS

After the bankruptcy of 1848 Charles James Mason attempted a comeback in 1851 at the 'Daisy Bank Works', Longton. Items made by him during this period often carry the name given to a specific type of ware, i.e. 'Bronzed Metallic', 'Bandana Ware', as well as a reference to the earlier 'Patent Ironstone China'. The large 'Fenton Stone Works', the moulds, patterns, and the right to the famous Patent had all been sold to meet his debts, so new trademarks were necessary and these are very different from the original family trading designs. This second venture at the 'Daisy Bank Works' was not successful and closed in 1853.

FRANCIS MORLEY 1848–58

After the Mason bankruptcy the moulds and designs were acquired by Francis Morley along with the names and trademarks; the business was then transferred to the factory in Broad Street, Shelton (now Hanley). Francis Morley continued to produce much the same type of ware as Mason's, using some of

their own designs as well as continuing to use the most popular of the Mason patterns. They also continued to use the Mason trademark with the addition of the name 'Morley' below, as well as their own trademarks which had been in use for some years.

Excellent quality stoneware was produced during this period, for Francis Morley was already an experienced potter by the time he acquired the Mason family business. He was also well connected to other successful potters of the day . . . he married the daughter of William Ridgway.

MORLEY & ASHWORTH 1858–61

In 1858 Francis Morley went into partnership with Taylor Ashworth. This partnership continued to make the same type of ware using the same patterns and shapes. Trademarks of this period show the two names of the partners very clearly. This partnership enabled the Mason name, the moulds and designs to carry through to the Ashworth period which used them extensively through to the present day.

GEO. L. ASHWORTH & BROS. (LTD.) 1861–1968

The Morley & Ashworth partnership ended in 1861 and this became the start of the very successful business, Geo. L. Ashworth & Bros. (Ltd.). They went on to produce enormous quantities of ironstone as well as earthenware. The quality of their wares was very good; indeed some table services and also ornamental items can be very sumptuous with much gilding of high quality. They also continued to use the old Mason marks, sometimes with their own name added but not always, and this can cause confusion. The popular patterns which had continued to be used through succeeding partnerships were still used; some of the older Mason patterns were reintroduced and this again can be confusing. These famous patterns and shapes are still being used to this day, although not now in ironstone but in a lighter earthenware body. Great care should be taken when dating items in these familiar patterns and shapes; it may say 'Mason's ironstone' in the mark on the reverse, but that is the trademark; if it is modern, or light in weight, it will be an earthenware body.

In 1968 the company reverted to using the name 'Mason's' once again and became 'Mason's Ironstone China Ltd.'. The name 'Mason's' had to some extent been in constant use ever since the bankruptcy by succeeding owners and partners. It is a name known the world over and the famous octagonal jugs have never stopped being produced since they were introduced in 1813. Many of the early patterns introduced by Charles James are still popular today. The name 'Mason's' is synonymous with bold, Imari and oriental patterns, as well as mugs and jugs; in fact, many people still believe it is the only type of ware they ever produced!

MASON'S FACTORY RECORDS

Gaye Blake Roberts

Sadly, no factory records appear to have survived from the Miles Mason period of factory production in Staffordshire. The few existing factory records of C. J. Mason's are fragments of working pattern books from which, unfortunately, it is not possible to ascertain when or for what purpose they were formulated whether they were a master pattern book or a duplicate book for the use of an agent or for general factory use. Similarly, it is not possible to ascertain whether they are the actual originals or a slightly later replacement book, and when the patterns were entered. Two individual sheets, watermarked 1821, appear to be the sole survivors of a dismembered book no longer in existence; however, three part-pattern books survive from the 1830s.

'Book One', watermarked 1834, is a tall narrow volume which contains some tea ware and a few ornamental designs as well as specimen mugs and cups, miniatures and a few toilet and dinner wares, with numbers that range between 1 and 824. A few of the early numbers are prefixed or suffixed with the letter 'A', but the sequence is not complete and in some instances the number is quoted without a drawing or even a description. Against some entries there are the occasional comments which can help to date the entries. For example, against 597 is the notation: 'Tea pattern Mr Faraday has the cup and saucer'. Samuel Bayliss Faraday was C. J. Mason's partner, continental traveller and auctioneer, who died in 1844. The book was obviously used for a number of years, as patterns 665 and 666 illustrate an engraving of a boat surrounded with marine trophies with the ship's name left blank. It has been suggested that these were prepared in advance of the launching of *Britannia* in 1841. Similarly, the names for two of the colours, 'Coronation' and 'Victoria Green', would suggest a date of introduction at about the time of Queen Victoria's coronation in 1838.

On one of the blank pages in this first volume is 'C. J. M. & Co.', written in what was originally black ink. Amongst the few actual pattern names recorded are 'New Chintz' (408–9), 'Hysan Japan' (A240), 'Dresden Birds' (361) and 'Old Green Bamboo Border', possibly an earlier name originally given during Miles's proprietorship. Not all the designs were original to the Mason's factory: names such as 'Ridgeways Rich' (A77) would suggest a degree of plagiarism, whilst others owed their inspiration to the Orient, both

China and Japan, such as 101A, which is a version of the well-known 'Tobacco Leaf' design, and 'New Japan' (126), 'Old Japan' (127), 'Compartments' (228), 'Peking' (303), 'Rich Japan' (648) and 'Leaf Japan' (745). The enduring 'Grasshopper' or 'Indian Grasshopper' pattern appears on tea ware under the number 104A.

It is interesting to note that the earlier bat printed designs of Miles Mason's porcelain are re-introduced or more probably re-entered into the pattern book. These include 'Shells', under pattern numbers 582, 687 and 689, and 'Trophies' as design numbers 577 and 676, whilst 'Baskets of Flowers' is noted as 624 and the well-known print 'Dresden Sheep' occurs as pattern 464. The classical ruins subjects which are generally referred to as pattern 351 on Miles Mason porcelains are included in this range as number 599.

'Book Two' contains numbers in the range 1008 through 1910½. It could well have been commenced simultaneously with 'Book One' and probably dates from the years 1832–4. The use of fractional pattern numbers was utilised when a variation to the basic design was implemented. The patterns included in this volume are all for dinner wares. The majority of the designs included in this second book are those generally referred to as Mason's 'Japan' patterns, which occur in a wide variety of colours. A few individual pattern names are recorded, including: 'Old Rock' (1049), 'New Rock' (1050), 'Red Breast Japan' (1177–1780), 'Shield Japan' (1190–3), 'Rush Japan' (1181–4), 'Flower Pot' (1252), 'Muscove Duck' (1220–3), 'Black Seaweed Leaf' (1169–72), 'Printed Blue Hawthorn' (1210–14) and 'Blue Hawthorn Japan' (1230–3), and 'Bamboo Blue' (1342–5), amongst others. New patterns were often created by introducing variations of colour, different edging or gilding to the basic design, which accounts for the various entries for Bamboo and Hawthorn, in several guises, and the numerous recorded versions of the pattern 'Peking'.

'Book Three' includes designs from the pattern range 1911 to 3355. The book is watermarked for the year 1839 and inside the front cover is the inscription 'November XXV −1838−'. Further pattern names are recorded, including, 'Shawl Japan', 'Wreath and Twist', 'Bottle Japan' and 'Canton California'. An unillustrated entry records 'Sherwin Sprigs', possibly named after John Sherwin, the designer and drawing master for the company at that time, but no conclusive proof exists to substantiate this piece of factory tradition.

Other surviving documents relating to the C. J. Mason period include a Crest and Badge Book, used to note armorial or specially commissioned wares for institutions and other buildings such as hotels, shipping companies, regiments and canteens which were often ordered through specific importers. There is no watermark on the paper though it would appear to date from 1842 until 1861 and bears the inscription 'This book was in succession the property of Ridgway and Morley; Ridgway, Morley, Weir and Company and

Francis Morley and Company'. Within the book are representations of the various marks employed by the firms such as 'Stone Ware', 'Improved Granite China', 'Real Stone China' and 'Royal Stone China'.

In the Wedgwood archives there are some letters and accounts which date from 1810 through 1816 and refer to Miles Mason, William Mason and G. & C. Mason and concern the production of matchings and the purchase of china clay. On 27 February 1810, Miles wrote from Lane Delph: 'We have received the pattern you mention in your letter, & have to inform you the Coffees will be charg'd £1 11 0 Net, Money – in consequence of its being Model'd & painted. The Caudil cup will be about 15/–'. Another letter which seems to be about a similar transaction, dated 6 December 1810 from Lane Delph, is signed by J. Marshall on behalf of 'M. Mason & Son'. It reads: 'The price we have charged you for the Table service is *nett* subject to *no* Disc.t we have no retail price, nor do we ever allow any discount on Table China, you are charged the same price as all our Customers.' The accounts of Wedgwood and Byerley indicate that after William Mason became an independent retailer in Manchester in 1815 he was purchasing Queen's ware for his shop. On 19 January 1815, he requests from Manchester a long list of ware to which he adds: 'Shall be greatly obliged to you if you will please to forward to Mr Mason's W[are]house the Closed order will thank you to send all or pert of the or[der] next Tuesday's boats as thease goods we are in particular want of.'

Of the later surviving documents, one of the most interesting is a small volume which is inscribed on the cover 'Prices of Workmanship. R&M. F. Morley' and on the inside 'Fras. Morley'. The book contains various notes about the costs of production and the costs incurred within the ceramic industry; for example, it details the respective wages of packers and warehouse men. The book probably dates from about 1850.

The later years of the company history are well covered in the surviving pattern books of George L. Ashworth, which are very nearly complete. Forty-seven pattern books survive, the earliest covering the period of approximately 1862 to 1872 with the pattern numbers 9960 through to 9999. The latest book in that run is dated 4 July 1936 and contains the patterns C.4458 to C.4854. Today the same tradition is maintained of keeping detailed records of the patterns manufactured for future reference.

Note: The quotations have been left with their original spelling. The documents are quoted by kind permission of the Trustees of the Wedgwood Museum, Barlaston, Staffordshire.

CHAPTER 7

MASON'S CHRONOLOGY

1752 *December* Birth of Miles Mason in Yorkshire.
1760s Miles Mason moves to London, possibly as apprentice to his uncle, John Bailey.
1775 Death of Richard Farrer, china dealer of Fenchurch Street, London, leaving a fortune of £30,000 to his daughter, Ruth.
1782 Miles Mason marries Ruth Farrer, and takes control of Richard Farrer's china retailing business.
1783 Birth of Miles and Ruth Mason's first child, Ann Ruth.
1783 *September* Miles Mason becomes a Freeman of the Glass Sellers Company.
1785 *January 27* Miles and Ruth Mason's first son, William, is born.
1789 *May 9* Their second son, George Miles, is born.
1791 *July 16* Their third son, Charles James, is born.
1796 Miles Mason enters into a porcelain-making partnership with Thomas Wolfe and John Lucock at the Islington Pottery, Liverpool (known as Thomas Wolfe & Co.).
 He engages in a wholesale pottery-retailing partnership with James Green & Limpus in London.
1796–1800 Miles Mason enters into a partnership with George Wolfe to manufacture pottery at the Victoria Pottery, Lane Delph, Staffordshire.
1800–6 Miles Mason continues production alone at the Victoria Pottery, Lane Delph.
c.1802 Miles Mason gives up his interests in the retail premises at Fenchurch Street, London.
1806–13 Miles Mason takes over the larger Minerva Works, Lane Delph, Staffordshire. William Mason, his eldest son, becomes a partner.
1808 *January 12* William Mason marries Susannah Heming of Mapleton, Derbyshire.
1811 Miles and William Mason take over Sampson Bagnall's Works, Lane Delph, Staffordshire.
1813 *June* Miles officially retires from ceramic manufacturing and moves to Liverpool.
1813 Charles James Mason takes out a patent on ironstone china for 'making English porcelain'.
 Mason's purchase the Fenton Stone Works, High Street, Lane Delph, Staffordshire.
1813–16 George Miles and Charles James Mason take control of the Minerva Works.

1814 *February* George Miles Mason marries Eliza Heming, sister of William's wife, Susannah.

1815 *August* Charles James Mason marries Sarah Spode.

1815 William Mason has opened a pottery retailing business at 1 Smithy Door, Manchester.

1822 *April 26* Miles Mason dies, and is buried at Barlaston, Staffordshire.

c.1822–4 William Mason listed in the Rate Books as the tenant of a pottery at Fenton Culvert.

c.1824 Samuel Bayliss Faraday is employed as Mason's sales manager and foreign traveller.

1826 George Miles Mason retires. The firm continues trading as C. Mason & Co.

1834 Death of Ruth, wife of Miles Mason. She is buried at Norbury, Derbyshire.

1836 Charles James Mason becomes an active member of the Potteries' Chamber of Commerce.

1840 Samuel Bayliss Faraday is made a partner in the Mason's business.

1844 Chartist riots in Staffordshire.

1844 Death of Samuel Bayliss Faraday.

1848 Charles James Mason is declared bankrupt.
Francis Morley buys the Mason's patterns and shapes and removes them to the Broad Street Works, Hanley, Staffordshire (present site of Mason's Ironstone factory).

1850–8 Firm trades as Francis Morley & Co.

c.1851–3 Charles James Mason enters into a second pottery manufacturing venture at the Daisy Bank Works, Lane End, Longton, Staffordshire.

1852 Charles James marries for the second time, to Miss Astbury of Longton.

1853 Charles James is forced to sell the factory for a second time.

1856 Death of Charles James Mason. He is buried at Norbury, Derbyshire.

1858 Francis Morley forms a partnership with his son-in-law, Taylor Ashworth, trading as Morley & Ashworth.

c.1862 Death of William Mason.

1862 Francis Morley retires from the business, passing the effects to Taylor Ashworth.

c.1861–1968 The company commences trading as Geo. L. Ashworth & Bros Ltd.

1883 *December* Ashworth's is purchased by John Shaw Goddard, son of a china exporter.

1884 *January* Ashworth's becomes a limited company.

1919 John Vivian Goddard succeeds his father.

1968 *March* The firm changes its name to Mason's Ironstone China Ltd.

1973 *April* Mason's join the Wedgwood Group and are renamed Mason's Ironstone.

CHRONOLOGY OF WORLD EVENTS

1752 Britain adopts Gregorian Calendar.

1756 Outbreak of the Seven Years War – England allies with Prussia against France and Austria.

1758 Halley's Comet.

1760 George III accedes to throne of Britain.

1762 Catherine II becomes Empress of Russia.

1763 Peace of Paris ends Seven Years War. Augustus the Strong, Elector of Saxony and King of Poland, dies. James Boswell meets Dr Johnson (16 May).

1765 Britain passes the Stamp Act devised by Grenville for taxing the American colonies (repealed one year later).

1767 Christie's of London founded. John Quincy Adams b. (d.1848).

1769 Richard Arkwright invents the `Spinning Jenny´. Robert Adam and his brothers build the Adelphi, London. Napoleon b. (d.1827).

1770 Lord North becomes Prime Minister. James Cook discovers Botany Bay (28 April). Thomas Gainsborough paints *The Blue Boy*. Beethoven b. (d. 1827).

1773 T. F. Pritchard, with Abraham Darby, builds first cast-iron bridge over the River Severn, near Coalbrookdale, Shropshire.

1774 Priestley discovers oxygen.

1775 19 April American War of Independence opens with defeat for the British at Lexington and Concord. George Washington appointed commander-in-chief of American forces. Sarah Siddon's debut at Drury Lane Theatre, London.

1782 Royal Irish Academy founded.

1783 Peace of Versaille. Britain recognises independence of USA.

1787 Edmund Burke impeaches Warren Hastings (10 May). W. A. Mozart composes *Don Giovanni*.

1788 Parliament moves to abolish slave trade. John Walter founds *The Times* newspaper. Lord Byron b. (d. 1824). Thomas Gainsborough dies, aged 61 years.

1789 Parliament introduces Regency Bill due to 'madness' of George III. William Blake publishes *Songs of Innocence*. French Revolution: sacking of Bastille (14 July).

1791 Ordnance Survey established in Britain. Boswell's *Life of Johnson* published. *The Observer* newspaper founded. Washington, DC is laid out. W. A. Mozart dies, aged 35 years.

1793 Louis XVI and Marie Antoinette are executed together with the Duke of Orléans, Phillippe Égalité. The Louvre, Paris, becomes a National Art Gallery.

1795 John Soane begins to build the Bank of England. Rowland Hill b. (d.1879).

1796 Napoleon Bonaparte marries Joséphine de Beauharnais. Start of Napoleon's Italian campaign. Edward Jenner vaccinates against smallpox.

1801 Act of Union of England and Ireland. First submarine built by Sutton. Thomas Jefferson inaugurated as third President of the USA. First accurate census taken: population of Great Britain = 10.4m. Wilberforce's Act abolishing slavery passed, 1 October. Peace signed between Britain and France.

1802 Peace of Amiens achieves complete pacification in Europe. Thomas Telford commences construction of roads. Duke of Richmond establishes horse racing at Goodwood.

1804 Napoleon Bonaparte is crowned Emperor as Napoleon I. Hobart, Tasmania founded. Joseph Priestley dies, aged 71 years. Benjamin Disraeli b. (d.1864). Beethoven's 3rd (Eroica) Symphony composed.

1805 Battle of Trafalgar.

1806 William Pitt dies, 23 January. Isambard Kingdom Brunel b. (d.1859). End of Holy Roman Empire.

1809 Pall Mall first street in London to be lit by gas. Edgar Allan Poe b. (d.1849). Charles Darwin b. (d.1882). Abraham Lincoln b. (d.1865). Joseph Haydn dies, aged 77 years. William Ewart Gladstone b. (d.1898).

1811 Prince of Wales becomes the Prince Regent. Publication of Jane Austen's novel *Sense and Sensibility*.

1812 Napoleon retreats from Moscow. Blenkinsop's railway locomotive hauls coal waggons at a colliery near Leeds. Francisco Goya paints portrait of the Duke of Wellington. Waltz introduced into English ballrooms. Charles Dickens b. (d.1870). Robert Browning b. (d.1889). Samuel Smiles b. (d.1904).

1813 Napoleon defeated at Battle of Leipzig. Elizabeth Fry begins to visit Newgate Prison. Philharmonic Society founded in London. David Livingstone b. (d.1873). Richard Wagner b. (d.1883). Giuseppe Verdi b. (d.1901). Publication of Jane Austen's *Pride and Prejudice*.

1815 Battle of Waterloo. The Congress of Vienna settles map of Europe. John Nash commences Brighton Pavilion (finished 1823). Humphry Davy invents miner's safety lamp. Anthony Trollope b. (d.1882).

1819 British represented by Sir Stamford Raffles establish a settlement at Singapore. Thomas Telford commences Menai suspension bridge. First ship fitted with steam engines crosses the Atlantic. Princess Alexandra Victoria (Queen Victoria) b. (d.1901).

1820 George III dies, is succeeded by Prince Regent as George IV. First iron steam ship launched. Walter Scott publishes *Ivanhoe*. John Keats publishes `Ode to a Nightingale´. Florence Nightingale b. (d.1910).

1825 British Navigation Acts are passed. Tzar Alexander I dies, aged 47, succeeded by Nicholas I, his younger brother. Stockton to Darlington railway is opened. John Nash refurbishes Buckingham Palace.

1827 Civil war in Portugal. Robert Peel reforms criminal law by reducing number of capital offences. Friction matches (`Lucifers´) introduced. Ludwig van Beethoven dies, aged 56 years. Joseph Lister b. (d.1912).

1830 George IV dies, is succeeded by William IV. King's College London founded. S. J. Anderson's *Birds of America* published. Hector Berlioz composes Symphonie Fantastique.

1831 Population of Great Britain = 12.2m. Charles Darwin leaves on the voyage of the *Beagle* (to 1836). Michael Faraday and Joseph Henry independently discover electromagnetic induction. Sarah Siddons, actress, dies aged 75 years.

1833 Britain proclaims sovereignty over the Falkland Islands. British Factory Act passed, whereby no children under nine years to work in factories and those between nine and thirteen to work no more than a nine-hour day. Edward Burne Jones b. (d.1898). Alfred Nobel b. (d.1896).

1834 Abolition of slavery in British Empire. Louis Braille perfects system of characters for the blind to read. 'Hansom´ cabs introduced in London. William Morris b. (d.1896). Edgar Degas b. (d.1917). Samuel Taylor Coleridge dies, aged 61 years.

1835 Halley's Comet reappears. 'Lacock Abbey, Wiltshire', the earliest negative photograph, taken by William Henry Fox Talbot.

1837 William IV dies. Victoria becomes queen. Martin Van Buren inaugurated as eighth President of the USA. England introduces official birth registration.

1838 Dickens's *Oliver Twist* and *Nicholas Nickleby* are bestsellers. Queen Victoria's coronation.

1840 Queen Victoria marries Prince Albert of Saxe-Coburg-Gotha. Botanical gardens opened at Kew, London. Penny postage established in Britain.

1841 Edward, future Edward VII, born. New Zealand becomes a British colony.

1842 Treaty of Nanking confirms cession of Hong Kong to Britain.

1843 William Wordsworth appointed Poet Laureate. SS *Great Britain*, the first propeller-driven ship to cross the Atlantic, launched at Bristol docks.

1846 *Daily News*, the first cheap English newspaper, appears, with Charles Dickens as editor.

1847 Charlotte Brontë publishes *Jane Eyre*. Emily Brontë publishes *Wuthering Heights*. British Factory Act restricts working day for women and children between thirteen and eighteen to ten hours. Gold discovered in America leads to first gold rush.

1848 Revolt in Paris, Louis Napoleon elected President of France, which becomes a Republic. First Public Health Act in Britain.

1849 Disraeli becomes leader of the Conservative Party.

1850 Robert Louis Stevenson b. (d.1894)

1851 The Great Exhibition in London.

1852 South African Republic established.

1853 Queen Victoria allows chloroform to be administered to her during the birth of her seventh child, thus ensuring its place as an anaesthetic in Britain.

1855 Tsar Nicholas I of Russia dies, succeeded by Alexander II. Florence Nightingale introduces hygienic standards into military hospitals during Crimean War.

1856 'Big Ben' cast at Whitechapel Bell Foundry.

1857 Indian mutiny against British rule. Victoria and Albert Museum opened.

1859 Work on Suez Canal begun.

1860 Abraham Lincoln elected sixteenth President of the USA.

1861 Outbreak of the American Civil War.

1863 Beginning of construction of the London Underground railway.

1865 Abraham Lincoln assassinated. American Civil War ends. Birth of King George V (d.1936)

1866 Dr Barnardo opens his first home for destitute children, in London.

1870 Charles Dickens dies.

1871 Albert Hall, London, opened.

1872 Civil War in Spain.

1874 Winston Churchill b. (d.1965).

1876 Alexander Graham Bell invents the telephone.

1877 Queen Victoria proclaimed Empress of India. Edison invents phonograph.

1879 The public granted unrestricted access to the British Museum.

1881 Pablo Picasso b. (d.1973).

1885 D. H. Lawrence b. (d.1930).

1886 Prime Minister W. E. Gladstone introduces bill for Home Rule in Ireland. R. L. Stevenson's *Dr Jekyll and Mr Hyde* published.

1887 Queen Victoria celebrates her Golden Jubilee.

1889 Adolf Hitler b. (d.1945).

1893 Henry Ford builds his first car.

1895 Birth of the future George VI (d.1952).

1901 Queen Victoria dies, is succeeded by Edward VII.

1903 Emmeline Pankhurst founds National Women's Social and Political Union.

1904 Russo-Japanese war breaks out. Puccini's *Madame Butterfly* opens in Milan.

1910 Edward VII dies, is succeeded by George V.

1912 British coal strike, London dock strike and transport workers' strike. SS *Titanic* sinks on her maiden voyage.

1914 First World War breaks out.

1915 Germans sink *Lusitania*. First Zeppelin attack on London. First transcontinental telephone call between Alexander Graham Bell in New York and Thomas Watson in San Francisco.

1916 Lloyd George becomes Prime Minister.

1917 USA declares war on Germany. British royal family renounces German names and titles. John F. Kennedy b. (d.1963).

1918 Armistice signed between Allies and Germany (11 November). Women over thirty get the vote in Britain.

1922 Lord Carnarvon and Howard Carter discover the tomb of Tutankhamen.

1924 Death of Lenin.

1925 Hitler reorganises the Nazi Party and publishes first volume of *Mein Kampf.*

1926 Birth of the future Queen Elizabeth II.

1928 Women's suffrage in Britain reduced from the age of thirty to twenty-one. Alexander Fleming discovers penicillin.

1929 The term 'apartheid' used for the first time. Construction begins on Empire State Building in New York (completed 1931).

1932 Famine in USSR.

1933 The first concentration camps erected by the Nazis in Germany. All books by non-Nazi and Jewish authors burned in Germany.

1936 King George V dies, is succeeded by Edward VIII. Edward abdicates and is succeeded by his brother George VI (11 December).

1937 Picasso paints *Guernica*, a mural for the Paris World Exhibition. Edward, Duke of Windsor, marries Mrs Wallis Simpson.

1939 Germany invades Poland. Britain and France declare war on Germany. Anglo-Saxon burial ship excavated at Sutton Hoo, Suffolk.

1940 Rationing begins in Britain. Churchill becomes Prime Minister. London 'Blitz' begins.

1941 Japanese bomb Pearl Harbor. USA and Britain declare war on Japan.

1942 The murder of millions of Jews in the Nazi gas chambers begins.

1943 Allied 'round-the-clock' bombing of Germany begins. Race riots break out in several major US cities.

1944 D-Day landings in Normandy (6 June).

1945 'VE Day' ends war in Europe (8 May). USA drops atomic bombs on Hiroshima and Nagasaki. George Orwell publishes *Animal Farm*.

1947 Princess Elizabeth, future Elizabeth II, marries Philip Mountbatten, Duke of Edinburgh. *The Diary of Anne Frank* published.

1948 Gandhi assassinated. Prince Charles born. Bread rationing ends in Britain.

1952 King George VI dies, is succeeded by Elizabeth II.

1953 Coronation of Elizabeth II. Death of Stalin. Hillary and Tenzing become the first to climb Mount Everest.

1954 USA tests hydrogen bomb at Bikini. Nobel Prize for Literature won by Ernest Hemingway.

1955 Death of Albert Einstein. Commercial television begins broadcast in Britain.

1956 Prince Rainier of Monaco marries Grace Kelly. Suez crisis in Egypt.

1957 Anthony Eden resigns as Prime Minister, is succeeded by Harold Macmillan. USSR launches *Sputnik I* and *II*, the first Earth satellites.

1959 Fidel Castro becomes premier of Cuba. First section of London to Birmingham Motorway (M1) opens.

1960 Brezhnev becomes President of the USSR. John F. Kennedy elected thirty-fifth President of the USA. Harper Lee's *To Kill a Mockingbird* published (wins Pulitzer Prize in 1961).

1961 Berlin Wall constructed.

1963 President Kennedy assassinated.

1964 Martin Luther King wins the Nobel Peace Prize.

1965 Death of Winston Churchill.

1968 Martin Luther King assassinated. Richard Nixon elected thirty-seventh President of the USA.

1969 British army sends 600 troops into Belfast to quell rioting. *Apollo II* lands lunar module on the moon's surface (20 July). Neil Armstrong steps out onto the moon (21 July).

1972 Britain imposes direct rule on Northern Ireland.

1973 Britain formally joins the Common Market. Noël Coward dies.

1974 US President Nixon resigns after the 'Watergate' affair. Charlie Chaplin knighted by Queen Elizabeth II.

1976 Agatha Christie dies. Mao Tse-tung dies.

1977 Queen Elizabeth II's Silver Jubilee.

1978 First 'test-tube baby' born in England.

1979 Margaret Thatcher becomes Prime Minister.

1981 Marriage of the Prince of Wales and Lady Diana Spencer. Mock assassination attempt on the Queen.

1982 Falklands War between Great Britain and Argentina.

1984 Brighton bombing by the IRA during Conservative Party conference.

1987 Disappearance of Terry Waite in Lebanon.

1990 Iraq invades Kuwait. Outbreak of the Gulf War. John Major becomes Prime Minister.

1992 Separation of the Prince and Princess of Wales.

CHAPTER 9

THE RAVEN MASON COLLECTION CATALOGUE

COLOUR PLATES

A Miles Mason case
B Case 1 with gilded ironstone
C Case 2 with gilded ironstone
D Jug case
E Case 3 with ironstone including mazarine blue
F Dessert dish case
G Dessert service alcove
H Ashworth case
I 7 dessert dish
J 9 + 9A dessert dishes

K 20 Essence jars
L 21 Wine cooler
M 24 Dessert plate
N 27 + 28 Inkstands
O 31 Pair of vases
P 32 Vase
Q 35 letter rack + 36 paper holder
R 48 3 items from dessert service
S 102 + 102A Dessert dishes
T 108 + 111 Dessert dishes
U 173 Pot-pourri vases

BLACK AND WHITE PICTURES

1. Exterior of Keele Hall
2. Interior of Raven Mason Suite
3. Interior of Raven Mason Suite
4. Ronald W. Raven
5. John M. Raven
6. Dame Kathleen Raven
7. 1 Tea service
8. 2 Coffee cup and saucer
9. 3 Tea service
10. 4 Tea service
11. 5 Tea service
12. 6 Tea cup, saucer, slop basin
13. 8 Tea bowl, saucer
14. 22 Pair of Campana shape vases
15. 23 Vase
16. 25 Pair of vases
17. 26 Pot-pourri pot
18. 33 Spill vases
19. 34 Candlestick
20. 39 Tureen and lid

21. 41 Sauce tureen stand
22. 43, 44, 45 dessert plates
23. 46 Soup bowl
24. 47 Footed bowl
25. 49 Tête-à-tête set
26. 50 Vase
27. 51 Vase and lid
28. 53 Mitre jar and cover
29. 56 Jug
30. 58, 59 Jugs
31. 60 Jug
32. 63 Jug
33. 64, 65 Jugs
34. 67 Jug
35. 68 Jug
36. 69 Set of 4 jugs
37. 74 Jug
38. 75 Jug
39. 79, 80, 81 Jugs
40. 100, 126 Vases

41. 101 Soup tureen and lid
42. 103, 105 Dessert dishes
43. 104, 110 Dessert dishes
44. 105A Dessert dish
45. 106, 106A Dessert dishes,
 113 sauce boat stand
46. 107, 107A Dessert dishes
47. 108, 109 Dessert dishes
48. 112 Meat plate
49. 143 Vase and cover
50. 169 Large vase
51. 170 Pair of vases
52. 171 Pair of vases
53. 172 Bowl
54. 174 Bowl
55. 175 Bowl
56. 176 Tea kettle
57. 177 Vase and cover
58. 179 Coffee jug and lid
59. 7 M Mason impressed
60. 10D MILES MASON + seal mark

61. 14 seal mark
62. 20 MASON'S PATENT
 IRONSTONE CHINA
63. 32 IRONSTONE CHINA
 PATENT
64. 41 Mason's Patent Ironstone
 CHINA
65. 55 MASON'S + crown
66. 58 MASON'S + crown
67. 62 FENTON STONE WORKS
68. 71 MASON'S + crown
69. 72 MASON'S + crown
70. 76 Bandana
71. 88 MASON'S + crown
72. 89 Beaded crown
73. 148 England
74. 168 Real Ironstone CHINA
75. 176 Ashworth Bros. + diamond
 patent office registration mark
76. 179 Arms over 'Ironstone China'
 + REAL IRONSTONE CHINA

ABBREVIATIONS USED IN THE CATALOGUE

Ill Illustrated in a named publication
Coll Collection
c. Circa
Plate Refers to a colour illustration by letter
Picture Refers to a black-and-white illustration by number

NOTES TO THE CATALOGUE SECTION

Where no mark is indicated in the text, the object is unmarked.
References from the pattern book are quoted by kind permission of the Trustees of the Wedgwood Museum, Barlaston, Staffordshire.

PICTURE AND PLATE SECTION

The caption which accompanies each photograph gives a brief description of the item(s), preceded by the catalogue number and followed by the plate or picture reference.

1 to 1AS PICTURE 7

Part Tea service, comprising: teapot, lid and stand, sucier (no lid), slop basin, saucer dish, two plates, six tea cups, six coffee cups, twelve saucers.
Marks: on plates 1G & 1F; 'M MASON' impressed & '351' in gold; on teapot, '351' in gold; on teapot stand, 'M MASON' impressed.
Bone china. Bat printed in red/orange. Gold band. Pattern number 351.

Miles Mason　　Lane Delph　　c.1805

Note: Pattern numbers are denoted by the gilding. Tea cups 1H and 1I have gold bands at foot of Bute shape. Coffee cans 1W and 1AC have gold bands at foot, and are therefore a different pattern number.
Ill: Skinner & Young 1992, page 53.

2 and 2A PICTURE 8

Coffee cup and saucer.
Bone china. Bat printed in black with mythological scenes. Gold band. Pattern number 351.

Miles Mason　　Lane Delph　　c.1805

3 to 3E PICTURE 9

Part tea service, comprising: sucier and lid, tea cup and saucer and coffee can.
Bone china, hand painted in enamel colours with poppies in pink and red.
Pattern number 630, written in gold inside sucier lid.

Miles Mason　　Lane Delph　　c.1808–13

Note: One cup and saucer, bone china, is from an unidentified factory, possibly a replacement dating c.1810–15.
Ill: Skinner & Young 1992, page 76.

4 to 4W PICTURE 10

Part tea service, comprising: sucier and lid, creamer, slop basin, six tea cups, seven saucers and six coffee cans.
Mark on creamer and sucier: 'M. MASON' impressed. `N: 84' in gilt.
Porcelain. Hybrid hard paste, hand-painted in enamels and gilt with roses in gilt trellis (diamonds).

Miles Mason　　Lane Delph　　c.1805

Note: Coffee can 4W is probably Coalport (John Rose), probably made as a replacement c.1810–15.
This service was at one time thought to have been decorated at Mansfield by W. Billingsley, current research suggests that this is factory decorated by Miles Mason with pattern number 84. In the Ronald Raven Room, Royal Crown Derby Museum, there is a Derby example of this pattern c.1805–10, pattern 626, but with inside decoration. This pattern is, at Derby, too late for W. Billingsley.
Ill: `Mason Porcelain and Ironstone' Haggar and Adams, 1977.
Godden 1980, plates 71 and 72.
Skinner & Young 1992, page 31.

5 to 5F PICTURE 11
Part tea service, comprising: sucrier and cover, teapot stand, plate, tea cup and saucer, coffee can.
Bone china, painted in underglaze blue and gold. Pattern number 473.
Marks: on sucrier, '473' in gold. On plate, '473' in gold and 'M MASON' impressed.

Miles Mason Lane Delph c.1805–13

Ill: Skinner & Young 1992, page 64.

6 to 6B PICTURE 12
Tea cup and saucer, slop basin.
Bone china, painted in underglaze blue and gold, referred to as pattern number 354.

Miles Mason Lane Delph c.1805–10

Ill: Skinner & Young 1992, page 54.

7 Plate I. Mark: PICTURE 59
Dessert dish, oval lobed form with scroll handles.
Marks: 'M MASON' impressed and '100' in gold.
Porcelain. Hybrid hard paste, painted in enamel colours and gold with stylised flowers in pink, yellow and red enamel. Fine gilding. Pattern number 100.

Miles Mason Lane Delph c.1805

Ill: Godden 1980, page 90, plates 113–15 for more pieces of the same service.
Skinner & Young 1992, page 34.

8 to 8A PICTURE 13
Tea bowl and saucer.
Porcelain, hybrid hard paste, outline transfer printed in overglaze black. Hand-painted in enamel colours. Pattern referred to as 'The Boy at the door' pattern.

Miles Mason Lane Delph c.1805

9 and 9A PLATE J
Pair of lobed oval dessert dishes.
Mark: 'M MASON' impressed (on both).
Porcelain. Hybrid hard paste, hand-painted on glaze with animal subjects in brown enamel. One with a greyhound, the other with a hind.

Miles Mason Lane Delph c.1805

Note: The design was probably adapted from a print source. Possible only one service of this type and decoration produced.
Ill: Godden 1980, plate 110, for another pair from same service, depicting two sporting dogs.
Haggar and Adams 1977, plate 84.

10 to 10F Mark: PICTURE 60

Slop basin and six coffee cups.
Marks: on 10A, 10B, 10C, 10E, 10F in underglaze blue 'MILES MASON' on either side of a square seal; on 10D, seal mark only.
Bone china, transfer printed in underglaze blue with the 'Broseley Willow' pattern. Gilded, with pattern number 241.

Miles Mason　　Lane Delph　　c.1805–10

Ill: Skinner & Young 1992, page 45.

11

Sucrier (no cover) with shepherd crook handles.
Mark: seal mark in underglaze blue and '50' in gold. Bone china.
Blue print of 'Broseley Willow'. Gilded with pattern referred to as number 50 a husk pattern.

Miles Mason　　Lane Delph　　c.1805–10

Ill: Haggar & Adams 1977, plate 10.
Skinner & Young 1992, page 29.

12

Coffee can.
Mark: seal mark in underglaze blue.
Bone china, transfer printed in underglaze blue with the 'China man on the veranda' pattern. Gilded with pattern number 99.

Miles Mason　　Lane Delph　　c.1810–15

Ill: Skinner & Young 1992, page 34.

13

Coffee can.
Mark: 'MILES MASON' above and below a square seal in underglaze blue.
Bone china, transfer printed in underglaze blue with 'Broseley Willow' pattern, gilt line.

Miles Mason　　Lane Delph　　c.1810–15

14 Mark: PICTURE 61

Coffee can.
Mark: square seal in underglaze blue.
Bone china, transfer printed in underglaze blue with 'Broseley Willow' pattern, gold edge.

Miles Mason　　Lane Delph　　c.1810–15

15

Saucer.
Porcelain, transfer printed in underglaze blue with 'Broseley Willow' pattern. Gold edge.

Probably John Rose of Coalport Coalport, Shropshire. c.1810

Note: Following his apprenticeship with Thomas Turner at Caughley in Shropshire, John Rose (with the financial support of Edward Blakeway) commenced to manufacture ceramics on his own account at the Calcut China Manufactory at Jackfield c.1793. By 1796 the new town of Coalport, which was nearby, had been started and Rose, Blakeway and Co. moved their factory to this new advantageously located site, where the works remained until 1926. Rose manufactured a wide range of utilitarian wares especially tea, dinner and dessert services of a high quality. In 1820 the company was awarded the Society of Arts Gold Medal for a leadless glaze using Feldspar instead, which was considered much healthier for the employees. At both the 1851 and 1862 International Exhibitions, Coalport were awarded medals for their production. For further reading see: *Coalport and Coalbrookdale Porcelains* by G. A. Godden, published by Herbert Jenkins (1970). *Coalport* by Michael Messenger, published by Antique Collectors Club (1995).

16 and 16A

Cup and saucer.
Bone china, transfer printed in underglaze blue with 'Broseley Willow' pattern. Gold border of leaf and dot motif.

Probably Hicks & Meigh c.1815–20

Note: Hicks & Meigh, Shelton, Staffordshire. Manufacturing earthenwares, stonewares and china, c.1803–22.

17 to 17B

Coffee can, tea cup and saucer (trio).
Mark: square seal in underglaze blue on all three pieces.
Bone china, transfer printed in underglaze blue with 'Broseley Willow' gold edge. Etruscan or Bell shape.

Probably Yates c.1820–5

Note: John Yates, c.1820–35, Shelton (Hanley) Staffordshire, manufacturing china and earthenwares.

18 to 18B

Cup and saucer, coffee cup.
Mark: on all three, double-framed square seal mark in underglaze blue.
Bone china, transfer printed in underglaze blue, with 'Broseley Willow' pattern, gold edge and band.

Possibly Charles Bourne c.1820–5

Note: Charles Bourne, c.1817–30, Foley, Fenton, Staffordshire. Manufactured china and earthenware.

19 to 19B

Coffee can, tea cup and saucer.
Bone china, transfer printed in underglaze blue with 'Broseley Willow' pattern, gilt border of stylised leaves and husks.

Maker unknown c.1820–5

Note: The pattern is similar to that recognised as Mason's pattern 50; possibly a replacement.

20 to 20C PLATE K. Mark: PICTURE 62

Pair of essence jars with lids.
Marks: 'MASON'S PATENT IRONSTONE CHINA' impressed in two lines (on 20).
Ironstone china, decorated in the English style, with random groups of flowers in enamel colours. Necks gilded with insects and flowers.

C. J. Mason Lane Delph c.1820–5

Note: This form of essence jar was produced with other versions of decoration, including applied and moulded reliefs of flowers and leaves.

21 PLATE L

Wine Cooler.
Marks: 'MASON'S PATENT IRONSTONE CHINA' impressed in a single line.
Ironstone, hand-painted in enamel colours with English flowers on one side and fruit on the reverse. Raised moulded vine leaves and grapes around top. Satyr mask handles. The vine and satyrs in gold. Gilded on socle and plinth. Moulded rim with stylised acanthus.

C. J. Mason Lane Delph c.1815–20

Note: The 1822 Phillip's Sale Catalogue includes a 'pair of wine coolers'.
Ill: 'The Masons of Lane Delph', Haggar 1952, plate 17.
Godden 1980, page 190, plate 293; Godden 1991, page 215, plate 293.
Exhibited: 'Mason's – The First Two Hundred Years', Barlaston, 1996.

22 and 22A PICTURE 14

Pair of Campana shape vases.
Mark: 'MASON'S PATENT IRONSTONE CHINA' impressed in two lines.
Ironstone, hand-painted oblong panels on the front, one depicting 'Goatherds', the other 'An Encampment'. Claret ground, blue underside, olive green plinths. Gilded plinth, handles and ornament. Rim moulded with pectern shells.

C. J. Mason Lane Delph c.1815–20

Note: See Godden 1980, page 192.
Ill: Haggar & Adams 1977, plate 94.

23 PICTURE 15

Vase.
Ironstone china, decorated in the English style with random groups of flowers in enamel colours. Gilt necks with birds and flowers. Base pink ground overpainted with purple flowers. Elaborate gilt handles terminating in Bacchus masks.

C. J. Mason Lane Delph c.1815–25

Note: Possibly by the same painter as objects 20 to 20C.

24 PLATE M

Plate from a dessert service.
Mark: 'MASON'S PATENT IRONSTONE CHINA' impressed in a single line, inscribed in red: 'Beauchief Abbey, Derbyshire'.
Ironstone china, hand-painted in enamel colours with a topographical scene. Gold outer border of stylised fans. Inner border of stylised anthemions in gold. Gold band.

C. J. Mason Lane Delph c.1815–22

Note: A very similar service was sold in Phillip's, London, in 1822, attributed to the painting of Samuel Bourne: 'A very beautiful, painted landscape dessert service, by S. Bourne' and 'A costly dessert service exquisitely painted in select views by S. Bourne, enriched with burnished gold'.
 Samuel Bourne (c.1789–1866) was born in Norton-in-the-Moors, Staffordshire. He is reputed to have served his apprenticeship with Wood and Caldwell, where he learned the art of enamel painting. Unfortunately, no evidence seems to survive about his period of employment with Mason's beyond the references to his finished work in the auction catalogues. It is possible that Bourne was employed in the decoration of ceramics from about 1809. His work for Mason's is unsigned and it is thought that he left the company's employment by 1828. Samuel Bourne is recorded as working as an artist and designer for Minton from 1828 until 1848. It is probable that he maintained his associations with Minton until 1863 when he retired. Samuel Bourne painted, in watercolour, George Miles Mason, his wife and children at Wetley Abbey and several topographical watercolours which were subsequently engraved and were published in John Ward's *The Borough of Stoke-on-Trent*, published in 1843.
Ill: Godden 1980, page 143, plate 197.
Godden 1991, page 161, plate 197; page 177, colour plate 47.
For two other pieces from the same service see Blake Roberts, 1996, page 95.

25 and 25A PICTURE 16

Pair of vases.
Mark: 'M MASON' impressed on both.
Bone china, hand-painted in enamel colours with a circular landscape. Bottom in underglaze blue with gilt strips. Female mask handles in gold.

Miles Mason Lane Delph c.1810–13

Note: The shape is believed to be unique to Mason's and can also be found in ironstone. The panoramic landscapes are unattributed.

Ill: Godden 1980, plate 139, for similar pair – though decorated with botanical sprays.
Godden 1991, page 115, plate 139.
Haggar & Adams, plate 87.
Coll: Formerly Mason's factory.

26 and 26A PICTURE 17

Pot-pourri pot with high-domed lid.
Ironstone china, hand-painted in enamel colours with a panoramic landscape.
Cobalt blue ground to base and lid. Gold male masks. Gold scale motif on lid.

C. J. Mason Lane Delph c.1815–20

27 to 27E PLATE N

Inkstand comprising: pen tray, pounce pot, ink well and stopper, wafer pot and lid.
Ironstone, hand-painted in enamel colours in the oriental manner and gilt. Paw
feet and loop handle.

C. J. Mason Lane Delph c.1815–20

Ill: Godden 1980, page 157, plate 224.
Godden 1991, page 183, plate 224.
Haggar & Adams, plate 166, for very similar example.

28 to 28B PLATE N

Inkstand, comprising pounce pot and inkwell, two taper or quill holders.
Mark: 'MASONS PATENT IRONSTONE CHINA' impressed in a single line.
Ironstone, hand-painted in underglaze blue and overglaze red enamel in the Imari
style. The holders moulded as baskets. Stand: paw feet, moulded stylised acanthus
leaves at edge, leaf handles.

C. J. Mason Lane Delph c.1815–25

29 PLATE C

Neapolitan ewer.
Mark: 'MASON'S PATENT IRONSTONE CHINA' impressed twice.
Ironstone (see illustration for shape). Hand-painted in enamel colours with rustic
landscape in panels on each side. Salmon ground to body, green base section,
ground gilded with arched forms. Band of moulded roses picked out in gold.

C. J. Mason Lane Delph c.1820–5

Note: Painting attributed to Samuel Bourne. Various ewers of this form with different
decoration are recorded including examples painted with 'Japan' patterns. Another
example was decorated with butterflies; reference, *Antique Traders Gazette*.
Shape taken from known printed source.
Ill: Godden 1980, page 169, plate 251.
Godden 1991, page 195, plate 251.
For another version see Blake Roberts, 1996, page 94.

30 PLATE C

Neapolitan ewer.

Mark: 'MASON'S PATENT IRONSTONE CHINA' impressed twice.

See No. 29, but blue ground to body with green lower section. The moulded roses left undecorated.

C. J. Mason Lane Delph c.1820–5

Note: See 29.

31 to 31A PLATE O

Pair of vases.

Mark: 'MASON'S PATENT IRONSTONE CHINA' impressed in two lines, on both.

Ironstone, goblet shape on satyr supports. Decorated with oblong panels hand-painted in enamel colours with landscape scenes on the front. Cobalt blue ground with gilding including a merman figure on the reverse. Yellow washed ground, decorated with different gilded designs, front and back, fully gilded satyrs.

C. J. Mason Lane Delph c.1815–25

Note: Mason's Club Newsletter No. 7, items 4 and 5 (March 1975).
Ill: Godden 1980, page 181, plate 272, with 32 as a garniture.
Godden 1991, page 206, plate 272.
Exhibited: 'Mason's – The First Two Hundred Years', Barlaston, 1996.

32 PLATE P. Mark: PICTURE 63

Vase.

Mark: 'PATENT IRONSTONE CHINA' impressed in a circle.

Ironstone, hand-painted in enamel colours with a panoramic scene, cobalt blue ground overpainted in gold. Gilded socle and plinth. Elaborate moulded, scroll handles in gold. Green enamel band to inside of neck.

C. J. Mason Lane Delph c.1815–25

Ill: Godden 1980, page 181, plate 272, with 31 and 31A as a garniture.
Godden 1991, page 206, plate 272.
Exhibited: 'Mason's – The First Two Hundred Years', Barlaston, 1996.

33 and 33A PICTURE 18

Pair of spill vases.

Mark: 'MASON'S PATENT IRONSTONE CHINA' impressed in two lines.

Cylindrical form. Hand-painted with half scenes of landscapes, claret ground, gold bands and gilt stylised acanthus leaves on yellow wash band around painted panels.

C. J. Mason Lane Delph c.1815–25

34 PICTURE 19

Candlestick.

Mark: 'PATENT IRONSTONE CHINA' impressed in a circle.
Ironstone hand-painted with random flower sprays in enamel colours, green ground to top and base, white beads, stylised bands of gold leaves.

C. J. Mason Lane Delph c.1815–25

35 PLATE Q

Letter rack.
Ironstone, rectangular form with elaborate foliate scroll pierced for hanging, cobalt blue ground, hand-painted with random flower sprays in enamel colours and gilt, moulded edges and scroll feet gilded.

C. J. Mason Lane Delph c.1820–5

Ill: Godden 1980, page 149, plate 208.
Godden 1991, page 170, plate 208.

36 PLATE Q

Paper holder.
Ironstone, rectangular form with central division, moulded top edge and scroll feet, cobalt blue ground hand-painted with random flower sprays in enamel colours and gilt. Yellow wash interior, gilt scrolls and feet.

C. J. Mason Lane Delph c.1820–5

Note: Similar decoration as 35.
Ill: For a similar example, see Godden 1980, page 149, plate 209.
Godden 1991, page 170, plate 209.

37

Paper holder.
Ironstone, rectangular form with central division, moulded top edge and scroll feet, cobalt blue ground hand-painted on the front in white enamel with a chinoiserie scene. Gold on moulded edge and feet, yellow wash interior.

C. J. Mason Lane Delph c.1820–5

Note: Same shape as 36.

38

Leaf-shaped dessert dish.
Mark: 'MASON'S PATENT IRONSTONE CHINA' impressed in two lines.
Ironstone, moulded in the form of an elongated leaf. Cobalt blue ground, central reserve hand-painted with random flower sprays in enamel colours, gilded with ivy leaves. Moulded handles picked out in gold on the white body.

C. J. Mason Lane Delph c.1815–25

Note: Items from similar services are illustrated: Godden 1980, page 177, colour plate 10.
Godden 1991, page 177, colour plate 46.

39 and 39A PICTURE 20

Tureen and lid.
Mark on lid: 'PATENT IRONSTONE CHINA' impressed in a circle.
Mark on Tureen: 'PATENT IRONSTONE CHINA' impressed in a circle and a
Crown surmounting a drape in black overglaze, overpainted in green enamel.
Ironstone: Melon shape on divided pedestal foot of moulded leaves, leaf-moulded
handles. Handles painted in underglaze blue and gold. Transfer printed outline in
black with the 'Table & Flower Pot' pattern, overpainted in enamel colours. Lid
with finial comprised of a fir cone emerging from four leaves, stylised acanthus
leaves radiating from the finial.

C. J. Mason Lane Delph c.1815–25

Ill: Shape: Godden 1980, page 134–5, plates 176 and 177.
Godden 1991, page 153–4, plates 176 and 177.

40

Dessert dish moulded with cabbage leaf.
Ironstone, outline transfer print in black, hand-painted in enamels with random
flower sprays. The moulding picked out in gold.

C. J. Mason Lane Delph c.1820–5

Note: This moulded form is found in both ironstone and bone china.

41 PICTURE 21, Mark: PICTURE 64

Sauce tureen stand.
Mark: 'MASON'S PATENT IRONSTONE CHINA' impressed in a line.
Ironstone, moulded with a cabbage leaf celedon ground, hand-painted in enamel
colours with botanical spray, gold line.

C. J. Mason Lane Delph c.1815–25

42

Sauce tureen stand.
Ironstone, moulded with cabbage leaves, picked out in blue enamel and gold lines,
hand-painted in enamel colours with random sprays.

C. J. Mason Lane Delph c.1815–25

43 PICTURE 22

Dessert dish moulded with cabbage leaves.
Mark: Pattern '967' painted in gold. Bone china moulded cabbage leaves picked
out in gold. The centre hand-painted in enamel colours with a botanical spray.

C. J. Mason Lane Delph c.1820–5

Note: The gold and the enamel colours have suffered in the final firing. Possibly
underfired and probably sold as a second.

44 PICTURE 22

Plate from a dessert service.
Bone china (description as 43), but with pale pink washes included in moulded border.

C. J. Mason Lane Delph c.1820–5

45 and 45A PICTURE 22

Dessert dishes moulded with cabbage leaves.
Ironstone, moulding picked and in gold. Blue enamel ground panels. The central reserves hand-painted in enamel colours with random flower sprays.

C. J. Mason Lane Delph c.1820–5

46 PICTURE 23

Soup bowl.
Mark: 'MASON'S PATENT IRONSTONE CHINA' impressed in a straight line.
Ironstone, outline transfer print in black, hand-painted in enamel colours with chinoiserie scene.

C. J. Mason Lane Delph c.1815–20

Note: Possibly a replacement for a Chinese original.

47 PICTURE 24

Footed bowl.
Mark: Crown and drape transfer printed in black, overpainted in pink enamel.
Ironstone, transfer printed outline in black, hand-painted in enamel colours and gilt with the 'Mandarin' pattern outside and inside.

C. J. Mason Lane Delph c.1815–25

Ill: Godden 1980, page 173, plate 260.
Godden 1991, page 199, plate 260.

48 to 48J PLATE R

Part dessert service comprising: cream or sauce tureen, footed comport, two moulded centre dishes and six plates.
Marks on each plate: 'MASON'S PATENT IRONSTONE CHINA' impressed in a straight line.
Ironstone, outline transfer print in red, hand-enamelled and gilt with chinoiserie scene comprising rock, peony and fence.

C. J. Mason Lane Delph c.1815–20

Note: Pattern now called 'Fence, Rock and Tree'; see *Compendium* of Mason's patterns, published by Mason's Collectors Club (1996).
Ill: Shape illustrated Godden 1991, page 155, plate 180.

49 and 49F PICTURE 25

Tête-à-tête set comprising: teapot and cover, creamer and two cups and saucers.

Mark on teapot lid: 'PATENT IRONSTONE CHINA' impressed in a circle.
Ironstone, Meissen shape, moulded with an osier border, hand-painted in enamel
colours with random flowers and gilt.

C. J. Mason Lane Delph c.1815–20

Note: Pattern now called 'Scattered Blossoms'; see *Compendium* of Mason's patterns,
published by Mason's Collectors Club (1996).
Ill: For similar shape: Godden 1980, page 176, plates 264 and 265.
Godden 1991, page 202, plates 264 and 265.
Skinner 1982, plate 43.

50 PICTURE 26

Vase.
Mark: 'MASON'S PATENT IRONSTONE CHINA' impressed in a straight line
on the footrim.
Ironstone, hexagonal central section with alternating moulded basketweave panels.
Trumpet-shaped neck, rising from a domed section. Hand-painted in underglaze
blue and enamel colours and gilt with the 'Waterlily Pattern'.

C. J. Mason Lane Delph c.1815–25

51 and 51A PICTURE 27

Vase and lid.
Ironstone, hexagonal 'pagoda' shape rising from a melon-shaped bottom section.
Elaborate handles comprising monkeys grasping mythical beasts in gilt. The top and
bottom section in underglaze blue. The whole hand-painted with random sprays of
flowers in enamel colours and gold. The lid with a 'Dog of Fo' finial in gold.

C. J. Mason Lane Delph c.1820–5

52 to 52B

Ink well. (Stopper, added at a later date, possibly not of Mason's production).
Ironstone, covered in underglaze blue, decorated in gold on the front with a
peony and small flowers. Single loop handle. A bird with open mouth in gold
forming the ornamental wick hole. The stopper with a 'Dog of Fo' finial. Based
on a Roman original.

C. J. Mason Lane Delph c.1820–5

Ill: Haggar & Adams 1977, colour plate H, for very similar example.

53 and 53A PICTURE 28

Mitre jar and cover.
Ironstone, covered in underglaze blue, handles serpents and masks, in gold. Spirally
moulded bottom section. Lid spirally moulded surrounded by a crown in gold.
Decorated with butterflies and moths in gold.

C. J. Mason Lane Delph c.1820–5

Note: 'Elegant mitre shaped jars and covers sumptuously gilded' are listed in the

Christie's sale catalogue for 15 December 1818. See Godden 1980, Appendix, pages 269–76; Godden 1991, Appendix, pages 297–304, for transcript.
Ill: Godden 1980, page 160, plate 231.
Godden, 1991, plate 186.
Samlesbury Hall, January 1987, Lot 48.

54

Jug.
Mark: 'MASON'S', over a large round crown, drape with 'PATENT IRONSTONE CHINA', printed in underglaze blue.
Ironstone, octagonal form with moulded twig handle. Transfer printed in underglaze blue with `Basket of Flowers' pattern, hand-enamelled in red. Green enamel handle.

C. J. Mason Lane Delph c.1820–5

55 and 55A Mark: PICTURE 65

Pair of jugs, 'Hydra' shape.
Mark: 'MASON'S' over a round crown, surmounting. 'PATENT IRONSTONE CHINA', printed in black.
Ironstone, octagonal form with moulded handles. Painted in underglaze blue, handles painted in green and red enamel.

C. J. Mason Lane Delph c.1845

56 PICTURE 29

Jug, 'Hydra' shape.
Mark: 'MASON'S' over an angular crown, drape with 'PATENT IRONSTONE CHINA' in underglaze blue; 'B9799' painted in red.
Ironstone, octagonal, transfer printed in underglaze blue with 'Bird and Peony' pattern, and enamelled in red and yellow. Moulded handle, painted in underglaze blue and gold.

Geo. L. Ashworth Broad Street Works, Hanley c.1900

Note: Same pattern as 82, 83 and 87–87A. The pattern book entry for B9799 reads 'Dinner ware No. 2 shape. Ironstone. Printed under-glaze. Enamelled. Best red, rose, coloured, yellow, yellow-green. Lustre edge.' The entry was made between December 1898 and November 1903.

57

Jug, 'Hydra' shape.
Mark: 'MASON'S' over angular crown, drape enclosing 'PATENT IRONSTONE CHINA' in black.
Ironstone octagonal jug, pattern as 54. Moulded handle enamelled in green, red and yellow.

C. J. Mason Lane Delph c.1840–8

58 and 58A PICTURE 30, Mark: PICTURE 66

Pair of Jugs.

Mark: 'MASON'S' over a crown, drape enclosing 'PATENT IRONSTONE CHINA' printed in black.

Ironstone, hexagonal with sea serpent moulded handle, cobalt blue ground. 'Double landscape' transfer printed in black, enamelled by hand in orange, yellow, red, green and gold.

C. J. Mason Lane Delph c.1840–8

59 PICTURE 30

Jug.

Mark: 'MASON'S' over angular crown drape enclosing 'PATENT IRONSTONE CHINA' printed in sepia.

Ironstone, hexagonal, cobalt ground, 'Double landscape' pattern as 58.

C. J. Mason Lane Delph c.1840–8

60 PICTURE 31

Jug.

Mark: 'MASON'S' over an angular crown, drape enclosing 'PATENT IRONSTONE CHINA' printed in purple.

Ironstone, ovoid form with scroll handle, cobalt blue ground. Central panel transfer printed outline of vase and Chinese symbols, hand-enamelled in red, yellow, blue, green and gold. Green scale inside border.

C. J. Mason Lane Delph c.1840–5

Ill: Godden 1980, page 163, plate 238.
Godden 1991, page 189, plate 238.

61

Jug.

Mark: 'MASON'S' over an angular crown drape enclosing 'PATENT IRONSTONE CHINA' printed in purple.

Ironstone, elongated, hexagonal form, handle terminal in the form of a grotesque mask. Cobalt blue ground oval panels enclosing 'Landscape in a scroll', transfer printed in black. Hand-painted in enamel colours and yellow enamel. Neck green enamel ground painted in yellow enamel.

C. J. Mason Lane Delph c.1840–8

62 Mark: PICTURE 67

Jug.

Mark: 'FENTON STONE WORKS' enclosed in a rectangular with canted corners and 'No. 306' in underglaze blue.

Earthenware, hexagonal, transfer printed in underglaze blue, hand painted in overglaze red. Handle moulded with a sea serpent painted in green enamel.

C. J. Mason Lane Delph c.1830–5

63 PICTURE 32

Jug.

Ironstone 'Fenton' shape covered with cobalt, decorated in gold with butterflies and stylised grass. Handle moulded in the form of a two-legged beast. The neck gilded with stylised leaves and scrolls.

C. J. Mason Lane Delph c.1820–5

64 PICTURE 33

Jug (small size).

Mark: 'PATENT IRONSTONE CHINA' impressed in a circle.

Ironstone, octagonal with hydra-shaped handle covered in cobalt. Hand-painted in enamel colours and gold with random flower sprays.

C. J. Mason Lane Delph c.1820–5

65 PICTURE 33

Jug (miniature).

Ironstone, 'Fenton' shape with handle moulded with a two-legged beast, picked out in gold. Decorated, hand-painted in enamel colours and gilt with random flower sprays.

C. J. Mason Lane Delph c.1820–5

66

Jug.

Ironstone, 'Fenton' shape covered with cobalt, decorated in gold with butterflies and moths. Handle moulded as two-legged beast.

C. J. Mason Lane Delph c.1820–5

67 PICTURE 34

Jug.

Ironstone, octagonal with elongated neck and pronounced spout. Handle moulded in the form of a hydra. Covered with a violet cobalt blue. Painted with stylised floral sprays in gold.

Unattributed, probably of North Staffordshire origin c.1825–30

68 PICTURE 35

Jug.

Ironstone, octagonal, with moulded hydra handle. Cobalt blue ground, hand-painted in gold with moths and butterflies and large peony. Elongated neck with exaggerated lobes.

C. J. Mason Lane Delph c.1820–5

69 to 69C PICTURE 36

Set of graduated jugs, 'Hydra' shape.

Mark: 'MASON'S' over an angular crown, drape enclosing 'PATENT

IRONSTONE CHINA' printed in black. 'C' over '107', and '9' below, painted in red.
Earthenware, octagonal, transfer printed in black with chinoiserie scenes, red scale
ground. The design hand-painted in enamel colours. Moulded handle painted in
red, green and yellow enamel.

Geo. L. Ashworth Broad Street Works, Hanley c.1900–10

Note: Earlier version see 71. The pattern book entry for C107 reads 'Hydra jugs.
Ironstone. Printed underglaze. Black. Coloured underglaze. Apple green underglaze,
oven blue enamelled, 427 red, 616 blue, rose coloured, yellow, black, opaque orange,
mixed blue green 159. Lustre edge.' The entry was made between 1900–3.

70

Jug, with strainer at spout, 'Hydra' shape.
Mark: 'MASON'S PATENT IRONSTONE CHINA' impressed in two lines.
'MASON'S printed in black over a large crown, drape enclosing 'PATENT
IRONSTONE CHINA'.
Ironstone, octagonal, transfer printed in black, hand-painted in enamel colours with
'Table and Flower Pot' pattern. Handle moulded and painted in apricot lustre.

C. J. Mason Lane Delph c.1820–5

71 Mark: PICTURE 68

Jug.
Mark: 'MASON'S' over a large crown, drape enclosing 'PATENT IRONSTONE
CHINA' printed in black.
Ironstone, octagonal, transfer printed in black, hand-painted in enamel colours.
Handle moulded as a twig, painted in green and brown enamel.

C. J. Mason Lane Delph c.1825–30

Note: Variation of pattern on 69.

72 Mark: PICTURE 69

Jug (miniature), 'Hydra' shape.
Mark: 'MASON'S' over a round crown drape enclosing 'PATENT IRONSTONE
CHINA' printed in black. 'H' painted in red.
Earthenware, octagonal, transfer printed in overglaze black, hand-painted in
enamel colours. Moulded handle decorated with part of the transfer printed
design. Red line border.

Geo. L. Ashworth Broad Street Works, Hanley c.1870–80

73

Jug, small size.
Mark: 'PATENT IRONSTONE CHINA' impressed in a circle.
Ironstone, octagonal, outline transfer print in black. Hand-painted in underglaze
blue and enamel colours and gold, with the 'Waterlily' pattern.

C. J. Mason Lane Delph c.1815–20

74 PICTURE 37

Jug.

Mark: 'MASON'S' over an angular crown drape enclosing 'PATENT
IRONSTONE CHINA' printed in black.

Earthenware, elongated oval shape with mean lip, decorated with a `Bandana'
pattern printed in black, hand-painted in enamel colour, predominantly green.
Red enamel rim.

C. J. Mason Lane Delph c.1840–8

Note: The word 'bandana' seems to have its origins in the Hindustani word, 'Bandhnu',
referring to the method of dyeing, in which parts of the cloth are tied to prevent
them receiving coloured dye. The word also relates to a type of calico printing in
which a pattern is produced by discharging the colour.

75 PICTURE 38

Jug.

Mark: 'MASON'S' over a round crown, drape enclosing 'PATENT
IRONSTONE CHINA' printed in black.

Ironstone, globular form, with twig moulded handle, transfer printed outline with
the 'sacrificial lamb' pattern. Hand painted in enamel colours.

C. J. Mason Lane Delph c.1830–40

76 Mark: PICTURE 70

Jug.

Mark: Standard `Bandana' mark.

Earthenware, cane-coloured body. Transfer printed outline in black. Hand-painted
in enamel colours. Handle moulded in the form of a sea serpent.

C. J. Mason Daisy Bank Works c.1851–3

Note: Made after the bankruptcy when C. J. Mason restarted for approximately two
years.

77 to 77C

Jugs.

Mark: 'MASON'S' over an angular crown drape enclosing 'PATENT
IRONSTONE CHINA' printed in black

Ironstone, octagonal, with twig moulded handle painted in green and brown
enamel. Transfer printed outline in black, hand-painted in enamel colours with
chinoiserie scenes.

Geo. L. Ashworth Broad Street Works, Hanley c.1860–70

Note: Same shape as 54 and 71.

78

Jug.

Mark: 'MASON'S' over an angular crown drape enclosing 'PATENT
IRONSTONE CHINA' printed in black.

Ironstone, moulded with a boar hunt on one side, the other with a stag hunt, both in low relief, elongated oval form. Twig moulded handle.

C. J. Mason Lane Delph c.1845–8

79 PICTURE 39

Jug.
Mark: 'MASON'S' over an angular crown, drape enclosing 'PATENT IRONSTONE CHINA' printed in black.
Ironstone grey-tinted body, moulded on one side with a boar hunt, the other with a stag hunt, both in low relief. Gold band to rim and base.

C. J. Mason Lane Delph c.1845–8

Note: See 78 for smaller version

80 PICTURE 39

Jug.
Mark: 'MASON'S' over an angular crown, drape enclosing 'PATENT IRONSTONE CHINA' printed in black. 'TOHO' impressed in an applied rectangular pad.
Ironstone, grey-tinted body, moulded in high relief with hunting dogs, moulded in low relief with a landscape. The neck moulded with two huntsmen drinking at a table.

C. J. Mason Lane Delph c.1840–8

Note: The command 'Toho' is given to a gun dog to stop, but no definitive reason why this mark was adapted by Mason's seems to have survived.
Ill: Haggar & Adams 1977, page 142.

81 PICTURE 39

Jug.
Mark: 'MASON'S' over an angular crown drape enclosing 'PATENT IRONSTONE CHINA' printed in black.
Ironstone, moulded in low relief with Falstaff and the 'Merry Wives of Windsor'. Handle moulded as a gnarled tree trunk.

C. J. Mason Lane Delph c.1840–8

Ill: Godden 1991, page 190, plate 240.

82

Jug, 'Hydra' shape.
Mark: 'MASON'S' over an angular crown drape enclosing 'PATENT IRONSTONE CHINA' printed in underglaze blue. 'B/9799' painted in red.
Earthenware, octagonal, transfer printed outline in underglaze blue, hand-painted in underglaze blue, and enamel colours. Moulded handle, painted in underglaze blue, painted in gold with scales. Apricot lustre edge line.

Geo. L. Ashworth Broad Street Works, Hanley c.1900

Note: Same pattern as 56, 83 and 87–87A. No information is given in the pattern books against the entry B9799. It was originally entered between December 1898 and November 1903.

83

Jug, 'Hydra' shape.
Mark: 'MASON'S' over an angular crown, drape enclosing 'PATENT IRONSTONE CHINA' printed in underglaze blue. 'B9799' painted in red. Earthenware, octagonal, transfer printed outline in underglaze blue, hand-painted in underglaze blue and enamel colours. Moulded handle, painted in underglaze blue, painted in gold with scales. Apricot lustre edge line.

Geo. L. Ashworth Broad Street Works, Hanley c.1900

Note: Same pattern as 56, 82 and 87–87A.

84

Jug, 'Hydra' shape.
Mark: 'MASON'S' over an angular crown drape enclosing 'PATENT IRONSTONE CHINA' printed in underglaze blue.
Earthenware, octagonal, outline transfer print in underglaze blue. Hand-painted in underglaze blue and enamel colours. Moulded handle painted in red, green and apricot lustre, apricot lustre edge line.

Geo. L. Ashworth Broad Street Works, Hanley c.1900

85 and 85A

Pair of Jugs, 'Hydra' shape.
Mark: 'MASON'S' over an angular crown drape enclosing 'PATENT IRONSTONE CHINA' printed in sepia. `B9748' painted in red. Earthenware, octagonal with square spout lip. Transfer printed outline in brown, hand-painted in enamel colours with the `Basket of Flowers' pattern. Moulded handle painted in underglaze blue and painted in gold with fish scales. Gold rim line.

Geo. L. Ashworth Broad Street Works, Hanley c.1900–20

86

Jug, 'Hydra' shape.
Mark: `B7648', painted in red, `B' in script incised.
Earthenware, octagonal, outline transfer print in underglaze blue. Hand-painted in underglaze blue and enamel colours. Moulded handle painted in red, green and apricot lustre.

Geo. L. Ashworth Broad Street Works, Hanley c.1900

Note: Pattern B7648 in the pattern book reads 'Jug. Hydra shaped. Ironstone, printed in blue. Enamelled and gilt as Davenport's Oriental pattern. Lustre to handles.' Entry originally made between December 1885 and October 1890.

87 and 87A

Two jugs (different sizes), 'Hydra' shape.
Mark: 'MASON'S' over angular crown drape enclosing 'PATENT IRONSTONE CHINA' in underglaze blue. `B9799' painted in red on both.
Earthenware, octagonal, outline transfer printed in underglaze blue. Hand-painted in enamel colours with the 'Bird and Peony' pattern. Moulded handle in underglaze blue painted in gold with scales. Apricot lustre rim line.

Geo. L. Ashworth Broad Street Works, Hanley c.1900

Note: Same pattern as 56, 82 and 83.

88 Mark: PICTURE 71

Jug.
Mark: In purple, 'MASON'S' over ribbon crown, with pattern name, 'PERSIANA'.
Earthenware. Outline printed in red, hand-painted in enamel colours, yellow, orange, green and purple.

Geo. L. Ashworth Broad Street Works, Hanley c.1930

89 Mark: PICTURE 72

Jug.
Mark: 'MASON'S' over beaded crown in brown with 'England' below.
Earthenware, transfer printed outline, painted in underglaze blue only (unfinished).

Geo. L. Ashworth Broad Street Works, Hanley c.1920–30

90

Jug, 'Hydra' shape.
Earthenware Imari pattern, painted in underglaze blue and overglaze enamel.

Geo. L. Ashworth Broad Street Works, Hanley c.1900–20

91

Jug.
Mark: 'MASON'S' over angular crown, transfer printed in black.
Earthenware, underglaze blue printed outline and painted also in underglaze blue cobalt. Traces of gilding.

C. J. Mason Lane Delph c.1845–8

92

Jug, 'Hydra' shape.
Mark: Impressed 'MASON'S PATENT IRONSTONE CHINA' in two lines.
Ironstone mazarine blue, on-glaze enamel flower sprays with gilding.

C. J. Mason Lane Delph c.1815–25

93

Jug.

Mark: 'MASON' over small round crown, drape enclosing 'PATENT IRONSTONE CHINA' printed in black.

Earthenware, outline print with enamelling. Twig handle, in green.

Geo. L. Ashworth Broad Street Works, Hanley c.1870–80

94

Jug, 'Hydra' shape.

Mark: 'MASON'S' over an angular crown, drape enclosing 'PATENT IRONSTONE CHINA' printed in sepia.

Earthenware, octagonal with rounded spout lip, pattern as 85.

Geo. L. Ashworth Broad Street Works, Hanley c.1900–20

95 to 95o

Part dessert service, comprising: six dishes of different shapes and ten plates.

Mark: 'MASON'S' over an angular crown, drape enclosing 'PATENT IRONSTONE CHINA' printed in sepia.

Ironstone, outline transfer printed in black. Hand-painted in enamel colours with Chinese figurative subjects within a scroll. Handles moulded in the form of scrolls. The foot decorated with scroll and wave motif transfer printed in black, hand-painted in red.

C. J. Mason Lane Delph c.1835–45

Note: Pieces of this period frequently have decorated footrims.

Ill: Godden 1980, page 133, colour plate 8.

Godden 1991, page 142, colour plate 29.

96

Base to vegetable tureen (no lid).

Mark: 'MASON'S' over a ribbon crown, drape enclosing 'PATENT IRONSTONE CHINA' printed in sepia.

Ironstone, outline transfer printed in red. Hand-painted in enamel colours with a vase of flowers standing on a table. The inner border picked out in underglaze blue and yellow enamel. The flange with panels alternating with green, orange and white backgrounds. The moulded handles in the form of bows, picked out in gold.

Geo. L. Ashworth Broad Street Works, Hanley c.1870–5

97

Platter.

Mark: 'MASON'S' over an angular crown, drape enclosing 'PATENT IRONSTONE CHINA' printed in red. `4/255', painted in red. Impressed '6G?'.

Earthenware, outline transfer printed in red with an exotic bird in stylised landscape with flowering peony. Hand-painted in enamel colours, with a small amount of gilding. The border enamelled in dark green, the edge in apricot lustre.

Geo. L. Ashworth Broad Street Works, Hanley c.1930–9

Note: The dark 'Brunswick Green' used is very typical of the Ashworth products. The pattern 4/255 in the pattern book reads 'Dinner. Printed in Purple brown coloured underglaze in Apple Green and oven blue. Enamelled in rose-red, 616 blue, yellow green, blue green and yellow, 17 brown. Lustre edge, Gilt. "Manderlay".' The design was entered about 1930.

98

Large rectangular platter. (Meat plate from a dinner service.)
Mark: 'MASON'S' over an angular crown, drape enclosing 'PATENT IRON-STONE CHINA'. Transfer printed in underglaze blue. Impressed '10 06', and 'B'. Ironstone, outline transfer printed in underglaze blue, a variation of the 'Asiatic Pheasant'. Hand-painted in enamel colours and gold. Traces of apricot lustre on edge.

Geo. L. Ashworth Broad Street Works, Hanley c.1906

Note: The pattern is now referred to as the 'Flying Bird' design; see *Compendium* of Mason's patterns, published by Mason's Collectors Club (1996).

99 and 99A

Pair of dessert dishes.
Mark: 'MASON'S PATENT IRONSTONE CHINA' impressed in a straight line. On 99A, 'MASON'S PATENT IRONSTONE CHINA' impressed in two lines. Ironstone, of moulded rectangular form with moulded debased rococo handles. Transfer printed outline in underglaze blue, hand-painted in enamel colours and gold. Apricot lustre edge.

C. J. Mason Lane Delph c.1815–20

Note: The pattern is called the 'Jardiniere' design; see *Compendium* of Mason's patterns, published by Mason's Collectors Club (1996).

100 and 100A PICTURE 40

Pair of vases (no lids).
Ironstone, octagonal faceted shape, tapering to a moulded faceted foot. The handles moulded in the form of cabbage roses and buds. Cobalt blue ground, hand-painted in underglaze blue and red, orange, yellow and gold.

C. J. Mason Lane Delph c.1820–5

Note: The pattern is now called 'Rose and Apple' and is usually found on ornamental wares; see *Compendium* of Mason's patterns, published by Mason's Collectors Club (1996).

101 and 101A PICTURE 41

Soup tureen and lid.
Ironstone, of rectangular form with moulded foot; the finial to the lid a stylised flower. Elaborate scroll moulded handles both painted in cobalt blue, pattern of stylised flowers. Hand-painted in underglaze blue and enamel colours. Apricot lustre edge lines to tureen, foot and lid.

Unidentified (not thought to be by C. J. Mason) c.1840

102 and 102A PLATE S

Pair of dessert dishes.

Marks on both: 'MASON'S PATENT IRONSTONE CHINA' impressed in a straight line.

Ironstone, of rectangular form with moulded debased rococo handles. Hand painted in enamel colours with stylised flowers in an oriental-type landscape, picked out in gold. Apricot lustre edge line.

C. J. Mason Lane Delph c.1815–20

Note: Pattern now referred to as 'Fence, Blue Leaf and Lilac'; see *Compendium* of Mason's patterns, published by Mason's Collectors Club (1996).
Ill: Shape: Godden 1980, page 137, plate 180.
Godden 1991, page 135, plate 180.

103 and 103A PICTURE 42

Pair of dessert dishes.

Mark: 'PATENT IRONSTONE CHINA' impressed in a circle. Printed in black, rounded crown with drape enclosing 'PATENT IRONSTONE CHINA' overpainted in green enamel.

Ironstone, moulded in the form of elongated leaves. On one side a stylised acanthus leaf moulded to form a handle, on the other a debased rococo handle. Outline transfer printed in black, overpainted by hand in enamel colours and gold with stylised oriental flowers.

C. J. Mason Lane Delph c.1815-1820

Note: These are based on designs made in the Orient for the export market – they are more stylised in form than the originals. See 102 and 102A for same form. Pattern now referred to as 'Prunus Tree, Rose and Flower'; see *Compendium* of Mason's patterns, published by Mason's Collectors Club (1996).
Ill: Shape: Godden 1991, page 134, colour plate 24.

104 and 104A PICTURE 43

Pair of dessert dishes.

Mark: 'MASON'S' over a rounded crown above a drape enclosing 'PATENT IRONSTONE CHINA' printed in sepia.

Ironstone, of moulded irregular leaf form. Outline transfer printed in sepia, hand- painted in underglaze blue, red, green and yellow enamel. Apricot lustre edge. Decorated footrim.

C. J. Mason Lane Delph c.1830–40

105 and 105A 105: PICTURE 42; 105A: PICTURE 44

Two dishes, from a dessert service.

Mark: on 105, crown above a drape enclosing 'PATENT IRONSTONE CHINA' printed in black, overpainted in green enamel. On 105A, 'MASON'S PATENT IRONSTONE CHINA' impressed in a straight line. 'MASON'S' over a crown,

the drape enclosing 'PATENT IRONSTONE CHINA' printed in black, overpainted in green enamel.
105: Ironstone, oval form with shaped rim, small moulded scroll handles. Inner moulded central panel. 105A: Semi-circular form with elaborate tri-form handle into a stylised acanthus leaf. Decorated with outline transfer print in black. Hand-painted in enamel colours with `Table and Flowerpot' design. Apricot lustre edge line.

C. J. Mason Lane Delph c.1815–20

Note: The decoration is frequently called `Table and Flower Vase' pattern.
Ill: Shape and pattern: Godden 1980, page 138, plate 181.
Godden 1991, page 156, plate 181.

106 and 106A PICTURE 45

Two dishes from a dessert service.
Marks: on 106, 'MASON'S PATENT IRONSTONE CHINA' impressed in two lines and 'MASON'S' over a rounded crown, the drape enclosing 'PATENT IRONSTONE CHINA'. Transfer printed in underglaze blue. '2' painted in red enamel. On 106A, rounded crown over a drape enclosing 'PATENT IRONSTONE CHINA' printed in underglaze blue.
106: Ironstone, oval form with shaped rim, small moulded scroll handles. Inner moulded central panel. 106A: Palette shape. Both outline transfer printed in black, overpainted in enamel colours and gold, with the `Mogul' pattern. Underglaze blue, printed scroll border. Apricot lustre edge.

C. J. Mason Lane Delph c.1815–20

Note: Generally referred to as the 'Mogul' pattern.
Ill: Godden 1991, colour page 30, plate 143; Godden 1980, colour page 136.

107 and 107A PICTURE 46

Two dishes from a dessert service.
Marks on both: 'MASON'S PATENT IRONSTONE CHINA' impressed in a straight line.
107: elongated leaf form with stylised acanthus moulded handle. 107A: Ironstone, semi-circular form with elaborate tri-form handle into a stylised acanthus leaf. Both decorated with a rich pattern, cobalt blue ground, with reserve panels, alternating `ogee' scroll shapes and circular reserves. The circular panels painted in pink enamel with rocks and stylised foliage. The others with oriental landscapes enclosing a zig-zag fence. The central oval reserve containing a screen, fence and table with vase of flowers, hand-painted in enamel colours, all the reserves outlined in gold. Gold scrolls decorating the cobalt ground. Gold edge line.

C. J. Mason Lane Delph c.1815–20

Note: See 119 and 119A for matching shaped dessert plates.
Pattern now referred to as 'Panelled Fence, Bonsai Tree and Box and Flowers' pattern; see *Compendium* of Mason's patterns, published by Mason's Collectors Club (1996).

108 PICTURE 47, PLATE T

Dessert dish.

Mark: 'MASON'S PATENT IRONSTONE CHINA' and `O' impressed in a straight line.

Ironstone, semi-circular form with elaborate tri-form handle into stylised acanthus leaf. On the opposite side debased rococo scrolls moulded. Hand-painted in underglaze blue cobalt, and overglaze red. Rich gilding, including panels of gold scales over a red ground and gold scales over a pale pink ground.

C. J. Mason Lane Delph c.1815–20

109 PICTURE 47

Dessert dish.

Mark: 'MASON'S PATENT IRONSTONE CHINA' impressed in a straight line.

Ironstone, of moulded rectangular form with debased rococo handles. Hand-painted in underglaze blue and red enamel with rich gilding, comprising alternate wedge- shaped reserves with cobalt and white ground. The central section containing a stylised daisy with red and white panels, the whole painted with floral subjects.

C. J. Mason Lane Delph c.1815–20

Note: See 117 and 117A and 118 and 118A for matching dessert plates.
The pattern is now referred to as 'Mazarine Quadrants'; see *Compendium* of Mason's patterns, published by Mason's Collectors Club (1996).

110 PICTURE 43

Dessert dish.

Mark: 'MASON'S PATENT IRONSTONE CHINA' impressed in two lines.

Ironstone, of moulded rectangular form with debased rococo handles. Hand-painted in underglaze blue and overglaze red and orange enamel, with stylised flowers including daisies.

C. J. Mason Lane Delph c.1815–20

Note: Pattern now referred to as 'Flowers and Wheels'; see *Compendium* of Mason's patterns, published by Mason's Collectors Club (1996).

111 PLATE T

Dessert dish.

Mark: 'PATENT IRONSTONE CHINA' impressed in a circle.

Ironstone, semi-circular form with elaborate tri-form handle into a stylised acanthus leaf. Hand-painted in underglaze blue and enamel colours, with oriental landscape comprising a holey rock and red zig-zag fence, stylised flowers, enriched with gold. Gold edge lines.

C. J. Mason Lane Delph c.1815–20

Note: Pattern now referred to as 'Fence, Rock and Gold Flower'; see *Compendium* of Mason's patterns, published by Mason's Collectors Club (1996).

112 PICTURE 48

Large meat plate.
Ironstone, moulded with channels leading to juice well. Hand-painted in underglaze blue with a basket of flowers in overglaze red and orange enamel enriched with gold. Apricot lustre edge line.

C. J. Mason Lane Delph c.1835–40

113 PICTURE 45

Sauce boat stand.
Mark: Large round crown above drape enclosing 'PATENT IRONSTONE CHINA' printed in black.
Ironstone, pear-shaped. Transfer printed in black and hand-painted in enamel colours with the 'Mogul' pattern. Underglaze blue printed border.

C. J. Mason Lane Delph c.1815–20

Note: Often erroneously called a spoon tray in early records.

114

Sauce tureen stand.
Ironstone, oval form with moulded edge. The handles moulded in the form of overlapping leaves. Transfer printed in underglaze blue, overpainted in red enamel, with the 'Basket of Flowers' pattern.

C. J. Mason Lane Delph c.1820–5

115

Plate.
Mark: 'MASON'S PATENT IRONSTONE CHINA' impressed in one line.
Ironstone, border moulded with a `leaf' design overdecorated. Transfer printed in underglaze blue and overpainted in red and orange enamel and gold, with the 'Rock, Peony and Vase of Flowers' pattern. Edge decorated with apricot lustre.

C. J. Mason Lane Delph c.1815–25

Note: Pattern now referred to as 'Vase and Rock'; see *Compendium* of Mason's patterns, published by Mason's Collectors Club (1996).
Ill: Pattern: Godden 1980, page 127, plate 153.
Godden 1991, page 145, plate 155.

115A

Plate.
Mark: 'MASON'S PATENT IRONSTONE CHINA' impressed in one line.
Ironstone, border moulded with a `leaf' design overdecorated. Transfer printed in underglaze blue and overpainted in red and orange enamel and gilt, with the 'Rock, Peony and Vase of Flowers' pattern. Decorated with green enamel.

C. J. Mason Lane Delph c.1815–25

Note: This plate has the appearance of overpainting (clobbering), possibly added at a later date, including the use of pink and pale green enamels.
Pattern now referred to as 'Vase and Rock'; see *Compendium* of Mason's patterns, published by Mason's Collectors Club (1996).

116

Plate.
Mark: 'MASON'S' over an angular crown, drape enclosing 'PATENT IRON-STONE CHINA' printed in underglaze blue.
Ironstone, moulded border of alternate panels of gadroons and overlapping scales, interposed with stylised daisy heads and shells. Pattern as 115. Green enamel wash on edge of well.

Geo. L. Ashworth Broad Street Works, Hanley c.1860–70

Note: The moulded border is found throughout the company history, though it is not common in any period. See 115 for same pattern.
Pattern now referred to as 'Vase and Rock'; see *Compendium* of Mason's patterns, published by Mason's Collectors Club (1996).

117 and 117A

Pair of plates.
Mark: 'MASON'S PATENT IRONSTONE CHINA' on both, impressed in a straight line.
Ironstone, hand-painted in underglaze blue and red enamel with additional gilding, comprising alternate wedge-shaped panels with cobalt and white ground. In the central reserve a stylised Catherine wheel with alternate panels in red enamel and white. The whole painted with floral subjects.

C. J. Mason Lane Delph c.1820–5

Note: See 109 for dessert dish of the same pattern. This pair not as richly gilded as 118 and 118A.
Pattern now referred to as 'Mazarine Quadrant'; see *Compendium* of Mason's patterns, published by Mason's Collectors Club (1996).

118 and 118A

Pair of dessert plates.
Mark: 'MASON'S PATENT IRONSTONE CHINA' on both, impressed in a straight line.
Ironstone: see 117 for description of pattern, but with richer gilding.

C. J. Mason Lane Delph c.1820–5

Note: See 109 for dessert dish and 117 for plates to match. Less richly gilded.
Pattern now referred to as 'Mazarine Quadrants'; see *Compendium* of Mason's patterns, published by Mason's Collectors Club (1996).

119 and 119A

Pair of dessert plates.
Marks: On 119, 'MASON'S PATENT IRONSTONE CHINA' impressed in a straight line. On 119A, 'PATENT IRONSTONE CHINA' impressed in a circle. Ironstone, see 107 for description of pattern.

C. J. Mason Lane Delph c.1815–20

Note: See 107 for dessert dishes to match.
Pattern now referred to as 'Panelled Fence, Bonsai Tree, Box and Flowers'; see *Compendium* of Mason's patterns, published by Mason's Collectors Club (1996).

120 to 120B

Pair of plates and oblong dessert dish.
Bone china, the plates moulded with eight points to the border. The dessert dish moulded with elaborate and exaggerated lobes. Transfer printed in underglaze blue with a central reserve depicting topographical scenes, the border of roses, gothic arches and chequered panels. The edge enamelled in green and pink enamel. Gold ornamentation. 'FLOREAT DOMUS' in transfer print on the edge.

C. J. Mason Lane Delph c.1825–30

Ill: Godden 1991, page 152, plate 172.

121 to 121C

Three plates (dessert), one dinner plate.
Mark: 'MASON'S PATENT IRONSTONE CHINA' on all four, impressed in a straight line.
Ironstone gadroon moulded edge picked out in blue enamel and gold. Hand-painted with random flower sprays, some in enamel colours and others in gold.

C. J. Mason Lane Delph c.1820–5

Note: Pattern now referred to as 'Central Rose Spray'; see *Compendium* of Mason's patterns, published by Mason's Collectors Club (1996).

122 to 122C

Three soup plates, one moulded dessert dish.
Mark: On soup plates, 'MASON'S PATENT IRONSTONE CHINA' impressed in a straight line. On dessert dish, 'MASON'S PATENT IRONSTONE CHINA' impressed in two lines.
Ironstone, dessert dish of moulded rectangular form with moulded debased rococo handles. Transfer printed in brown on glaze, hand-painted in enamel colours. The pattern of random baskets of flowers, a larger basket in the centre. Brown edge line.

C. J. Mason Lane Delph c.1820–5

Note: 122A, 122B and 122C exhibits, large filled-in fire cracks. All the soup plates have 'spit-out' and other firing faults possibly sold as 'Thirds'.
Pattern now referred to as 'Posy Baskets'; see *Compendium* of Mason's patterns, published by Mason's Collectors Club (1996).

123 to 123B

Plate and pair of small side plates.

Mark: On 123, 'MASON'S PATENT IRONSTONE CHINA' impressed in a straight line. On 123A and 123B, 'PATENT IRONSTONE CHINA' impressed in a circle.

Ironstone, outline transfer printed in black depicting two exotic birds in an oriental landscape with holey rock and stylised peony. Hand-painted in enamel colours and gold. Underglaze blue painted border line and apricot lustre edge line.

C. J. Mason Lane Delph c.1820–5

Note: Pattern now referred to as 'Peacocks, Peony and Rock'; see *Compendium* of Mason's patterns, published by Mason's Collectors Club (1996).
Ill: Godden 1980, page 186, plate 285.
Godden 1991, page 211, plate 285.
Samlesbury Hall, 1977 and 1987, Lot 171.

124

Plate.

Mark: 'MASON'S' over a round crown drape enclosing 'PATENT IRONSTONE CHINA' printed in brown.

Ironstone, outline transfer printed in black, hand-painted in enamel colours and gold. The border with four triangular panels in green enamel. The centre with stylised oriental flowers in underglaze blue and enamels. Apricot lustre edge.

C. J. Mason Lane Delph c.1835–40

Note: Pattern now referred to as 'Peonies and Daisies'; see *Compendium* of Mason's patterns, published by Mason's Collectors Club (1996).

125

Plate.

Mark: 'MASON'S' over an angular crown, drape enclosing 'PATENT IRONSTONE CHINA' printed in black. '1762' painted in red.

Ironstone, outline transfer printed in black, hand-painted in enamel colours and gold. The border with four alternating panels of green enamel with diagonal gold lines and cream with black and peach flower and scale motif. The centre with a tree peony in naturalistic colours.

C. J. Mason Lane Delph c.1845–50

Note: Pattern now referred to as 'Peony and Prunus Bush'; see *Compendium* of Mason's patterns, published by Mason's Collectors Club (1996).

126 and 126A PICTURE 40

Pair of vases.

Mark: 'MASON'S' over an angular crown, drape enclosing 'PATENT IRONSTONE CHINA' printed in black. '199^1/$_2$' painted in red.

Ironstone, body moulded with four ribs providing central 'ogee'-shaped panel. Flaring neck with swan neck handles. Each side decorated with black transfer

prints depicting a 'landscape in a scroll'. The central section with red enamel wash, the neck green wash divided by an underglaze blue band. The whole overprinted in black with Prunus flowers, picked out in enamel colours. The swan necks in yellow enamel. Gold edge line.

C. J. Mason Lane Delph c.1840–5

Note: See 142 for same pattern. The basic pattern carries the full number, the fractional figures refer to variations in the decoration.
Pattern now referred to as 'Scroll and Prunus'; see *Compendium* of Mason's patterns, published by Mason's Collectors Club (1996).

127

Tureen stand.
Mark: 'MASON'S PATENT IRONSTONE CHINA' impressed in a straight line.
Ironstone, moulded border of alternate panels of gadroons and overlapping scales, interposed with stylised daisy heads and shells. Decorated in underglaze blue. Hand- painted in red enamel with stylised daisies. Enriched with gilding.

C. J. Mason Lane Delph c.1825–30

Note: Same moulded border as 116.

128

Soup plate.
Mark: 'MASON'S PATENT IRONSTONE CHINA' impressed in a straight line and 'MASON'S' over a large crown, drape enclosing 'PATENT IRONSTONE CHINA' printed in underglaze blue.
Transfer printed in underglaze blue with an Italianate landscape with man on horseback. The border composed of classical fragments including columns, frescos and pillars known as 'Quodlibet'. Plate moulded with eight lobes around the rim.

C. J. Mason Lane Delph c.1820–30

Note: Pattern now referred to as 'Ancient Ruins'; see *Compendium* of Mason's patterns, published by Mason's Collectors Club (1996).
Ill: Godden 1980, page 128, plate 159.
Godden 1991, page 148, plate 159.

129

Small side plate.
Mark: 'MASONS' over an angular crown, drape enclosing 'PATENT IRONSTONE CHINA' printed in black.
Ironstone, transfer printed outline in black, with a vase of flowers and four Chinese symbols, painted in enamel colours. The border in underglaze blue decorated with daisies and leaves, picked out in yellow enamel. Apricot lustre border.

C. J. Mason Lane Delph c.1840–5

Ill: Godden 1980, page 163, plate 238.
Godden 1991, page 189, plate 238.

130

Small side plate.
Mark: 'MASON'S PATENT IRONSTONE CHINA' impressed in a straight line.
Ironstone, hand-painted in underglaze blue, overpainted in red enamel and gold
with stylised flowers and leaves. Apricot lustre edge.

C. J. Mason Lane Delph c.1820–5

Note: Pattern now referred to as 'Stylised Chrysanthemum'; see *Compendium* of
Mason's patterns, published by Mason's Collectors Club (1996).

131

Deep saucer (probably for a breakfast cup).
Mark: 'MASON'S PATENT IRONSTONE CHINA' impressed in two lines.
Ironstone, outline transfer printed in underglaze blue. Hand-painted in red
enamel and apricot lustre.

C. J. Mason Lane Delph c.1815–20

Note: Pattern now referred to as 'Basket Japan'; see *Compendium* of Mason's patterns,
published by Mason's Collectors Club (1996).
Ill: Godden 1980, page 114, plate 144. See 54 for same pattern.

132 to 132E

Three cups and saucers.
Marks: On 132 to 132D, 'MASON'S' over a round crown drape enclosing
'PATENT IRONSTONE CHINA' printed in underglaze blue. 'B9824' painted
in red. On 132E, 'MASON'S' over a round crown, drape enclosing 'PATENT
IRONSTONE CHINA' printed in black.
Ironstone, cups of comma shape. The whole decorated with transfer prints in
underglaze blue. Overpainted in overglaze red. Apricot lustre edge.

Geo. L. Ashworth Broad Street Works, Hanley c.1900–10

Note: 132E was probably manufactured as a replacement for the earlier service. This
comma form is uncommon. They derive from eighteenth-century French (Sèvres) and
later English custard cups.
Pattern now referred to as 'Basket Japan'; see *Compendium* of Mason's patterns,
published by Mason's Collectors Club (1996).

133 to 133C

Pair of coffee cups and saucers.
Mark: 'MASON'S' over a round crown, drape enclosing 'PATENT IRONSTONE
CHINA' transfer printed in underglaze blue. 'B8834' painted in red. 133B has
incised 'B'.
Ironstone, coffee cups of comma shape. Decorated with an underglaze blue
transfer print. Hand-painted in red and orange enamel and gold. Apricot lustre
edge line. Border of intersecting diamonds enclosing a quatrefoil. Transfer printed
in underglaze blue.

Geo. L. Ashworth Broad Street Works, Hanley c.1900–10

Note: Pattern now referred to as 'Jardiniere'; see *Compendium* of Mason's patterns, published by Mason's Collectors Club (1996).
Ill: Godden 1980, pages 178–9, plates 269 and 270.
Godden 1991, pages 203 and 204, plates 269 and 270.

134

Plate.
Mark: 'MASON'S PATENT IRONSTONE CHINA' impressed in a straight line over a large crown, drape enclosing 'PATENT IRONSTONE CHINA' transfer printed in underglaze blue.
Ironstone, eight-lobed plate. Transfer printed in underglaze blue.

C. J. Mason Lane Delph c.1820–30

Note: Pattern now referred to as 'Chinese Dragon'; see *Compendium* of Mason's patterns, published by Mason's Collectors Club (1996).

135

Jug.
Mark: 'MASON'S' over an angular crown, drape enclosing 'PATENT IRON-STONE CHINA' printed in brown.
Ironstone, faceted body, on three scroll feet, wide flaring spout, elaborate scroll handle. Decorated with outline transfer print in brown, hand-painted in blue, red and yellow enamel, with a basket of flowers. Border including lambrequin motifs, enamelled by hand. Gold border line.

C. J. Mason Lane Delph c.1835–40

136

Rose water bottle (no lid).
Mark: 'MASON'S PATENT IRONSTONE CHINA' impressed in two lines.
Ironstone bottle, eight-faceted body with elongated neck. Spout from halfway up the neck, simple high loop handle. Hand-painted in underglaze blue and red enamel. Apricot lustre and gold. 'Imari' style. The handle and spout with gilded gold neck edge.

C. J. Mason Lane Delph c.1820–5

Note: Pattern now referred to as 'Fence Japan'; see *Compendium* of Mason's patterns, published by Mason's Collectors Club (1996).
Ill: Godden 1980, page 189, plate 292.
Godden 1991, page 214, plate 292.
Samlesbury Hall 1987 Lot 45.

137

Vase.
Mark: 'MASON'S PATENT IRONSTONE CHINA' impressed in two lines.
Ironstone, of inverted baluster shape, slightly flaring neck, scroll handles on the shoulders. Decorated with underglaze blue transfer print and overglaze red enamel.

Apricot lustre with gilding, of an oriental scene including stylised flowers and leaves, zig-zag fence and holey rock. Gilding on the handles.

C. J. Mason Lane Delph c.1820–5

Note: This form should not, according to the records, have a lid.
Pattern now referred to as 'Fence Japan'; see *Compendium* of Mason's patterns, published by Mason's Collectors Club (1996).

138

Candlestick.
Mark: 'PATENT IRONSTONE CHINA' impressed in a circle.
Ironstone, pillar candlestick form with turned beads on top flange, two on column and on footrim. Hand-painted in underglaze blue and red enamel with apricot lustre.

C. J. Mason Lane Delph c.1820–5

Note: Candlestick of same form, decorated with polychrome enamels No. 34.
Pattern now referred to as 'Fence Japan'; see *Compendium* of Mason's patterns, published by Mason's Collectors Club (1996).
Ill: Godden 1980, page 148, plate 207.
Godden 1991, page 167, plate 207.

139 and 139A

Vase and cover.
Earthenware, decorated with 'Bandana' pattern. Orange enamel background picked out in enamel colour. Stylised acanthus leaf handles terminating in an animal mask painted on the exterior in underglaze blue, and on the interior in pink enamel, overpainted in yellow/ochre enamel. Finial to lid, a four-storeyed pagoda.

C. J. Mason Daisy Bank Works c.1850–1

Note: see 74 for reference to 'Bandana'.

140 and 140A

Covered canister.
Porcelain jar of tapering square form, with sloping shoulders into a long neck covered by a deep square lid. Each facet containing a rococo scroll panel enclosing chinoiserie scenes. Outline transfer print in black, hand-painted in enamel colours. The background composed of transfer printed cells enclosing a small red enamel circle. Around the base of the neck a peach band overpainted with foliate scrolls in gold.

Factory unknown Nineteenth century

141

Vase (no cover).
Porcelain, inverted baluster form. The neck band and bottom third transfer printed in underglaze blue and overpainted in enamel colours and gilt with flower sprays. The central section transfer printed outline in black with two Chinese court

scenes: the first presenting his papers; the second depicting the Emperor reading a sheet of written words.

Factory unknown c.1840–50

Note: The decoration is probably based on a piece of oriental export porcelain.

142

Vase.

Mark: 'MASON'S' over an angular crown, drape enclosing 'PATENT IRONSTONE CHINA' printed in black.

Bone china, body moulded with six faceted panels. Flaring neck. Decorated with oval panels of red enclosing black transfer printed landscape in a scroll, surrounded by 'Prunus', picked out in enamel colours. The body and foot covered in under-glaze blue. The neck decorated in green, overpainted in yellow/ochre enamel with stylised flowers and scrolls.

C. J. Mason Lane Delph c.1840–8

Note: See 126 for similar decoration.

Pattern now referred to as 'Scroll and Prunus'; see *Compendium* of Mason's patterns, published by Mason's Collectors Club (1996).

143 and 143A PICTURE 49

Vase and cover.

Mark: 'MASON'S PATENT IRONSTONE CHINA' impressed around the flange of the lid in a straight line.

Ironstone, body moulded with six panels, pronounced shoulder from which flares a deep neck. A flat pedestal base with four bracket feet. The lid in the form of an elongated dome, rising to a point on two facets, moulded zig-zag trellis corresponding with trellis moulded on the neck. Elaborate dragon moulded handles painted in gold. The whole covered in a green enamel with cream reserves, randomly placed depicting chinoiserie landscapes and fishing scenes. Outlines in thick bands of gold.

C. J. Mason Lane Delph c.1815–20

Note: On the base and inside of the lid, a heavily blued glaze.

Ill: Similar Samlesbury Hall 1987, Lot 156.

144

Tureen (no lid).

Mark: Large early crown drape enclosing 'PATENT IRONSTONE CHINA' printed in black and overpainted in green enamel.

Ironstone, melon shape on divided pedestal foot of moulded leaves, leaf moulded handles painted in underglaze blue and picked out in gold. Decorated with outline transfer print in black, hand-enamelled in colours. Gold line scallop moulded rim and outlines to leaves. The foot moulded with beads between two gold lines.

C. J. Mason Lane Delph c.1820–5

Note: See 39 for same form with lid.

Pattern now referred to as 'Prunus Tree, Rock and Flower'; see *Compendium* of Mason's patterns, published by Mason's Collectors Club (1996).

145

Vegetable tureen (no lid).

Mark: 'PATENT IRONSTONE CHINA' impressed in a circle.

Ironstone, hexagonal shape on pierced base. Decorated in underglaze blue and red enamel, orange lustre and gold with a basket of flowers. Apricot lustre edge line and single line on foot.

C. J. Mason Lane Delph c.1820–5

Note: Pattern now referred to as 'Basket Japan'; see *Compendium* of Mason's patterns, published by Mason's Collectors Club (1996).

146 and 146A

Chamber pot and tooth brush vase (part of a wash stand set).

Mark: 'MASON'S' over an angular crown drape enclosing 'PATENT IRONSTONE CHINA' printed in black, '1365' painted in red.

Earthenware, chamber pot, faceted with hydra handle. Transfer printed outline in black, hand-painted in enamel colours, with pagoda and bridge in chinoiserie landscape. Brown and ochre edge lines. Tooth brush vase – as above.

Geo. L. Ashworth Broad Street Works, Hanley c.1875–85

147

Wash bowl (miniature).

Mark: 'MASON'S' over a rounded crown, drapes enclose 'PATENT IRONSTONE CHINA' printed in black 'B1763' painted in red.

Earthenware, octagonal, outline transfer printed in black, painted in enamel colours with flowers, fence and urn in the oriental manner. Brown enamel edge line.

Geo. L. Ashworth Broad Street Works, Hanley c.1900–10

Note: Pattern book entry reads: 'B 1763 – As B 1749 but landscape centre'. B 1749 reads 'As B 1747 but pink band'. B 1747 reads 'Table Windsor shape, band marone lines and spots gold'.

148 Mark: PICTURE 73

Vase.

Mark: 'MASON'S' over a rounded crown, drape enclosing 'IRONSTONE CHINA' 'ENGLAND' and 'Rd. No. 66906' all printed in underglaze blue. 'B9709' painted in red.

Earthenware, faceted, with eight panels, baluster shape with tall flaring neck. Transfer printed in underglaze blue with birds and peonies, overpainted in enamel colours. Broad band of underglaze blue oriental pattern around top. Apricot lustre edge line.

Geo. L. Ashworth Broad Street Works, Hanley c.1910–20

Note: Pattern now referred to as 'Blue India Pheasant'; see *Compendium* of Mason's patterns, published by Mason's Collectors Club (1996).

149

Loving cup.
Mark: 'MASON'S' over an angular crown, drape enclosing 'PATENT IRONSTONE CHINA' printed in underglaze blue.
Ironstone, of inverted bell shape on circular foot, slightly flared rim, scroll handles. Transfer printed in underglaze blue with oriental landscape.

Geo. L. Ashworth Broad Street Works, Hanley c.1890–1900

150

Coffee cup (no saucer).
Mark: 'MASON'S' over an angular crown drape enclosing 'PATENT IRONSTONE CHINA' printed in brown.
Ironstone, slightly ribbed form with snake handle. Outline transfer print in black, the ground of scales overpainted in red enamel, reserves on each side of Chinese scenes overpainted in enamel colours. The handle painted in green enamel and apricot lustre.

C. J. Mason Lane Delph c.1840–8

151

Tea cup.
Mark: 'MASON'S' over rounded crown, drape enclosing 'PATENT IRONSTONE CHINA' transfer printed in sepia.
Earthenware, low shape, decorated in underglaze blue overpainted in red and orange enamel, elaborate gilding. 'D' shaped handle with inner spur and pronounced thumb rest.

Geo. L. Ashworth Broad Street Works, Hanley c.1860–70

152

Tea cup.
Bone china, moulded with vine leaves and tendrils. Handle with thumb rest and inner spur. Transfer printed in underglaze blue overpainted in red enamel with a basket of flowers.

C. J. Mason Lane Delph c.1815–20

Note: Pattern now referred to as 'Basket Japan'; see *Compendium* of Mason's patterns, published by Mason's Collectors Club (1996).

153

Soup plate.
Mark: 'MASON'S' over angular crown, drape enclosing 'PATENT IRONSTONE CHINA' printed in sepia. Pattern number '3296' painted in ochre inside the footring.

Ironstone. Rib moulded flange. The edge and bowl painted in underglaze blue intersected by pink and green enamel band. Decorated with flowers in enamel colours and gold foliate sprays. The flange ornamented with diaper border and four reserves enclosing leaves and buds all painted in gold.

C. J. Mason Lane Delph c.1840–8

Note: Three ochre enamel sprigs on the reverse.

154

Plate.
Mark: 'MASON'S' over ribbon crown, drape enclosing 'PATENT IRONSTONE CHINA' printed in black. '1435' painted in red enamel.
Ironstone, painted in underglaze blue with elaborate border motif and central vase of flowers on a table, hand painted in red, orange and ochre enamel. Apricot lustre border line.

C. J. Mason Lane Delph c.1840–8

Note: Three flower sprays on reverse

155

Plate.
Mark: 'MASON'S' over an angular crown, drape enclosing 'PATENT IRON-STONE CHINA' printed in sepia, '3271' painted in ochre enamel inside footrim.
Ironstone. Rib moulded flange. The flange decorated in underglaze blue with reserves of alternating Chinese figures and flowers on an orange background, overpainted in gold with stylised trailing leaves. The centre panel, square with canted corners, containing outline transfer printed design in sepia of Chinese symbols on a leaf with peonies, overpainted in enamel colours and gold.

C. J. Mason Lane Delph c.1840–8

156 and 156A

Pair of plates.
Marks: '6702' in yellow enamel and 'No 13' transfer printed in blue on the flange. A sun motif and 'O' transfer printed in blue.
Earthenware, transfer printed outline in dark blue, overpainted in enamel colours.

Manufacturer unknown c.1870–5

Note: No 13 is probably a copper plate number relating to the manufacturer.

157

Dessert plate.
Mark: 'MASON'S' over an angular crown drape enclosing 'PATENT IRON-STONE CHINA' printed in sepia, 'B9229' painted in red enamel.
Earthenware, moulded gadroon edge. Transfer printed outline in sepia of a basket of flowers, overpainted in enamel colours. Orange lustre edge line. Underglaze blue inner band border. Waterleaf motifs on flange, alternating with printed lambrequins.

Geo. L. Ashworth Broad Street Works, Hanley c.1910–20

Note: The pattern book entry for B9229 reads 'Dinnerware. Rundell shape. Ironstone no. 3/496, but brown edge.' The pattern was entered between 1898–1903.

158

Plate.

Mark: 'MASON'S' over an angular crown, drape enclosing 'PATENT IRONSTONE CHINA' printed in black. The mark appears to have some black overpainting in enamel. '2596' painted in red enamel.

Ironstone, moulded edge with shaped profile. Transfer printed outline in grey with exotic birds in a fenced garden and tree peony, painted in underglaze blue and enamel colours. Elaborate border design of panels alternating in underglaze blue and green enamel linked with foliate sprays. Gold edge line.

C. J. Mason Lane Delph c.1840–8

159

Plate.

Mark: 'MASON'S' over a round crown, drape enclosing 'PATENT IRONSTONE CHINA' printed in sepia.

Ironstone. Facet moulded flange. Outline transfer printed in sepia depicting the 'Lyre Bird' pattern, overpainted in enamel colours. Apricot lustre edge line. Gold embellishment to design.

C. J. Mason Lane Delph c.1835–45

160

Plate.

Mark: 'MASON'S PATENT IRONSTONE CHINA' impressed in a straight line.

Ironstone, embossed edge. Transfer printed in underglaze blue with 'Rock, Peony and Vase' pattern.

C. J. Mason Lane Delph c.1815–25

Note: This piece is only part decorated – no enamels or gilding having been added. The object obviously sagged during the glaze firing, making it unsaleable in the nineteenth century.

161

Plate.

Mark: 'MASON'S' over an angular crown, drape enclosing 'PATENT IRONSTONE CHINA' printed in black.

Ironstone. Facet moulded edge flange. Outline transfer printed in black. The design is asymmetrical with a large half wheel motif. Three panels in underglaze blue divide the remainder of the rim, all joined with foliate sprays. The centre enclosed within a double band of semi-circles, with an oriental landscape of a tree, fence and a tri-part banner, all overpainted in enamel colours and gold. Apricot lustre edge line.

Geo. L. Ashworth Broad Street Works, Hanley c.1870–80

162

Soup plate.
Mark: 'MASON'S' over a ribboned crown, drape enclosing 'PATENT IRON-STONE CHINA' printed in sepia.
Ironstone. Facet moulded rim decorated with underglaze blue edge line. Inner well painted with green enamel. The whole outline transfer printed in sepia with oriental landscape overpainted in enamel colours.

Geo. L. Ashworth Broad Street Works, Hanley c.1890–1900

163

Plate.
Mark: 'MASON'S PATENT IRONSTONE CHINA' impressed in a straight line.
Ironstone. Facet moulded rim, outline transfer printed in black of oriental landscape with large brick wall and islands.

C. J. Mason Lane Delph c.1820–30

Note: It is possible that this piece has been later decorated and refired.
Pattern now referred to as 'Coloured Wall'; see *Compendium* of Mason's patterns, published by Mason's Collectors Club (1996).

164

Soup tureen stand.
Mark: pattern number 2661. Earthenware, outline transfer printed in black with the 'Peking – Japan' pattern, overpainted in red, orange and blue enamels. The moulded handles painted in underglaze blue and gold. Apricot lustre edge line.

Geo. L. Ashworth Broad Street Works, Hanley c.1890–1900

Note: This piece is part decorated.
Ill: Haggar & Adams 1977, plate 101 and 102 for pattern.

165 and 165A

Tea cup and saucer.
Bone china. Pink lustre decoration of foliate scrolls intersected by blue and red enamel bells. Pink lustre edge line. Handle in the form of a loop with upward pointing thumb rest.

Factory 'Z', possibly Wolfe at Stoke-on-Trent c.1810–15

Note: Handle form similar to known Miles Mason pieces but not identical and different knop to top of handle.
Factory Z is as yet not positively identified, but is thought to be Thomas Wolfe manufacturing at Stoke-on-Trent or Liverpool, c.1800–20.

166

Jug.
Mark: 'IRONSTONE CHINA' impressed in a straight line.
Ironstone, octagonal with two-legged beast handle. Covered in mazarine blue.

Decorated in white enamel and gold with flower sprays. The handle painted in green enamel, the beast's ruff painted in orange enamel and gold.

Maker unknown c.1825–30

Note: Similar to the Fenton shape. The mark also emulates the Mason products.

167
Plate.
Hard-paste porcelain, painted in underglaze blue and red and green enamels.

Japanese Nineteenth Century

Note: Probably for export to Europe.

168 Mark: PICTURE 74
Small oblong meat platter
Mark: Crown over 'REAL IRONSTONE CHINA', printed in sepia and '144' painted in red enamel.
Ironstone, outline transfer print in sepia with an oriental landscape overpainted in underglaze blue and red enamel with orange lustre. Some gold embellishments.

Geo. L. Ashworth Broad Street Works, Hanley c.1860–70

169 to 169B PICTURE 50
Large vase, pierced inner cover and lid.
Earthenware, traditional Chinese form with long and flaring neck. Domed cover surmounted by crossed dolphins. The handles in the form of three arcaded arches. The whole covered with a bright toned blue enamel. Design with hand-painted flowers and leaves in underglaze blue and enamel colours enriched with gilding.

Possibly Geo. L. Ashworth Broad Street Works, Hanley c.1870–80

170 to 170C PICTURE 51
Pair of vases and covers.
Mark: 'MASON'S' over a crown, drape enclosing 'PATENT IRONSTONE CHINA' and 'ENGLAND' painted in black. Pattern number 'C107' painted in black enamel. Earthenware, octagonal, the foot decorated with outline transfer print in black with flowers and leaves painted in enamel colours. The body decorated with a ground of scales transfer printed in black overpainted in red enamel. Reserves on each side of Chinese scenes overpainted in enamel colours. The pattern repeated on the domed lid. The finial in the form of a circular ball.

Geo. L. Ashworth Broad Street Works, Hanley c.1910–20

Note: Pattern same as jug 69
Pattern now referred to as 'Red Scale'; see *Compendium* of Mason's patterns, published by Mason's Collectors Club (1996).

171 and 171A PICTURE 52

Pair of vases.

Mark: On 171, 'MASON'S' over a rounded crown, drape enclosing 'PATENT IRONSTONE CHINA' printed in black. 'C1659' painted in black. On 171A, same as above, and 'ENGLAND' printed in black.

Earthenware, baluster shape with circular foot and flared neck. Decorated with panels in orange with alternate 'Prunus' blossom and oriental figures, transfer printed in black painted in enamels and gold. The rest decorated in underglaze blue overlaid with gold scales. Inside neck band orange enamels.

Geo. L. Ashworth Broad Street Works, Hanley c.1920–30

Note: No information is given in the pattern books for C1659. It was originally entered between 1903–15.

172 PICTURE 53

Bowl.

Mark: 'MASON'S' over an angular crown, drape enclosing 'PATENT IRONSTONE CHINA' printed in black. 'C205' painted in red enamel.

Earthenware, transfer printed pattern in black of oriental figures and random flower sprays overpainted in enamel colours. The background overpainted in matt black enamel.

Geo. L. Ashworth Broad Street Works, Hanley c.1920–30

Note: No information is given in the pattern books for C205. It was originally entered between 1900–3.

173 to 173E PLATE U

Footed pot-pourri vases, lids and inner lids.

Mark: On both, 'MASON'S' over an angular crown, drape enclosing 'PATENT IRONSTONE CHINA' printed in dark violet.

Earthenware, square form with canted corners and moulded flared tops, standing on four lion paw feet. Plain inner lid with button finial, domed pierced outer lid terminating in flared moulded chimney. Decorated with outline transfer print in puce with alternating panels of oriental figures, butterflies and Chinese symbols. The top and bottom painted in turquoise enamel with red enamelling on moulding and lion feet. Lid decorated with oriental figures, outline transfer prints hand-enamelled.

Geo. L. Ashworth Broad Street Works, Hanley c.1860–70

Note: Pot-pourri vases of an identical form and decoration were produced by Davenport in both porcelain and stone china. See page 147, colour plate X in *Davenport* by T. A. Lockett & G. A. Godden, published by Barrie & Jenkins (1989).

174 PICTURE 54

Footed bowl.

Mark: 'MASON'S' over an angular crown, drape enclosing 'PATENT IRONSTONE CHINA' printed in black, and '2XD' impressed.

Earthenware, of lobed form. The exterior decorated with underglaze blue overlaid with gold scales, reserved panels in sky blue containing stylised daisies. The interior decorated with a central reserve with a vase of flowers in underglaze blue surrounded by gold. The sides decorated with alternating panels in yellow enamel with Chinese figures, outline transfer printed and enamelled in colours and gold and dragons in underglaze blue and gold. The panels divided by underglaze blue overlaid with scales. Gold edge line.

Geo. L. Ashworth Broad Street Works, Hanley c.1870–80

175 PICTURE 55

Bowl.

Mark: 'MASON'S' over an angular crown, drape enclosing 'PATENT IRONSTONE CHINA' printed in black.

Earthenware, lobed footed bowl. Decorated foot rim, both internal and external, in underglaze blue with stylised flowers in enamel colours. The remainder with yellow ground overprinted with 'oil spots' in black.

Geo. L. Ashworth Broad Street Works, Hanley c.1920–30

176 and 176A PICTURE 56, Mark: PICTURE 75

Tea kettle.

Mark: 'A. BROs' embossed, '18' embossed. Diamond patent office registration mark and 'B2538' in yellow enamel.

Earthenware, oval form with over handle. The lid with foliate protrusion to act as a stop to prevent tilting. *Fleur-de-lis* finial. Decorated in underglaze blue with rectangular panel with canted corners. Transfer printed outline in black, painted in enamel colours with oriental symbols on a waterlily leaf and with a tree peony. Small reserve around the neck. Handle painted in orange and picked out in gold, moulded in the form of overlapping stylised acanthus leaves.

Geo. L. Ashworth Broad Street Works, Hanley c.1880–90

177 and 177A PICTURE 57

Vase and cover.

Mark: Remnants of 'MASON'S' above an angular crown, drape containing 'PATENT IRONSTONE CHINA' printed in brown.

Ironstone, baluster form with flared foot. Domed pierced lid with button finial. Decorated with underglaze blue ground, two panels oblong with canted corners, outline transfer print overpainted in enamel colours. Border picked out in yellow enamel. Smaller reserves around the base and neck alternating panels in red with oriental figures and white with flowers and holey rock. The whole decorated with gold foliate scrolls. Gold edge lines to lid and vase.

C. J. Mason Lane Delph c.1840–5

Note: Similar design as 176 in different enamel colours.

178

Plate.

Mark: 'MASON'S' over a rounded crown, drape enclosing 'PATENT IRON-
STONE CHINA' and 'ENGLAND' printed in black. 'C1659' in ochre enamel.
'1XJ' impressed.

Earthenware, with gadroon moulded edge.

Geo. L. Ashworth Broad Street Works, Hanley c.1920–30

Note: Decoration as 171

179 and 179A PICTURE 58. Mark: PICTURE 76

Coffee jug and lid

Mark: 'REAL IRONSTONE CHINA' impressed. Royal coat of arms over 'IRON-
STONE CHINA' printed in underglaze blue. 'B1845' painted in red enamel.
Ironstone, globular form with bamboo moulded handle. Spout moulded with two
lines of bamboo. Domed lid with pointed finial. Body decorated with dark green
enamel. Reserve (as 177). Neck band underglaze blue, outline print enamelled in
red. Gilt swags.

Geo. L. Ashworth Broad Street Works, Hanley c.1865–75

Note: Pattern book entry reads: 'B 1845 as B 1847 but Cupid shape', 'B 1847. Teapot.
print purple and brown'.

GLOSSARY

acanthus
Southern European plant with spiked leaves which has been used as a decorative motif since early times.

Angoulême, sprig
cornflowers used as a decorative motif frequently found as a sprig or repeated pattern. Adapted from a French pattern frequently found on Paris porcelain.

anthemion
decorative motif derived from a stylised honeysuckle. It can be either in floral or foliate patterns.

armorial ware
ceramic pieces decorated with either heraldic arms or a crest. The fashion developed from armorial engraving on silver and enamelled oriental porcelain.

Art Nouveau
a style of decoration introduced into England during the 1880s, partly as a result of the Arts and Crafts Movement and the work of William Morris.

back-stamp
a modern term sometimes applied to the factory mark placed on a ceramic piece. It can be printed, painted or impressed.

ball clay
type of potter's clay found predominantly in Devon and Dorset and used extensively in the Staffordshire pottery industry. It is a dark-coloured clay which becomes lighter when fired. It is used to give strength and plasticity to the body.

baluster
shape similar in form to the upright supports of a balustrade. Usually used to describe vase shapes.

bas-relief
French term referring to low-relief decoration.

bat printing
developed about 1774, it is a method used to transfer printed patterns by means of a bat of either soft glue or gelatine, which were substituted instead of the more commonly used tissue paper.

biscuit
unglazed porcelain or earthenware which has been fired once from the cheese hard state.

blue
a colour used for the decoration of pottery and porcelain, derived from cobalt oxide.

body

the composite material from which earthenware, stoneware or porcelain is manufactured. Sometimes used to describe the main portion of the vessel, as distinguished from the base, cover etc.

bone ash

derived from calcined animal bones (mainly cattle), and used in significant quantities in the production of bone china.

bone china

ceramic body first introduced by Josiah Spode about 1796 and almost exclusively manufactured in England.

burnished

polished by friction. Gilding when fired onto ceramics has a dull or matt surface which needs to be polished. This is usually done with a metal tool or agate stone burnisher.

Bute

name given to a specific shape of cup, thought to have been named after the Earl of Bute.

cabaret set

the term 'Cabaret' originally referred to a tea-table but in later usage came to mean a set of ceramics comprising a tray, teapot, cream jug, sucrier and cups and saucers. For one person it became known as a solitaire, whilst for two people it was called a tête-à-tête.

campana

a vase shape derived from the Greek krater. It is of inverted bell shape.

can

a cylindrical cup, made in England towards the end of the eighteenth century, used for serving coffee.

casting

the process of shaping a ceramic object by pouring liquid clay, called slip, into a dry plaster mould. The mould absorbs the water from the slip leaving a layer of clay to build up on the inner surface of the mould. When the clay has reached a sufficient thickness the surplus is poured off and the object is left to dry before being removed from the mould.

celadon

a colour derived from iron oxide which can range in colour from sea-green to putty.

cheese hard

the consistency of clay after some of the moisture has been evaporated but whilst it is still soft enough to work and before its first firing. Also known as leather hard.

china clay

the English term for kaolin, a white clay which is derived from decomposed granite. The largest deposits in England are found in Cornwall.

china stone

the English term for petuntse, an essential ingredient in the manufacture of porcelain.

chinoiserie

European decoration inspired by oriental sources usually based on Chinese originals and frequently including pseudo-Chinese figures, pagodas, monsters, landscapes etc., with an imaginative fantasy element.

clobbering
overpainting in enamels on an underglaze blue pattern.

coloured glaze
a glaze coloured by staining with a metallic oxide such as manganese for a brown-purple tone, copper oxide for green.

comport
a form of dessert dish, usually on a stem base.

crazing
a network of fine surface cracks, usually due to incompatibility between the shrinkage of the body and glaze.

decoration
the enhancement of the basic ceramic piece by one of the many methods of decoration, painting, printing gilding etc.

dessert service
a set of plates, compotiers, tureens, icepails, bowls etc., specially adapted for serving dessert and usually separate from the dinner service.

dipped
glazed by being immersed in a liquid in which glaze particles are suspended.

Dog of Fo
also known as Lion of Fo. A Chinese lion, pairs of which were originally temple guardians, often miscalled 'dogs'. The male is represented playing with a ball, and the female with a cub. Fo means Buddha.

drainer
a flat pierced false bottom resting on a platter, frequently used for meat or fish plates.

earthenware
an English term for factory-made pottery which is not vitrified (therefore it excludes stoneware and porcelain). Earthenware is porous if not covered with a glaze.

enamel
an opaque or transparent pigment of a vitreous nature, coloured with metallic oxides and applied to ceramics over the glaze.

enamel firing
a low temperature firing to secure permanently the enamels to the glaze. This is done in a muffle kiln.

everted
turned outwards in shape, such as the rim of a piece or the lip of a jug.

fettling
the process in manufacturing of finishing a pot before firing by removing any seam marks, casting marks or other blemishes. It is especially used with slip-cast hollow-ware pieces.

finial
the terminal ornament on an object, especially on the cover where it also acts as a handle.

firing
the process of transforming the object from a raw clay state into pottery or porcelain by exposing it to the required temperature in a kiln.

gadroon
an ornamental border, from the silver forms, consisting of a continuous pattern of

short repetitive reeds or flutes which can be vertical or set diagonally or twisted.

garniture

the French form for a set of vases or ornaments, usually to decorate a chimney piece or shelf.

gilding

the application of gold to the decoration of an object.

glaze

a coating of glass applied to the porous body to seal it against penetration by liquids. It gives a brilliant, smooth surface. Glaze can be applied by dipping or spraying, after which it is fired in what is generally referred to as the glost firing.

hard-paste porcelain

more correctly termed 'true porcelain', it is made from kaolin and petuntse.

hardening-on

firing underglaze decoration lightly in order to fix the decoration to the biscuit body before glazing.

hybrid hard-paste porcelain

porcelain made basically to the hard-paste formula but with the addition of magnesium and quartz.

Imari

a term given to a type of decoration adapted from the Japanese porcelain made at Arita and shipped through the port of Imari from the early years of the eighteenth century. The style was copied extensively in Europe and Britain.

impressed

indented, as distinguished from incised or cut, into the soft unfired clay by means of a stamp.

inkstand

a receptacle which includes inkwells, a pounce pot or sand dredger and taper stick, sometimes found in association with a spill vase and letter rack en suite.

ironstone china

a type of opaque stone china introduced into England in the first quarter of the nineteenth century. Patented by C. J. Mason in 1813.

kaolin

white china clay which is an extremely pure aluminium silicate and is the essential ingredient of all true porcelains.

kiln

the oven used for firing all ceramic wares.

lustre

a form of decoration giving a metallic, sometimes iridescent, appearance. It can be used as a complete surface cover, as part of the pattern or as an edge line to emulate gilding.

mandarin decoration

a form of decoration in emulation of Chinese export porcelain, usually comprising alternating panels of figure subjects and flowers.

manganese

an oxide colour which will give a variety of tones from purple through to a rich brown.

marks

names, letters, numbers or symbols placed over or under the glaze to indicate the

different manufactories or information relating to the production of the piece.

mazarine blue
an English version of the dark underglaze blue which was used extensively on the Continent from at least 1686.

Meissen
(Saxony) porcelain manufactured from 1710 under the patronage of Augustus the Strong (Elector of Saxony and King of Poland).

mould
a form used in making, from an original model, ceramic pieces. Frequently made from plaster of Paris.

muffle
the inner chamber or box in which objects were enclosed to protect them from the flames or smoke whilst being fired, especially during the enamel firing.

ogee
a shape or ornamentation in the form of a double curve, as in the letter 'S'.

on-glaze
the same as overglaze, where enamel colours are applied on top of the glaze.

osier
(from the German *Ozier*) literally meaning a willow twig used in basketry from which a number of woven-type patterns have been derived.

overglaze
decoration either painted or transfer printed on the surface of the piece after it has been glazed.

painted
decoration which has been applied with a brush by hand. It can be either underglaze or overglaze.

pedestal
a stand of pottery or porcelain, higher than it is wide, to support a figure, bust or urn.

petuntse
the Gallicised form of the Chinese Pai-Tun-Tzu, first used by Jesuit missionaries in the eighteenth century to describe the rock which forms an essential ingredient of true porcelain. It is a silicate of potassium and aluminium, also called feldspathic rock. The discovery of petuntse in England during the eighteenth century led to the production of true porcelain in Britain.

plinth
the lower, usually square, part of the base of a column; correspondingly, the base of a vase when it is similarly designed.

polychrome
decoration in more than two colours.

porcelain
the usual explanation is that the word was derived from the Portuguese *Porcella*, which refers to a cowrie shell, because the appearance of the interior was not dissimilar to Chinese porcelain. Porcelain is usually translucent to transmitted light.

pottery
a generic term for all ceramic wares without exception, but in most instances it is used to designate wares which are not porcelain; therefore, it includes both earthenware and stoneware.

pounce-pot

a pot with a perforated cover or top for sprinkling pounce, a fine powder of gum sandarac formerly used on parchment to prepare it for writing and to stop the ink spreading. Pounce is different from pumice or other powders used in place of blotting paper to dry the ink after writing. The pounce-pot usually forms part of a desk or inkstand.

quodlibet

from the Latin, meaning 'what pleases'. A decorative design in *trompe l'oeil* style as if casting shadows. Used by Mason's as a decorative border motif transfer printed in underglaze blue.

raised gilding

gilding thickly applied or applied over a paste base to stand proud of the surface, or in low relief.

reserve

a portion of the surface of a ceramic object left without the application of a ground colour, but surrounded by it. Such reserved areas or panels are usually decorated with enamel colours.

Rococo

a style of decoration which followed the Baroque style. The principal features are asymmetricality of the ornament and a considerable use of shell, flower, foliage and scrollwork motifs.

saggar

a protective case of fire clay used to enclose the objects during firing.

socle

a low block, rectangular, square, or circular, used as a base below the plinth (if any), for a bust, statue or vase.

spill vase

a cylindrical vase used for holding spills, wood splinters or paper tapers for obtaining a light from the fire. Also called quill-holder or luminary.

spit-out

small black blemishes caused by dust being trapped between the body and glaze, which become evident after the second firing.

stippled

type of engraving used in bat printing where the design is composed of dots rather than the more conventional lines.

stone china

a fine white porcellaneous stoneware, hard and compact and sometimes translucent. It was first developed by John and William Turner of Lane End, Staffordshire, about 1800.

sucrier

the French term for a sugar bowl.

terminal

a sprigged ornament frequently found at the lower end of a handle where it joins the main body of the vessel.

throwing

the act of shaping a ceramic object on a rotating potter's wheel.

transfer printing

the process of decorating a ceramic piece by inking an engraved copper plate with an ink made from mineral oxides and then transferring the design onto a specially prepared tissue paper; whilst the pigment is still wet the tissue is pressed onto the ware leaving the desired imprint. This is subsequently fixed by firing.

turning

a method of finishing ceramic ware, after preliminary shaping on the potter's wheel and drying to a leather hard state. Turning is usually done on a lathe.

underglaze

decoration of any kind applied to the ceramic body before the application of a glaze.

underglaze colours

colours employed in the decoration of a piece which can be applied before glazing. The commonest colour is cobalt blue, though manganese and copper can also be used under the glaze.

zaffer

(from the Arabic) refers to impure cobalt oxide obtained from fusing the mineral ore with sand. It is used in the manufacture of smalt and as an underglaze colour for some blue and white wares. It produces a dark impure blue colour.

MASON'S MARKS 1813–48

With the granting of the patent for making Ironstone China in July 1813, Miles Mason retired and the business was then put into the names of his two younger sons, George Miles and Charles James. The patent, however, was in the name of the youngest, Charles James.

With the change, the method of marketing the wares changed too. The ironstone body was the principle body produced and it was always well marked. The other types included: bone china, which was seldom marked; earthenware, under the name 'Cambrian Argil'; and Fenton stoneware, another earthenware body, which was more frequently marked with the name of the particular body.

The first marks to have been used were impressed.

> PATENT IRONSTONE CHINA impressed in a circle.
> MASON'S PATENT IRONSTONE CHINA impressed in one straight line.
> MASON'S PATENT IRONSTONE CHINA impressed in two lines.

A transfer printed mark came into use sometime during this period, probably around 1818. This was printed in underglaze blue and was as follows:

> A LARGE ROUNDED CROWN, above a cartouche and drape which contained the words 'Patent Ironstone China'; the word 'Mason's' surmounting the crown and spreading well over the crown itself. This mark can sometimes be found without the name Mason's above and in conjunction with one of the impressed marks.

These marks can be found on almost every piece of a service and were in use for a number of years, probably well into the late 1820s.

> A LARGE PRINTED COAT OF ARMS supported by a lion and unicorn couchant, above 'Patent Ironstone Warranted' in a drape, all printed in black, c.1820–30.
> A RAMPANT LION AND UNICORN, supporting a cartouche with the word 'Patent' and 'Ironstone China' in two lines beneath; all impressed. Occasionally found on dinner services but more usually on the moulded dessert ware of the period, 1818–20s.

Around 1820 a different earthenware body was made using Welsh clay. This was not as heavy nor as durable as the ironstone and to underline the Welsh connection a new mark was introduced.

MASON'S CAMBRIAN ARGIL, impressed in one or two lines, occasionally transfer printed in underglaze blue.

During the 1820s three transfer printed marks were designed to be placed on special items in a table service.

PATENT YACHT CLUB FINGER BOWL, with a crown, all contained within a double framed circle.
MASON'S UNMERAPOORA TEA POT, contained within a double oval frame.
PATENT BUTTER FRIGEFACTER, with a crown below, all contained within a double framed circle.
These last three marks are seldom found today.
FENTON STONE WORKS This can be found within a single or double frame and dates from the mid-1820s but if a pattern number is shown below the frame this denotes a date in the 1830s.

In 1826 the partnership between G. M. & C. J. Mason was dissolved, leaving Charles James as sole proprietor. The marks which show the impressive front of the factory are after this dissolution, and are printed in black.

FENTON STONE WORKS, with C. J. M & Co. in three lines contained within a cartouche and, 'GRANITE CHINA' above, with 'STAFFORDSHIRE POTTERIES' below, or
IMPROVED CHINA, STAFFORDSHIRE POTTERIES, or
GRANITE CHINA, STAFFORDSHIRE POTTERIES, placed below or on either side.

From 1830 there is another change of marking. The impressed marks and the large underglaze blue transfer printed crown and cartouche are superseded by another printed mark.

A SMALL ROUNDED CROWN, with the name 'MASON'S' fitting neatly over the crown, a cartouche and drape with the words 'PATENT IRONSTONE CHINA' below.
This mark is printed in a sepia/mauve colour and in any other colour must be considered suspect. This mark was used again later, in blue or black, during the ASHWORTH period.

By 1840 yet another change takes place; the small round crown is superseded by:

A LARGE ANGULAR CROWN, with 'MASON'S' placed over the crown and 'PATENT IRONSTONE CHINA' in the cartouche and drape below, printed in black.
This mark was used until the Mason bankruptcy in 1848.
A LARGE PSEUDO CHINESE SEAL MARK, printed in underglaze blue, with no name or initials accompanying it; found on large ornamental items, it appears to be from the last period of the Mason era c.1840—8.

During the short time that Charles James Mason attempted to restart his business (1851—3), he used the following printed marks:

C. J. MASON, BRONZED METALLIC POTTERY, FENTON STONE WORKS, LONGTON 1850. Sole Patentee of the Patent Ironside China. All of this is contained within a circle.

MASON'S BANDANA WARE, 1851, enclosed within a garter in the centre of which are the words: 'Patentee of the Patent Ironstone China'.

In the early years of the G. M. & C. J. Mason partnership, pattern numbers were seldom used. They are occasionally found on items of the moulded dessert ware, and also tea ware, which was produced in bone china, numbered in the high 900s and again in the 1100 range. Pattern numbers are not found on the early ironstone services of the impressed mark period.

Later, in the 1830s, they are found much more frequently on ironstone tables services and ornamental ware; also on bone china tea ware which often does not carry a factory mark. Names of patterns were not used during the Mason family's ownership of the company.

After the bankruptcy of 1848 the business passed into the hands of Francis Morley.

FRANCIS MORLEY & CO. 1848–58

Francis Morley used the Mason moulds and designs. He also used some of the Mason marks, adding his own name or initials below. Several other purely Morley marks were used including:

REAL IRONSTONE CHINA, printed or impressed.
ROYAL STONE CHINA, printed.
OPAQUE CHINA, printed.

These last three could be found within a belt and buckle devise surrounding a Coat of Arms, or with a crown over. The name was given in full or just as initials accompanying the mark; the name of the pattern was also often incorporated into the transfer.

In 1858 Francis Morley entered into partnership with Taylor Ashworth.

MORLEY & ASHWORTH 1858–61

This partnership continued to use the Mason moulds and designs. Several printed marks were used. They incorporated the names of the partners or their initials; one had the words 'Imperial Ironstone' beneath the Coat of Arms used before. Pattern numbers from this period are 3356 or over, without a B or C prefix, or fraction 4 over the pattern number.

GEO. L. ASHWORTH & BROS. (LTD) 1861–1968

Ashworth's continued to produce the same type of wares as the previous partnerships. The Mason marks, shapes and popular designs were still in use alongside their own factory marks etc., and great care should be taken when trying to put a date on a piece which has the late Mason 'Angular' crown used during the 1840s. This mark was used extensively, but the small crown of the 1830s was also used, often in underglaze

blue or black in place of the earlier sepia/mauve. There were some variations made to the crown over the years which were not found in the Mason period, although the basic design of crown, cartouche and drape with the words 'Patent Ironstone China' with 'Mason's' above, were kept.

Pattern numbers are a great help. Ashworth's introduced a 'B' series in 1862, so any item which carries such a number must come from the Ashworth period. 'B' numbers were phased out around 1900 and a new 'C' series was introduced; any 'C' pattern is likely therefore to be from this century. If a piece has 'ENGLAND' incorporated in the mark it denotes a date after 1891; if it has 'Made in England' it dates from this century.

G. L. Ashworth & Bros. used their marks alongside the Mason marks. Several printed marks, similar in style and often incorporating a crown were used.

REAL IRONSTONE CHINA is used again, both printed and impressed.
Marks carried with either the initials or name in full:
G. L. A. & Bros.
ASHWORTH BROS.
G. L. ASHWORTH & BROS.

The pattern name can be found with the factory mark, but it is as well to remember that although Ashworth's had their own marks they also continued to use the Mason printed marks without any other identifying mark. The long use of the familiar Mason transfer printed marks by succeeding owners of the pottery can make it difficult to assess during which period a piece was made. To add to the confusion, several patterns were used almost continuously and others were re-introduced again later. Over many years the dyes used changed, altering the colours slightly, and that can be a guide if you have knowledge of the original pattern.

The world-famous Mason, Imari 'Basket of Flowers' pattern, found on mugs and jugs of all sizes in great quantities today, is a good example of a pattern and shape which has changed very little over very many years. Later items may not be of ironstone but earthenware; these of course will be lighter in weight and that will help with dating. Later pieces may also have extra marks, odd numbers or letters, often in red and not part of the factory mark; these are other pointers to a later date.

The Raven Mason
Collection

Exterior of Keele Hall PICTURE 1

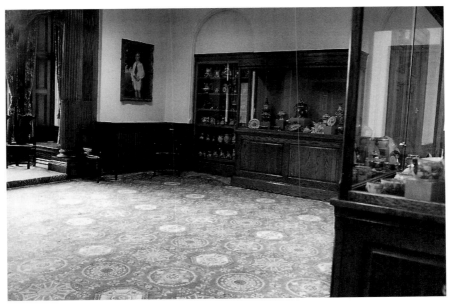

Interior of Raven Mason Suite PICTURE 2

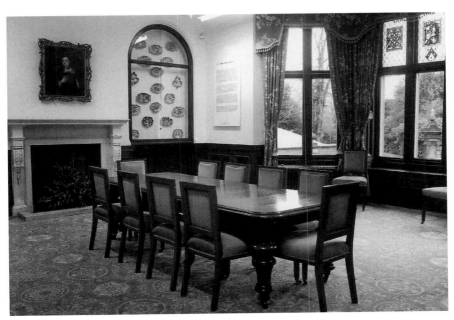

Interior of Raven Mason Suite PICTURE 3

Ronald W. Raven
PICTURE 4

John M. Raven
PICTURE 5

Dame Kathleen Raven
PICTURE 6

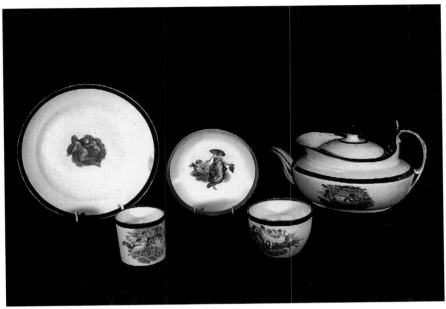

1 Tea service PICTURE 7

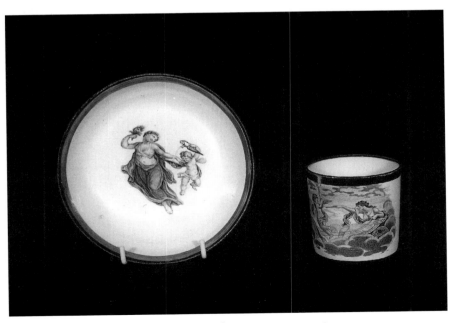

2 Coffee cup and saucer PICTURE 8

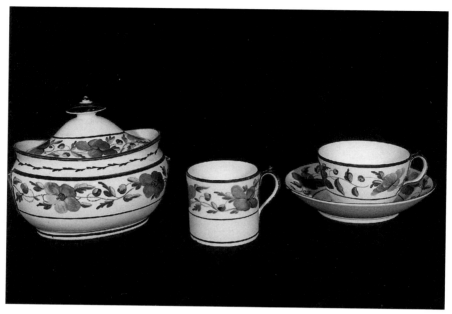

3 Tea service PICTURE 9

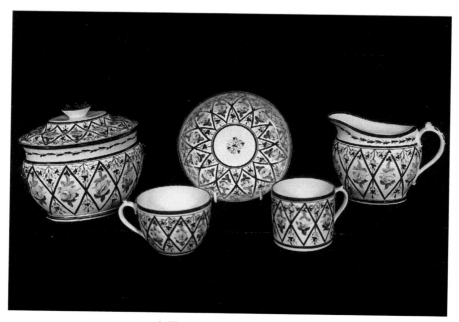

4 Tea service PICTURE 10

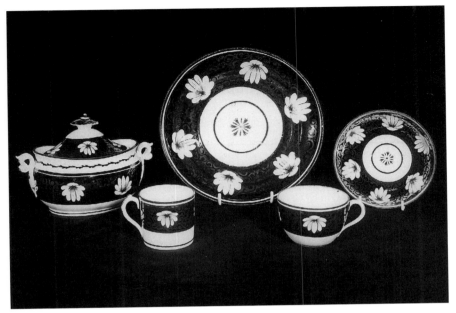

5 Tea service PICTURE 11

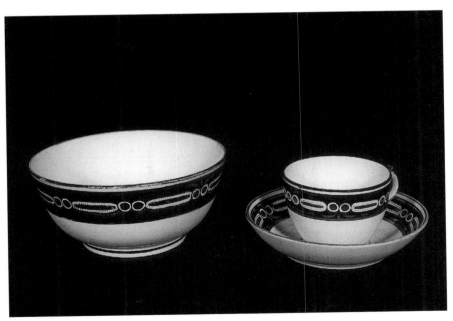

6 Tea cup, saucer, slop basin PICTURE 12

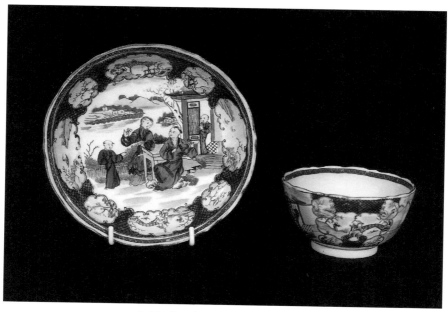

8 Tea bowl, saucer PICTURE 13

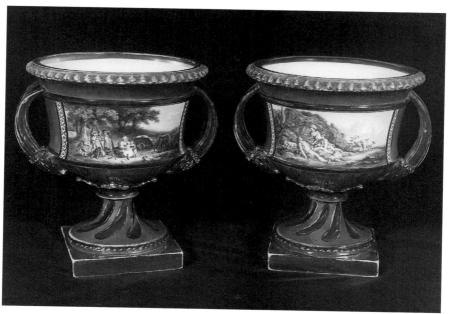

22 Pair of Campana shape vases PICTURE 14

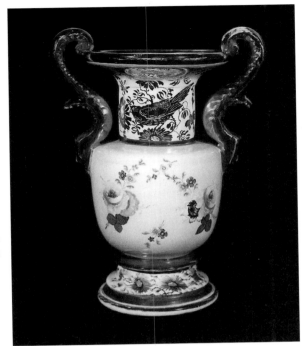

23 Vase
PICTURE 15

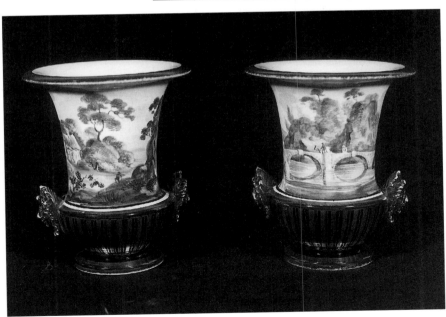

25 Pair of vases PICTURE 16

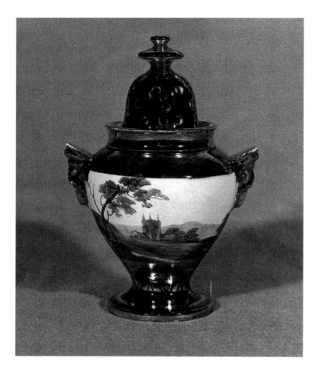

26 Pot-pourri pot
PICTURE 17

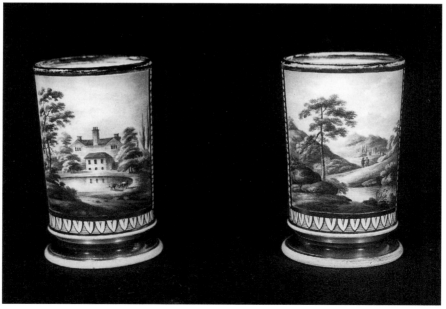

33 Spill vases PICTURE 18

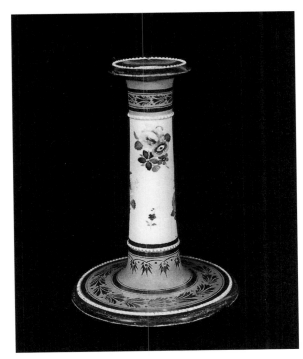

34 Candlestick
PICTURE 19

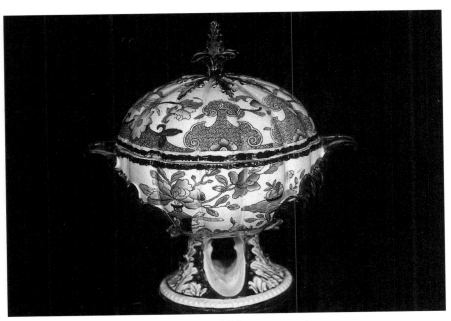

39 Tureen and lid PICTURE 20

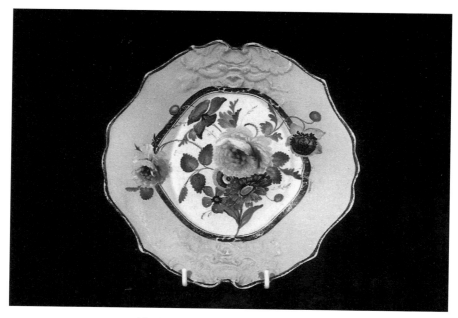

41 Sauce tureen stand PICTURE 21

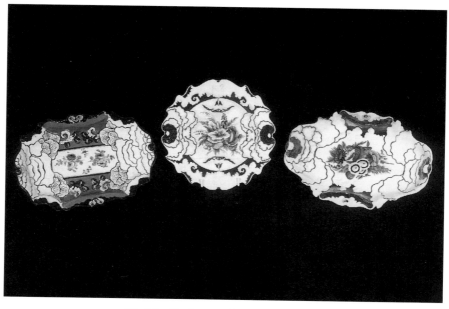

43, 44, 45 dessert plates PICTURE 22

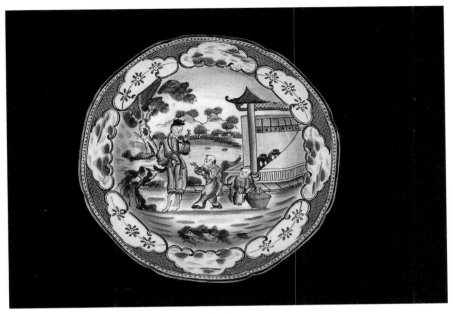

46 Soup bowl PICTURE 23

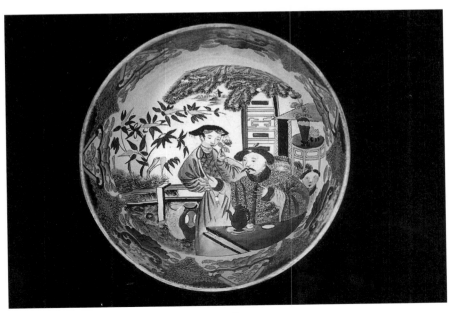

47 Footed bowl PICTURE 24

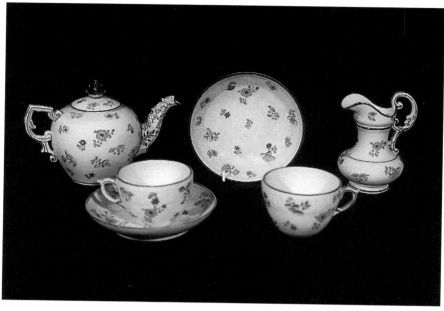

49 Tête-à-tête set PICTURE 25

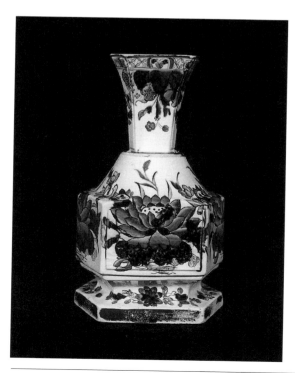

50 Vase
PICTURE 26

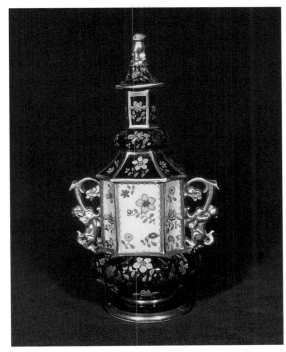

51 Vase and lid
PICTURE 27

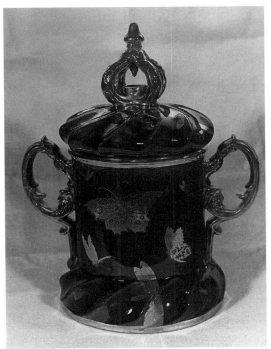

53 Mitre jar and cover
PICTURE 28

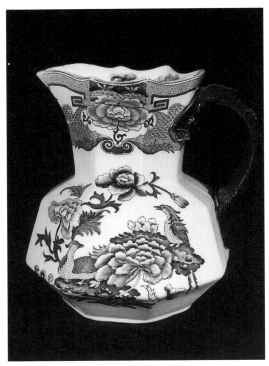

56 Jug
PICTURE 29

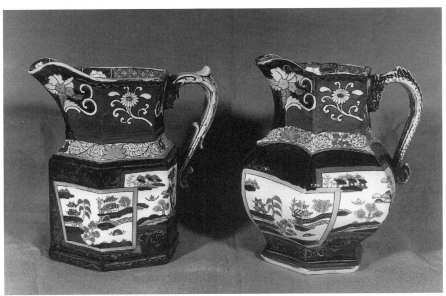

58, 59 Jugs PICTURE 30

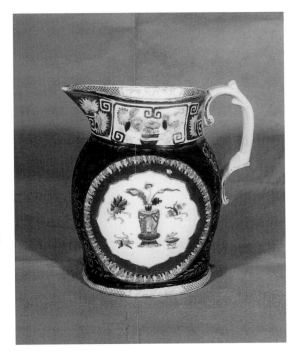

60 Jug
PICTURE 31

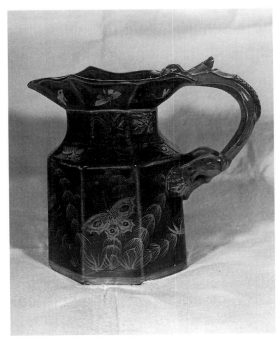

63 Jug
PICTURE 32

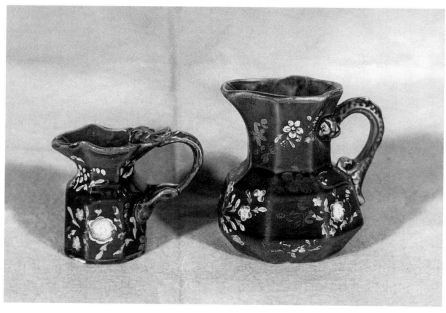

65, 64 Jugs PICTURE 33

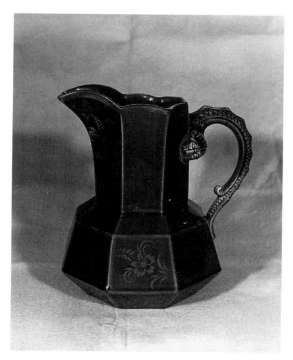

67 Jug
PICTURE 34

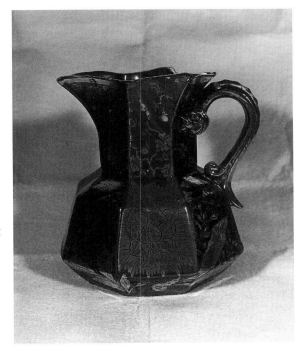

68 Jug
PICTURE 35

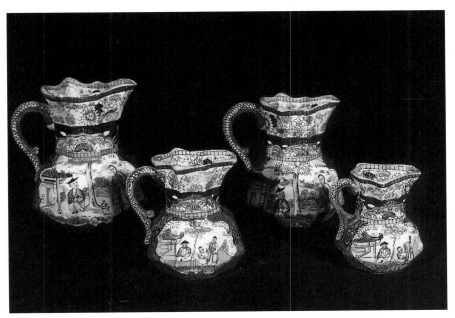

69 Set of 4 jugs PICTURE 36

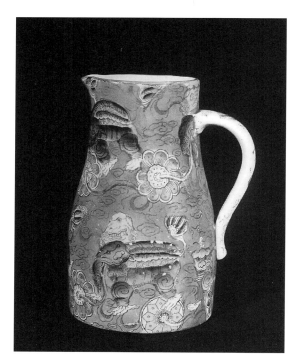

74 Jug
PICTURE 37

75 Jug
PICTURE 38

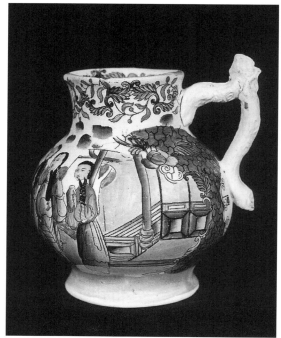

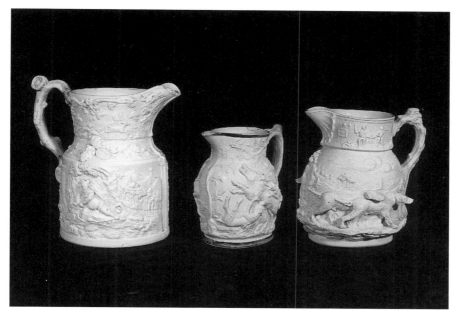

81, 79, 80 Jugs PICTURE 39

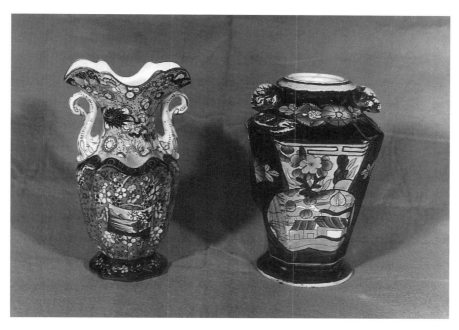

126, 100 Vases PICTURE 40

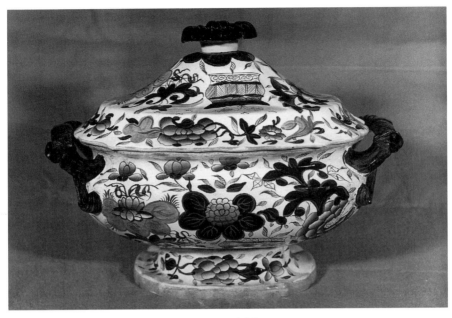

101 Soup tureen and lid PICTURE 41

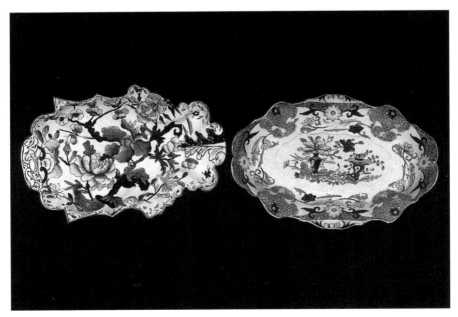

103, 105 Dessert dishes PICTURE 42

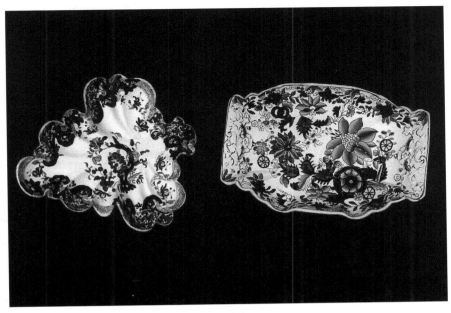

104, 110 Dessert dishes PICTURE 43

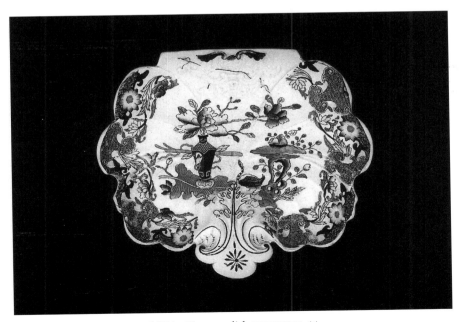

105A Dessert dish PICTURE 44

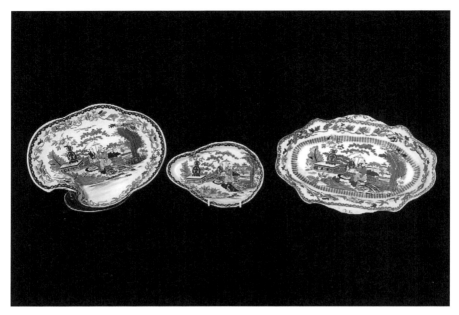

106A, 113, 106 Dessert dishes [(middle) **113** sauce boat stand] PICTURE 45

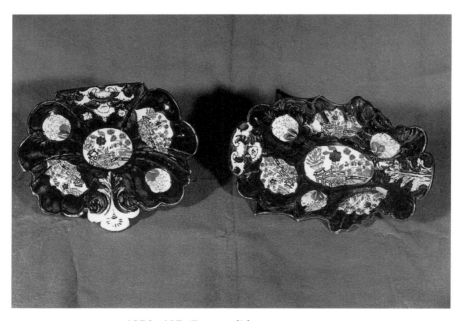

107A, 107 Dessert dishes PICTURE 46

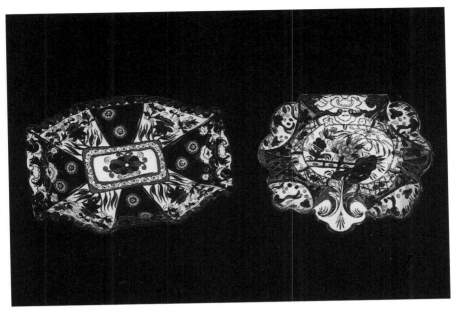

109, 108 Dessert dishes PICTURE 47

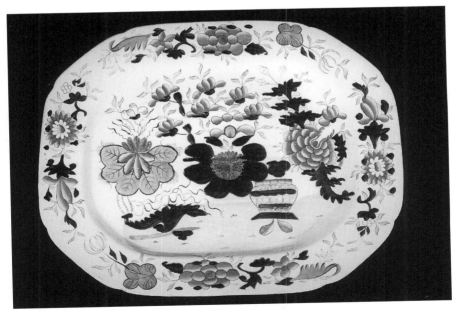

112 Meat plate PICTURE 48

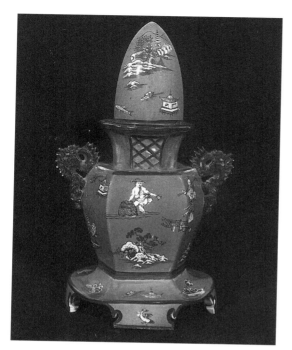

143 Vase and cover
PICTURE 49

169 Large vase
PICTURE 50

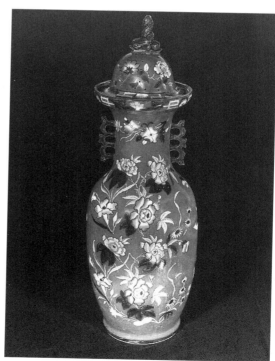

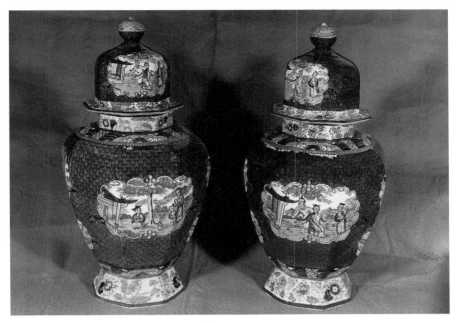

170 Pair of vases PICTURE 51

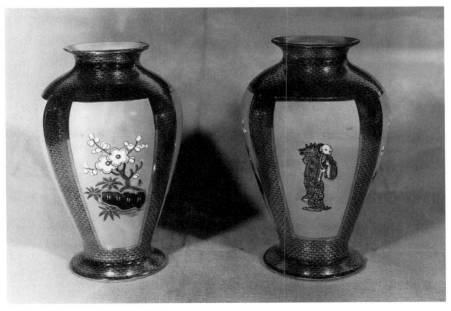

171 Pair of vases PICTURE 52

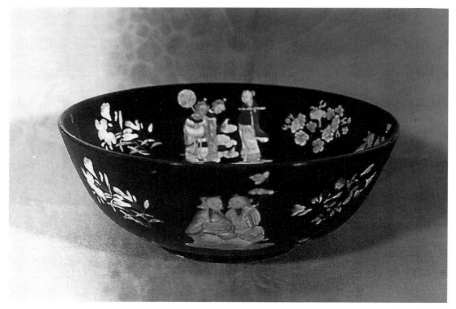

172 Bowl PICTURE 53

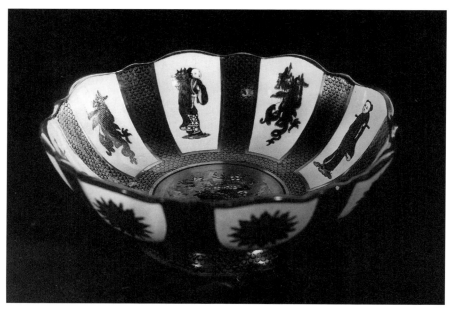

174 Bowl PICTURE 54

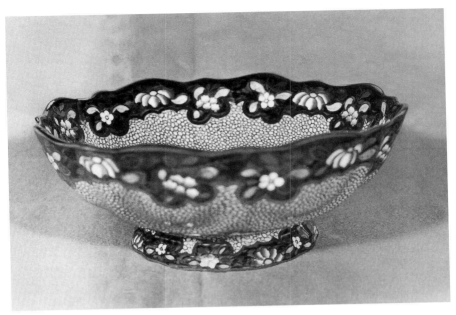

175 Bowl PICTURE 55

176 Tea Kettle
PICTURE 56

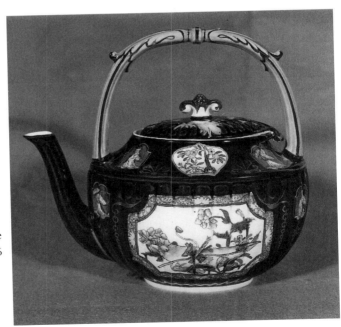

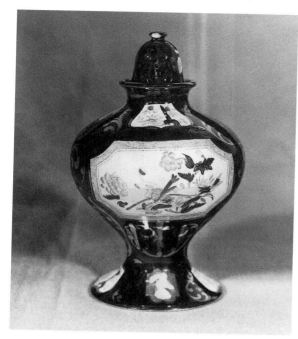

177 Vase and cover
PICTURE 57

179 Coffe jug and lid
PICTURE 58

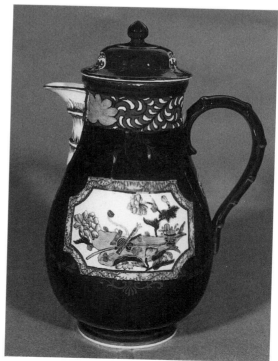

7 M Mason impressed PICTURE 59

10D MILES MASON + seal mark PICTURE 60

14 seal mark PICTURE 61

20 MASON'S PATENT IRONSTONE CHINA PICTURE 62

32 IRONSTONE CHINA PATENT PICTURE 63

41 Mason's Patent Ironstone CHINA PICTURE 64

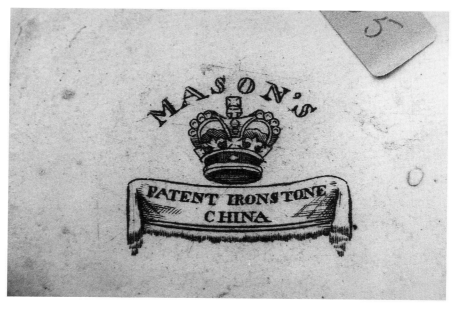

55 MASON'S + crown PICTURE 65

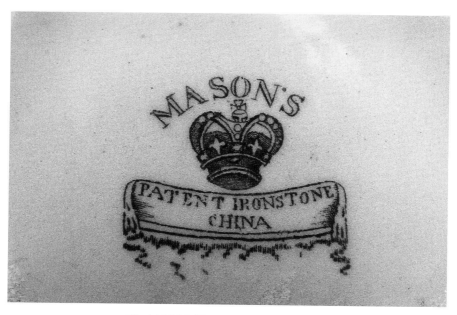

58 MASON'S + crown PICTURE 66

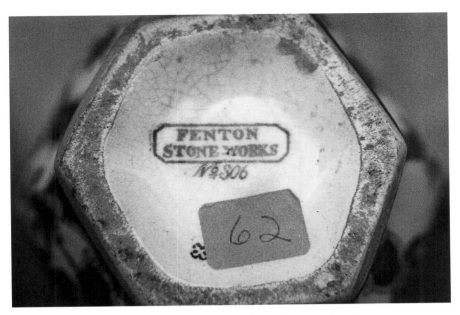

62 FENTON STONE WORKS PICTURE 67

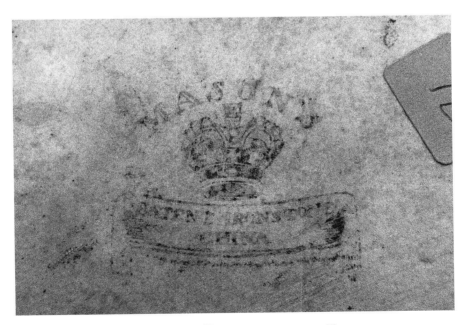

71 MASON'S + crown PICTURE 68

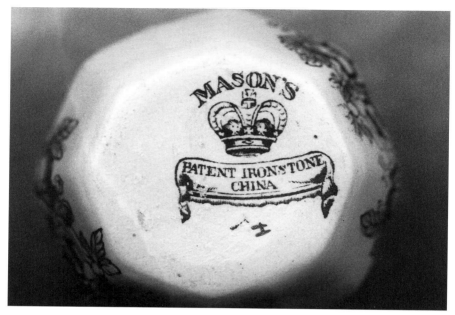

72 MASON'S + crown PICTURE 69

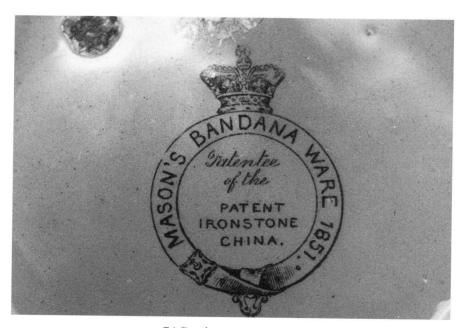

76 Bandana PICTURE 70

88 MASON'S + crown PICTURE 71

89 MASON'S + crown PICTURE 72

148 England
PICTURE 73

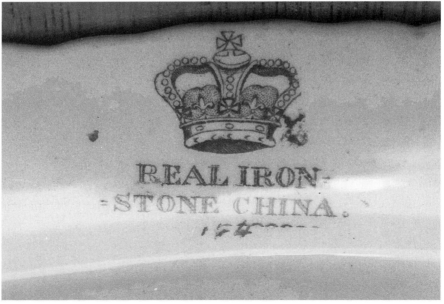

168 Real Ironstone CHINA PICTURE 74

176 Ashworth Bros. + diamond patent office registration mark PICTURE 75

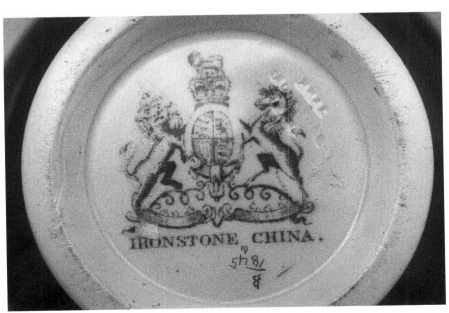

179 Arms over 'Ironstone China' + REAL IRONSTONE CHINA PICTURE 76

BIBLIOGRAPHY

Dr Peter Stovin and Mrs Deborah Skinner

This Bibliography was compiled in June 1994 by Dr P. G. I. Stovin MRCP FRCpath and Mrs Deborah Skinner for the Mason's Collectors Club Newsletter, and was published in issues 108, 109, 110.

Anonymous. 1955. *A survey of Stoke on Trent histories of famous firms Part 2.* 'Geo. L. Ashworth & Bros. Ltd. Broad Street, Hanley, Stoke-on-Trent'. British Bulletin of Commerce. Volume 16, number 8, pages 18–19.★

Ashworth G. L. & Brothers. Date unknown. *Catalogue of Patterns and Shapes for Mason's Ironstone China.* 10 pages of colour illustration.★

Ashworth G. L. & Brothers. 1910. *A Note on the Mason Family and Pottery.*★ (See Goddard)

Ashworth George L. & Bros. 1913. Advertisement. *The Connoisseur.* Volume 35, April, page XLIV.#

Ashworth George L. & Bros. c.1913–25. *Catalogue and gross price list.* 13 pages.★ (Grocers and butchers outfitting goods)

Ashworth George L. & Bros. Ltd. c.1920. *Price list and rate book for dinner, tea, breakfast, dessert, toilet and kitchen ware.* Printed by Wood, Mitchell & Co. Ltd., Hanley. 94 pages.★

Ashworth Geo. L. & Bros. c.1929. *A note on the Mason Family and Pottery. Catalogue and price lists of Mason's Ironstone China tableware.* 44 pages.★

Ashworth Geo. L. & Bros. c.1929. *Geo. L. Ashworth & Bros. Sole makers of Mason's Patent Ironstone China.* A catalogue containing: *A note on the Mason Family and Pottery.* 3rd Edition. 1929, 9 pages; *Mason's Ironstone China Tableware.* No date, 9 pages; Ashworth Bros. Catalogue and price lists of Mason's Ironstone China tableware. No date, alternate pages numbered 1–44. (Probably same as preceding item)

Ashworth George L. & Bros. c.1953. *Catalogue and price list for Mason's Ironstone China.* 14 pages.★

Beardmore F. G. 1934. 'Old Mason Ware'. *Antique Collector*, December. Volume 5, issue 12, pages 390–3.

Berthoud, M. 1982. *An Anthology of British Cups.* Micawber Publications, Wingham, pages 9, 19, 23, 32, 36, 40, 45, 50, 56, 59, 108, 120–2.

Blacker, J. F. c.1910. *Nineteenth-Century English Ceramic Art.* Stanley Paul & Co., London, pages 41 and 189–97.#

★ Information Library, Hanley.
Cambridge University Library.

Blacker J. F. c.1910. *The ABC of Collecting Old English China. Giving a short history of the English Factories and showing how to apply tests for unmarked china before 1800.* Stanley Paul & Co., London, pages 318–22.#

Blake Roberts, G. 1996. *Mason's – The First Two Hundred Years.* Merrell Holberton, London.

Bolton Museum and Art Gallery. 1980–1. *The Masons – A Dynasty of Potters 1796–83.* (Compiled by D. J. Morris and L. G. King. Exhibition). 12 pages.

Burchill F. & Ross R. 1977. *A History of the Potter's Union.* Ceramic & Allied Trades Union, Hanley, Stoke-on-Trent, pages 17, 89.˜

Burgess F. W. 1916. *Old Pottery & Porcelain.* George Routledge & Sons Ltd., London, pages 205–7.#

Cansdell W. 1828. Advertisement for sale of goods by Samuel Baylis, Faraday & Co. *The Times* (London). 25 April, page 4, column f.#

Cansdell W. 1828. Letter in reply to letter by 'Manufacturer'. *The Times* (London). 30 April, page 4, column a.#

Chaffers W. 1965. (15th edition). *Marks & Monograms on European and Oriental Pottery and Porcelain.* William Reeves, London. Volume 2, pages 103–5, 362.

Collard E. 1967. *Nineteenth Century Pottery & Porcelain in Canada.* McGill University Press, Montreal, pages xiii, 3, 47–8, 51, 66–7, 71, 83–4, 96, 98, 106, 118–19, 125–35, 137, 151, 163, 165, 168, 190–1, 193, 214, 216, 224, 231, 233–4, 236–7, 284, 314.˜

Collard E. 1977. 'Iron hard for Canada'. *Country Life*, 10 March, pages 588–90.#

Collard E. 1984. *Nineteenth Century Pottery & Porcelain in Canada.* 2nd edition. McGill University Press, Montreal, pages xix, 120, 125–30, 131–2, 164–5, 214, 216, 233–4, 237, 284.

Coysh A. W. 1972. *Blue-Printed Earthenware 1800–1850.* David & Charles, Newton Abbot, pages 44–7, 54–5.

Coysh A. W. 1974. *Blue and White Transfer Ware 1780–1840.* David & Charles, Newton Abbot, pages 15–16, 44–7.

Coysh A. W. & Henrywood R. K. 1982. *The Dictionary of Blue and White Printed Pottery 1780–1880.* Antique Collectors' Club Ltd., Woodbridge, pages 239 and 241.

Cushion J. P. 1976. *Pottery and Porcelain Tablewares.* Studio Vista, London, pages 121, 123.˜

Cushion J. & Cushion M. 1992. *A Collector's History of British Porcelain.* Antique Collectors' Club Ltd., Woodbridge, pages 242–3.

Davis H. 1991. *Chinoiserie – Polychrome Decoration on Staffordshire Porcelain 1790–1850.* The Rubicon Press, London, pages 122–3 and 183.˜

Downman Rev. E. A. revised by Gunn A. D. 5th edition 1910. *English Pottery and Porcelain. A Handbook for Collectors.* 'The Bazaar Exchange and Mart', London, pages 104–8.#

Emmerson R. 1992. *British Teapots & Tea Drinking 1700–1850 illustrated from the Twining Gallery, Norwich Castle Museum.* HMSO, London, pages 22, 235–9, 249, 253, 256, 259, 267, 300.

Ewins N. M. D. 1992. 'Staffordshire Ceramic Trade with the United States: the Role of the Merchants, Goddard, Burgess and Dale, in the Mid-nineteenth Century'.

Journal of the Northern Ceramic Society, Volume 9, pages 153–61.

Fisher S. W. 1955. 'Mason's Ironstone China'. *Country Life*, 29 December, pages 1518–19.#

Fisher S. W. 1956. 'Splendor for the Masses'. *Antique Dealer*, November, pages 39–41.

Fisher S. W. 1959. 'Mason's Patent Ironstone China; an Underrated Ware'. *Antiques*, June. Reprinted 1980 in Atterbury P. (ed.), *English Pottery and Porcelain: an Historical Survey*. Peter Owen, London, pages 263–6.

Foster J. 1888. *Alumni Oxoniensis* ('George Miles Mason'). Parker & Co., Oxford. Volume 3, page 924.#

Friends of Blue. 1973 to date. *Friends of Blue Bulletin*. Members only.

Glover S. E. 1951. 'History of Mason's Ironstone China'. *Ceramics*, volume 3, April, pages 83–90.+

Goddard J. V. (1910) 3rd edition 1936. *The Mason Family and Pottery*. G. L. Ashworth & Bros. Ltd., Hanley, 16 pages.

Godden G. A. 1963. *British Pottery and Porcelain 1780–1850*. Arthur Barker Limited, London, pages 36–40.

Godden G. A. 1971. *The Illustrated Guide to Mason's Ironstone China. The Related Ware – 'Stone China', 'New Stone', 'Granite China' – and their Manufacturers*. Barrie & Jenkins, London, xiv, 175 pages, 141 plates and 8 colour plates.

Godden G. A. 1972. *Jewitt's Ceramic Art of Great Britain 1800–1900*. Barrie & Jenkins, London, pages xix, 48, 49, 53–4, 62–3, 102–3.

Godden G. A. 1975. 'Miles Mason's Teapots (1805–1815)'. *Antique Dealer & Collectors' Guide*, August, pages 74–8.

Godden G. A. 1976. 'Miles Mason's Breakthrough – porcelain designs at earthenware prices'. *Art and Antiques Weekly*. Volume 22, number 10, 13 March, pages 46–50.

Godden G. A. 1977. *Mason's Pottery & Porcelain*. Illustrated supplement to tape-recorded talk. Godden, Worthing, 9 pages.~

Godden G. A. 1980 (2nd edition). *Godden's Guide to Mason's China and the Ironstone Wares*. Antique Collectors' Club Ltd. Woodbridge. 316 pages, 362 plates and 14 colour plates.

Godden G. A. (ed.) 1983. *Staffordshire Porcelain*. Granada, London, pages 164–80, 232–3,
361, 379, 542.

Godden G. A. 1988. *Encyclopaedia of British Porcelain Manufacturers*. Barrie & Jenkins, London, pages 98, 513–15.

Godden G. A. 1991 (3rd edition). *Godden's Guide to Mason's China and the Ironstone Wares*. Antique Collectors' Club, Woodbridge. 344 pages, 362 plates and 54 colour plates.

Grove A. 1993. *Index and Compendium to Masons Collectors' Club Newsletters numbers 1–101*. (Club members only)

Haggar D. 1974. 'A Miles Mason dessert service'. Northern Ceramic Circle News Letter. March. Number 9, pages 13–14.@

Haggar D. 1974. 'Children's games on Mason vases'. Northern Ceramic Circle News

Cambridge University Library.
+ Leeds University Library.
~ City Museum & Art Gallery, Hanley.
@ Royal National Museum of Scotland, Edinburgh.

Letter. November. Number 12, page 12. @

Haggar R. 1952. *The Masons of Lane Delph and the Origins of Mason's Patent Ironstone China*. Lund Humphries & Co. Ltd, xvii, 104 pages, 41 plates and 8 colour plates.

Haggar R. G. 1960. *The Concise Encyclopaedia of Continental Pottery & Porcelain.* Andre Deutsch, London, page 168.

Haggar R. 1972. 'Miles Mason'. English Ceramic Circle Transactions, Volume 8, part 2, pages 183–98.#

Haggar R. 1975. 'C. J. Mason, Pattern Books and Documents'. English Ceramic Circle Transactions, Volume 9, part 3, pages 276–90.#

Haggar R. 1976. 'Black-printing on Porcelain'. English Ceramic Circle Transactions, Volume 10, part 1, pages 39–53.#

Haggar R. 1978–9. 'Miles Mason and Others'. Journal of the Northern Ceramic Society, Volume 3, pages 7–24.@

Haggar R. 1980–1. 'Some Unusual Miles Mason Pieces'. Journal of the Northern Ceramic Society, Volume 4, pages 109–12.@

Haggar R. G. 1983. 'Miles Mason's Porcelains 1794–1813 and continued by his sons'. In Godden G. A. (1983) *Staffordshire Porcelain*. Granada, London, Chapter 11, pages 164–80.

Haggar R. 1984. 'Miles Mason and the Landscape of Inheritance'. Northern Ceramic Society Newsletter, 54/3, pages 8–12.

Haggar R. & Adams E. 1977. *Mason Porcelain and Ironstone 1796–1853*. Faber & Faber, London. 133 pages, 144 plates and 8 colour plates.

Halfpenny P. & Lockett T. A. 1979. *Staffordshire Porcelain 1740–1851*. (Exhibition). Northern Ceramic Society & City Museums & Galleries, Stoke-on-Trent, pages 30–1, 41–3, 49–50, 61–3, 72, 74, 76, 82–3, 98–103.˜

Hampson R. 1990. *Longton Potters 1700–1865*. Journal of Ceramic History, City Museum & Art Gallery Stoke-on-Trent. Volume 14, pages 122–3.

Hayden A. 1904. *Chats on English China*. T. Fisher Unwin, London, pages 215–18.#

Hayden A. 1909. *Chats on Old English Earthenware*. T. Fisher Unwin Ltd., London, pages 445–7, 450–4, 477, 482.

Henrywood R. K. 1984. *Relief-Moulded Jugs 1820–1900*. Antique Collectors' Club, Woodbridge, pages 162–72, 200.

Howard V. 1993. *An Exhibition Dedicated to the Landscape & Flower Painting on Miles Mason Porcelain & Early Ironstone China*. (Includes a section, pages 4–8, on 'Characteristics of Miles Mason's ornamental wares', by Sabina J.) Pardy & Son (Printers) Ltd. Ringwood. 24 pages.

Hughes B. & Hughes T. 1956. *The Collector's Encyclopaedia of English Ceramics*. Lutterworth Press, London, pages 108–9.

Hughes G. B. 1959. *Victorian Pottery and Porcelain*. Spring Books, London, pages 45, 52–6.

Jewitt L. 1878. *The Ceramic Art of Great Britain from prehistoric times down to the present day, being a history of the ancient and modern pottery and porcelain works of the kingdom and of their productions of every class*. 2 volumes. Virtue and Co. Limited, London. Volume 2, pages 315–18, 405, 407–8, 413, 525.#

Cambridge University Library.
@ Royal National Museum of Scotland, Edinburgh.
˜ City Museum & Art Gallery, Hanley.

Jewitt L. 1883 (2nd edition). *The Ceramic Art of Great Britain*. R. Worthington, New York, pages 491–2, 551–4, 557.

King L. 1983. 'C. J. Mason at Daisy Bank, 1850–53'. Northern Ceramic Society Newsletter, Number 52, part 3, pages 4–10.

King L. G. 1987. 'Improved Ironstone China'. Northern Ceramic Society Newsletter, Number 65, part 11, pages 28–30.

Lewis G. 1969. *A Collector's History of English Pottery*. Studio Vista, London, pages 152–5, 213.

Lewis G. 1985. *A Collector's History of English Pottery*. Antique Collectors' Club, Woodbridge, pages 139–42, 336.

Litchfield F. revised by Tilley F. 6th edition 1953. *Pottery & Porcelain. A Guide to Collectors*. Adam & Charles, London, pages 147, 179–80.

Mankowitz W. & Haggar R. G. 1957. *The Concise Encyclopaedia of English Pottery and Porcelain*. Andre Deutsch, London, pages 9–10, 142–4.

'Manufacturer' 1828. Letter about sales of goods by Samuel Baylis, Faraday and Mason. *The Times* (London). 28 April, supplement page 2 column c.#

Markin T. 1983. 'Thomas Wolfe and his Associates'. Northern Ceramic Society Newsletter, Number 52, part 10, pages 21–30.

Markin T. 1984. 'Thomas Wolfe and his Associates. Part II'. Northern Ceramic Society Newsletter, Number 55, part 5, pages 15–22.

Markin T. 1985. 'Thomas Wolfe: Man of Property. Part III'. Northern Ceramic Society Newsletter, Number 58, part 4, pages 6–15.

Markin T. 1986. 'Thomas Wolfe and China Clay in Cornwall'. Northern Ceramic Society Newsletter, Number 63, part 6, pages 28–30.

Markin T. L. 1989. 'Thomas Wolfe: Teawares at Liverpool and Stoke'. Journal of the Northern Ceramic Society, Volume 7, pages 1–14.

Markin T. 1991. 'Miles Mason's Partnerships at Liverpool'. Northern Ceramic Society Newsletter, Number 81, pages 25–30.

Markin T. 1991. 'Thomas Wolfe's Pearlware and other Wares at Stoke upon Trent'. Northern Ceramic Society Newsletter, Number 84, pages 29–37.

Markin T. 1992. 'The Wolfe-Mason-Lucock version of the dagger border pattern and related patterns'. Northern Ceramic Society Newsletter, Number 86, pages 19–23, and News Letter 89, page 36.

Markin T. & Alleker B. 1993. 'Liverpool Porcelains – Thomas Wolfe & Co.'. In *Made in Liverpool: Liverpool Pottery & Porcelain 1700–1850*, edited by E. M. Brown & T. A. Lockett. (Exhibition) National Museums & Galleries on Merseyside, pages 34–6.

Mason C. J. 1813. *Patent Number 3724. Specification of Charles James Mason Manufacturer of Porcelain*. (A subheading reads 'A process for the improvement of the Manufacture of English Porcelain'.) 31 July. George E. Eyre and William Spottiswode, Holborn, 1856. 3 pages.#

Mason's Collectors' Club. 1972 to date. *Mason's Collectors' Club Newsletter*. Club members only.

Mason's Collectors' Club. 1974. *The Masons of Lane Delph; Porcelain, Stoneware and*

Letter. November. Number 12, page 12. @

Haggar R. 1952. *The Masons of Lane Delph and the Origins of Mason's Patent Ironstone China*. Lund Humphries & Co. Ltd, xvii, 104 pages, 41 plates and 8 colour plates.

Haggar R. G. 1960. *The Concise Encyclopaedia of Continental Pottery & Porcelain*. Andre Deutsch, London, page 168.

Haggar R. 1972. 'Miles Mason'. English Ceramic Circle Transactions, Volume 8, part 2, pages 183–98.#

Haggar R. 1975. 'C. J. Mason, Pattern Books and Documents'. English Ceramic Circle Transactions, Volume 9, part 3, pages 276–90.#

Haggar R. 1976. 'Black-printing on Porcelain'. English Ceramic Circle Transactions, Volume 10, part 1, pages 39–53.#

Haggar R. 1978–9. 'Miles Mason and Others'. Journal of the Northern Ceramic Society, Volume 3, pages 7–24.@

Haggar R. 1980–1. 'Some Unusual Miles Mason Pieces'. Journal of the Northern Ceramic Society, Volume 4, pages 109–12.@

Haggar R. G. 1983. 'Miles Mason's Porcelains 1794–1813 and continued by his sons'. In Godden G. A. (1983) *Staffordshire Porcelain*. Granada, London, Chapter 11, pages 164–80.

Haggar R. 1984. 'Miles Mason and the Landscape of Inheritance'. Northern Ceramic Society Newsletter, 54/3, pages 8–12.

Haggar R. & Adams E. 1977. *Mason Porcelain and Ironstone 1796–1853*. Faber & Faber, London. 133 pages, 144 plates and 8 colour plates.

Halfpenny P. & Lockett T. A. 1979. *Staffordshire Porcelain 1740–1851*. (Exhibition). Northern Ceramic Society & City Museums & Galleries, Stoke-on-Trent, pages 30–1, 41–3, 49–50, 61–3, 72, 74, 76, 82–3, 98–103.˜

Hampson R. 1990. *Longton Potters 1700–1865*. Journal of Ceramic History, City Museum & Art Gallery Stoke-on-Trent. Volume 14, pages 122–3.

Hayden A. 1904. *Chats on English China*. T. Fisher Unwin, London, pages 215–18.#

Hayden A. 1909. *Chats on Old English Earthenware*. T. Fisher Unwin Ltd., London, pages 445–7, 450–4, 477, 482.

Henrywood R. K. 1984. *Relief-Moulded Jugs 1820–1900*. Antique Collectors' Club, Woodbridge, pages 162–72, 200.

Howard V. 1993. *An Exhibition Dedicated to the Landscape & Flower Painting on Miles Mason Porcelain & Early Ironstone China*. (Includes a section, pages 4–8, on 'Characteristics of Miles Mason's ornamental wares', by Sabina J.) Pardy & Son (Printers) Ltd. Ringwood. 24 pages.

Hughes B. & Hughes T. 1956. *The Collector's Encyclopaedia of English Ceramics*. Lutterworth Press, London, pages 108–9.

Hughes G. B. 1959. *Victorian Pottery and Porcelain*. Spring Books, London, pages 45, 52–6.

Jewitt L. 1878. *The Ceramic Art of Great Britain from prehistoric times down to the present day, being a history of the ancient and modern pottery and porcelain works of the kingdom and of their productions of every class*. 2 volumes. Virtue and Co. Limited, London. Volume 2, pages 315–18, 405, 407–8, 413, 525.#

Cambridge University Library.
@ Royal National Museum of Scotland, Edinburgh.
˜ City Museum & Art Gallery, Hanley.

Jewitt L. 1883 (2nd edition). *The Ceramic Art of Great Britain*. R. Worthington, New York, pages 491–2, 551–4, 557.

King L. 1983. 'C. J. Mason at Daisy Bank, 1850–53'. Northern Ceramic Society Newsletter, Number 52, part 3, pages 4–10.

King L. G. 1987. 'Improved Ironstone China'. Northern Ceramic Society Newsletter, Number 65, part 11, pages 28–30.

Lewis G. 1969. *A Collector's History of English Pottery*. Studio Vista, London, pages 152–5, 213.

Lewis G. 1985. *A Collector's History of English Pottery*. Antique Collectors' Club, Woodbridge, pages 139–42, 336.

Litchfield F. revised by Tilley F. 6th edition 1953. *Pottery & Porcelain. A Guide to Collectors*. Adam & Charles, London, pages 147, 179–80.

Mankowitz W. & Haggar R. G. 1957. *The Concise Encyclopaedia of English Pottery and Porcelain*. Andre Deutsch, London, pages 9–10, 142–4.

'Manufacturer' 1828. Letter about sales of goods by Samuel Baylis, Faraday and Mason. *The Times* (London). 28 April, supplement page 2 column c.#

Markin T. 1983. 'Thomas Wolfe and his Associates'. Northern Ceramic Society Newsletter, Number 52, part 10, pages 21–30.

Markin T. 1984. 'Thomas Wolfe and his Associates. Part II'. Northern Ceramic Society Newsletter, Number 55, part 5, pages 15–22.

Markin T. 1985. 'Thomas Wolfe: Man of Property. Part III'. Northern Ceramic Society Newsletter, Number 58, part 4, pages 6–15.

Markin T. 1986. 'Thomas Wolfe and China Clay in Cornwall'. Northern Ceramic Society Newsletter, Number 63, part 6, pages 28–30.

Markin T. L. 1989. 'Thomas Wolfe: Teawares at Liverpool and Stoke'. Journal of the Northern Ceramic Society, Volume 7, pages 1–14.

Markin T. 1991. 'Miles Mason's Partnerships at Liverpool'. Northern Ceramic Society Newsletter, Number 81, pages 25–30.

Markin T. 1991. 'Thomas Wolfe's Pearlware and other Wares at Stoke upon Trent'. Northern Ceramic Society Newsletter, Number 84, pages 29–37.

Markin T. 1992. 'The Wolfe-Mason-Lucock version of the dagger border pattern and related patterns'. Northern Ceramic Society Newsletter, Number 86, pages 19–23, and News Letter 89, page 36.

Markin T. & Alleker B. 1993. 'Liverpool Porcelains – Thomas Wolfe & Co.'. In *Made in Liverpool: Liverpool Pottery & Porcelain 1700–1850*, edited by E. M. Brown & T. A. Lockett. (Exhibition) National Museums & Galleries on Merseyside, pages 34–6.

Mason C. J. 1813. *Patent Number 3724. Specification of Charles James Mason Manufacturer of Porcelain*. (A subheading reads 'A process for the improvement of the Manufacture of English Porcelain'.) 31 July. George E. Eyre and William Spottiswode, Holborn, 1856. 3 pages.#

Mason's Collectors' Club. 1972 to date. *Mason's Collectors' Club Newsletter*. Club members only.

Mason's Collectors' Club. 1974. *The Masons of Lane Delph; Porcelain, Stoneware and*

Ironstone. (Exhibition) City Museum and Art Gallery, Stoke-on-Trent Museum. 36 pages.

Mason's Ironstone. No date (after 1973). *Mason's Ironstone: a short History.* Wedgwood Group. 16 pages.

Mason's Ironstone. Folded single sheet product leaflets. Later half of twentieth century:
Mason's Ironstone. No date. *Fruit.*

Mason's Ironstone, Member of the Wedgwood Group. No date. *Furnivals Denmark.*

Mason's Ironstone, Member of the Wedgwood Group. No date. *Furnivals Quail.*

Mason's Ironstone. No date. *Gold Giftware.* (Comprising Mandalay, Chartreuse, and Brown Velvet)

Mason's Ironstone. No date. *Mandarin.*

Mason's Ironstone, Member of the Wedgwood Group. 1975. *Mason's Ironstone Christmas Plate.*

Mason's Ironstone, Member of the Wedgwood Group. No date. *Nabob.*

Mason's Ironstone, Member of the Wedgwood Group. No date. *Paynsley.*

Mason's Ironstone, Member of the Wedgwood Group. No date. *Pink Vista.*

Mason's Ironstone. No date (c.1990). *Table Lamps.* 12 pages.

Mason M. 1804. Advertisement. 'Mason's China'. *The Morning Herald* (London), Monday 15 October, page 1 column a; repeated on Wednesday 17 October, page 1 col. c and on Friday 19 October, page 1 col. c.$

Mason M. 1822. 'Obituary of Miles Mason'. *Gentleman's Magazine.* Volume 92, part 1, pages 474–5.#

Meigh A. 1939. *The Mason Potters of Lane Delph Staffordshire.* Privately published, Forsbrook, Stoke-on-Trent, 20 pages.˜ (lacks the 35 illustrations)

Miller P. & Berthoud M. 1985. *An Anthology of British Teapots.* Micawber Publications, Broseley, pages 75, 118–19, 164, 198, 208–9, 225, 244, 251, 312, 323–34, 341, 352.

Moody J. 1991. 'Two Rare Marks'. (1, Mason; 2, Folch & Sons). Northern Ceramic Society Newsletter, Number 82, pages 6–7.

Price B. 1978. *The Arthur Negus Guide to English Pottery and Porcelain.* Hamlyn, London, pages 147–8.

Raven R. W. 1990. 'Mason's Porcelain and Ironstone'. *Antique Collector,* February, pages 64–8.

Rhead G. W. & Rhead F. A. 1906. *Staffordshire Pots and Potters.* Hutchinson and Co. London, pages 294–5.

Sackville-West T. 1978. 'Mason's Patent Ironstone China'. *Antique Collector,* September, pages 60–3.

Samlesbury Hall. 1977. *Exhibition of Mason's Patent Ironstone China.* 48 pages.

Samlesbury Hall. 1987. *Anniversary Exhibition and Sale of Mason's Patent Ironstone China.* 56 pages.

Shirley Fox A. R. 1915. Untitled illustrated report of Mason's yacht club finger bowl. *The Queen,* 11 September, pages 485–6.#

Skinner D. S. 1982. *Mason, a Family of Potters.* (Exhibition) City Museum & Art Gallery, Stoke-on-Trent. 36 pages.

$ The British Library, Newspaper Library, Colindale.
Cambridge University Library.
˜ City Museum & Art Gallery, Hanley.

Skinner D. S. & Young V. 1992. *Miles Mason Porcelain, a Guide to Patterns and shapes.* (Exhibition) City Museum and Art Gallery, Stoke-on-Trent, 103 pages.

Smith A. 1972. 'Thomas Wolfe, Miles Mason and John Lucock and the Islington China Manufactory, Upper Islington, Liverpool'. English Ceramic Circle Transactions, Volume 8, part 2, pages 199–202.#

Staniland K. 1992. 'Miles Mason and the China Club 1785–88. Part 1'. Northern Ceramic Society Journal, Volume 9, pages 25–43.

Stoke-on-Trent Historic Building Survey. 1985. *Mason's Pottery Factory, Hanley, Stoke-on-Trent.* City Museum & Art Gallery, Stoke-on-Trent, Drawing No. H158. 24 pages and 3 sheets of measured drawings.~

Stuart D. (ed.) 1985. *People of the Potteries. A Dictionary of Local Biography.* Volume 1. Department of Adult Education, University of Keele, pages 93, 103–4, 147–8, 159.~

Thomas J. 1971. *The Rise of the Staffordshire Potteries.* Adams & Dart, Bath, pages 27, 56, 202–3, 213–14.~

Warburton R. H. 1931. *The History of the Trade Union Organisation in the North of Staffordshire.* George Allen & Unwin Ltd., London, pages 83, 115.~

Watney B. 1973. *English Blue and White Porcelain of the Eighteenth Century.* Faber & Faber Ltd., London, pages 3, 76, 81.#

Wedgwood J. C. 1913. *Staffordshire Pottery and its History.* Sampson Low Marston & Co. Ltd., London, pages 144, 155, 169, 176, 191.#

Wetherbee J. 1985. *A Second Look at White Ironstone.* Wallace-Homestead Book Co., Illinois, pages 13, 21–2.~

Williams P. & Weber M. R. 1986. *Staffordshire II Romantic Transfer Patterns, Cup Plates and Early Victorian China.* Fountain House East, Jefferson, Kentucky, pages 205, 214–15, 422.

Young V. 1972. 'Ironstone China from the Mason Family'. *Antique Collecting.* Part 1, Volume 7, Number 12 (April), pages 30–4; Part 2, Volume 8, Number 1 (May), pages 4–7.

Young V. 1973. 'Ironstone China from the Mason Family'. *The Trade*, Volume 2, Number 4 (April), pages 30–8.

Young V. M. 1974. 'Mason's Porcelain and Ironstone'. Australasian Antique Collector Annual. 15th edition, pages 62–6.

~ City Museum & Art Gallery, Hanley.
Cambridge University Library.